Images of Christ

An Introduction to
Christology

Glenn F. Chesnut

THE SEABURY PRESS

ACKNOWLEDGMENTS

The author wishes to thank the following for permission to quote from works issued by their publishing houses:

Cambridge University Press for permission to quote from the Thirty-nine Articles of Religion from their present English edition of the Book of Common Prayer.

The United Methodist Publishing House for a section from the Order for Confirmation and Reception into the Church from *The Methodist Hymnal* (copyright 1964, 1966).

Scriptural passages marked NEB are taken by permission from *The New English Bible.* © The Delegates of the Oxford University Press and the Syndics of the Cambridge University Press 1961, 1970.

Scriptural passages marked RSV are taken by permission of the National Council of the Churches of Christ from the Revised Standard Version of the Bible, copyrighted 1946, 1952 © 1971, 1973.

All other Old and New Testament quotations are the author's own translation, as are the selections from Dante, Seneca, and Diotogenes.

Library of Congress Catalog Card Number 83-16367
ISBN: 0-86683-875-9

Printed in the United States of America
5 4 3 2 1

The Seabury Press
430 Oak Grove
Minneapolis, Minnesota 55403

TO MY MOTHER

God through all things seen and heard
makes known to man the secret things
of life and death.
　　　　　　　　—*A. T. Hind*

Contents

Preface

Special thanks are due to a number of people. John E. Smith read the entire manuscript through in its first draft and made a detailed and useful commentary on each chapter; in the section on Nestorius and elsewhere I have tried to take advantage of his criticisms and insights. Dennis E. Groh and J. Patout Burns also read the manuscript and gave valuable general comments. The first chapter in particular was rewritten in light of observations by Groh. Brian McDonald was yet another contributor: a central part of the argument towards the end of the final chapter is to be credited to him.

The one who first introduced me to the Christological problem twenty years ago, and showed me what was fundamentally at stake, was my dear and respected teacher, Albert C. Outler. I was pleased that he was able to read this book when it was in its final stage, for he once again helped me to sharpen and clarify my thought.

Linda L. Schultz, the secretary of the history department, typed the manuscript and helped in innumerable other ways during the entire period when the work was in progress. The librarians at Indiana University at South Bend, who have aided me so much over the years, were once again indomitable in tracking down every book I needed. The university also gave me a Summer Faculty Fellowship to finish the last revisions of the manuscript, for which I am most grateful.

The quotation on the dedicatory page, which seemed to fit the spirit of this book so well, is from a poem by my grandfather, first a professor of Bible and then pastor of churches in north Georgia for many years.

One of the most special debts is owed, however, to my wife Judith, who read and discussed with me every draft of every section of the book, commenting on each of them in light of her own considerable layperson's knowledge of philosophy, religion, and political thought. Her common sense and understanding of things spiritual, together with her unfailing moral support, were a rock of support along the way.

Indiana University, G. F. C.
South Bend.
October 1983.

Introduction

The central figure in Christianity is Jesus Christ himself. Countless men and women over the past two thousand years have devoted their lives to him, found their joy in him, and gone willingly to their deaths for him. This is the core of the Christian religion. With loving care, great artists have created paintings, erected cathedrals, and written hymns and epics to his glory. Western culture cannot be understood at all without some knowledge of who he was and what he meant for those who believed in him.

This is a book about Christ. It is divided into eight chapters, each dealing with one of the central images which Christianity has used to help explain who he was and what he did: Christ as the sacrifice for our salvation, the Messiah, the Word of God, the revealer of God, the human being who was also divine, the head of a new humanity, and the conqueror of death.

It is designed first of all for the ordinary layperson, as a book which can be read and enjoyed. It does not assume any previous background in either theology or history; anything which would not be immediately understandable to the general reader is explained right at that point. But it can be read at a different level as well. For those who do know a bit about philosophy and religion, or who are reading this book for a university or seminary course, I have phrased my words simply, to be sure, but carefully

and precisely as well, and have laid out the basic issues in their proper terms. For readers of the latter sort, I have attempted to put matters in such a way as to make it easier to understand the nature of the fundamental problems being discussed when they go on to read other books, such as the ones which are listed (with a line or two of commentary on each) in the suggestions for further reading at the end of this volume.

A good portion of the book is historical. Each chapter begins with the period of the Old and New Testament and attempts to give some idea of the way in which a modern biblical scholar would see the central issues and alternatives as they were presented by the original authors of the scriptures themselves. In most chapters, each of these basic problems is then traced down successively through all the major eras of subsequent Christian history: patristic, medieval, reformation, enlightenment, and modern. In part, the idea is to see in each period, as fairly and sympathetically as possible, how the Christians of that time spoke of that facet of Christ's person and work. At every point, however, the attempt has been made to show what the true issue was and which fundamental Christian assertion was at stake in each century's formulation of that aspect of the Christian message.

The first part of each chapter analyzes the historical development of the ideas themselves, but abstract theology of this sort is close to meaningless when totally disconnected from the daily life of the ordinary religious person. This is obviously true for the believer, and every truly good Christian theologian down through the centuries has known it. Anselm in the eleventh century went so far as to declare that all good theology must be cast in the form of *fides quaerens intellectum*, "faith seeking understanding." But whatever the formulation, the connection must exist, for the believer, between theological principle and everyday life, or the ideas themselves are not genuinely understood at all. It is not always so obvious that this is equally the case for the nonbeliever. The same thing is true about books on Christianity that is true of works on Zen Buddhism, Hasidic Judaism, or Freudian psychiatry—anyone who wishes to understand what the system is really about has to see how it impinges on ordinary human life, and how it enables one to interpret everyday experience.

The last part of each chapter therefore moves from the theoretical and the historical to the life of ordinary Christian piety in the modern world. Christianity has its spiritual heights but it is also an earthy religion: farm families singing the old Protestant hymns in a simple country church; a Roman Catholic laborer kneeling before one of the stations of the cross before going to his day's work; people weeping at a cemetery as the body is lowered into its grave; a solitary fisherman lost in the beauty of a sunrise beaming across the water. It is in ordinary, everyday life that religion becomes truly real. And here one may also learn that Christianity can be a far richer thing in actual human experience than our thinking about it can encompass.

It is also the case that one can be true neither to the message of Christ nor to the message about Christ without showing that it is a demand—for belief, for insight, for action. I have put this demand as forcefully as I could, especially at the end of each chapter, because if the reader does not understand that Christ asked no less than total commitment of body, mind, and feeling, he or she has not truly understood the more philosophical and historical parts of the book at all.

On two important issues, this book also attempts to make a theological statement of its own, more at the general than at the particular level, for at this point in history—unlike the first few centuries of Christianity, when almost everyone was a Platonist, or the thirteenth century, when Aristotelian philosophy provided a widely accepted stock of ideas—there are a plethora of theological systems abounding, based on fundamentally different philosophical foundations. Some of them are quite promising, but there is no clear-cut candidate at present for any truly universal acceptance. One thinks of Barthianism, Tillichianism, Bultmannianism, Neo-Thomism, British empiricism, followers of the later Wittgenstein, Jungian psychology, process philosophy, Schubert Ogden's excellent recent exposition of a new, neoclassical transcendental metaphysics, and on and on.

The first of the two theological issues was brought to clearest focus perhaps by Friedrich Nietzsche, even though it was phrased from the negative side as an attack on Christianity. He proclaimed that God was dead in the modern world, because the vital

link had been severed between the intellectual understanding of God and the way human beings actually lived their lives in the world. So the book discusses, in almost every chapter, the ways in which some sense of the real divine presence can be retrieved. The first chapter describes the idea of the sacred and the profane as it occurs in the history of religions. The third chapter speaks of the way in which the logical structures of nature can be seen as shadows of the divine essence itself, and expressions of the divine. The fourth chapter takes a broader look at the intuitive, non-rational knowledge of God, ranging from the classical description of the mystical vision of God to the "natural piety" of nineteenth-century Romantic poetry to the Protestant concept of salvation by faith. Christ himself is of course the supreme instance of the Christian claim that God in his own true being can be genuinely present in human life and history.

I am not a partisan for the use of one modern theological system over another on this issue, at least in the present book. My intent has been instead to show that there are many possible sources to draw on, quite relevant to the modern world, in proclaiming the continuing reality of the divine presence. Contemporary theology must earnestly continue to work at this task, however, consciously and deliberately, for the forces which Nietzsche represented are serious countervalents working continuously in the very fabric of modern society, in all its beliefs and biases.

The other major issue concerns the assertion of the divinity of the historical human being, Jesus of Nazareth. The general council of the Christian church held at Chalcedon in 451 A.D., which has been the touchstone of belief on this topic for most of the Christian world ever since, said that in Christ the two natures, divine and human, were joined into a single "hypostasis." My fundamental criticism here is that most authors of modern books on Christology continue to read that word hypostasis in categories no wider than those used by the Christian theologians who disputed about the nature of universals at the depth of the Dark Ages. Neither of the two key terms, nature or hypostasis, meant either the universal or the particular in that rather narrow sense. "Nature" meant primarily function, and "hypostasis" referred only to rational beings who possessed free will: in the human

context it meant that which made an individual human being the unique person or self he or she was. Two specific suggestions are put forward in this book: reading hypostasis in the modern world in terms of the existentialist idea of the "project" which forms the central, unique, purposive axis of the individual self; or reading it in terms of what the contemporary Christian ethicist, Stanley Hauerwas, has called personal "character." But any reasonably sophisticated modern theological system could cast other workable answers to the Chalcedonian problem on those general guidelines, as long as the true intent of the term hypostasis is understood.

Christ himself remains, however, the center and the key. Theological systems have come and gone over the centuries; Christians have lived under every conceivable political system in societies with almost every imaginable set of social rules; the gospel has undergone verbal changes ranging from the subtle to the profound as it has been translated into the various languages of the earth. But it has been the concrete person of Christ himself, and the common experience of the unchanging reality of God reaching through him for our salvation, which has held it all together. That is why it can be said in truth that all Christians down through the ages have been Christians just like us.

At every period of Christian history, from the New Testament on, the sheer magnitude of God's explosive entry into the world in the person of Jesus of Nazareth has forced the transcending of all inherited categories. He was in fact much more than contemporary Judaism meant by a Messiah, or than contemporary paganism meant by a divine man. The reality of God's act in Christ was far greater also than any of our modern categories will allow us to speak of, unless we force these conceptualizations to transcend themselves and point to something beyond themselves, as all our Christian predecessors did.

It is a great Mystery of which we seek to speak, in fact the greatest of all. By this is meant Mystery in the proper sense—not dishonesty, or special pleading, or obscurantism. Mystery is what invariably, ultimately appears when one is resolutely logical, scientifically honest, and courageous enough to pursue truth to the end. Practicing scientists know what this means, particularly in the fields of chemistry, astronomy, and the strange, disorienting

world of modern physics. On the other side of our theories lies at all times a reality which our schematizations and models do not fully comprehend.

But speak we must. And as Thomas Aquinas said, in a particularly profound observation: as we observe in our everyday human relationships, we can love someone even when we do not fully "understand" him. Such is the case with God also.

❖

The Sacrifice on the Cross

J esus was not literally sacrificed in formal religious ritual by a robed priest on a stone altar; he was executed by Roman soldiers as a criminal and revolutionary, using a form of the death penalty as common in his century as the hangman's noose, the electric chair, and the firing squad are in ours. And yet the metaphor or symbol of Jesus as sacrificial victim has been one of the most important of all the images of Christ through most of the past two thousand years. In hymns and liturgy, in crucifixes and even in the paintings of the great artists of the western world, again and again one is presented with the figure of the Crucified One, the suffering redeemer who saved humanity by the sacrifice of himself upon the cross.

Because of what seems its extremely primitive character, this is also one of the most difficult images of Christ for many modern Christians. But there is no way of appropriating the Christian tradition in the modern world without coming to terms of some kind with it.

The concept of sacrifice did not represent exactly the same set of problems to early Christians because they were living in a pluralistic society where most of the other religions were in fact sacrificial cults. Whether they converted to Christianity from paganism or Judaism, they had been in contact with real sacrifices before their conversion, and knew what it was like to participate in such a ritual.

Judaism, for example, centered around the temple and its sacrificial altar at Jerusalem until its destruction by the Romans in 70 A.D. Even Jesus' parents celebrated his birth in the age-old Jewish ritual by sacrificing a pair of doves on the altar there (Luke 2:22–24). The Apostle Paul and Jesus' brother James both participated in the Jerusalem temple cult. Cattle, sheep, goats, birds, oil, flour, cakes, and incense were all ritually offered up with the aid of the temple priests, according to the ancient rules prescribed in Leviticus and elsewhere in the Old Testament. The pagan world was equally involved in ritual sacrifice. The great philosopher Socrates asked his own disciples, in his final dying words, to offer a rooster for him to the healing deity Asclepius. In Roman ruins wherever one goes—Pompeii, Ostia, the capital city itself—one sees the same scene repeated over and over, in floor mosaics, carved reliefs, and sculptured altar stones: A hooded priest stands beside a glowing charcoal brazier, accompanied by a flutist and an assistant holding a container of wine, while a huge bull is being led up to the altar, where a hammer and knife are ready to stun him and cut his throat.

It was particularly, however, from Old Testament sacrificial cult that the Christians of the New Testament period drew their ideas of the meaning of sacrifice. There was a complex Hebrew technical terminology to describe the various kinds of offerings made to God, but the broadest terms (like *mattanah, minḥah,* and *qorban*) all basically meant "gift." Sacrifices were never a mechanically exact *quid pro quo* payment, where the value of the offering precisely and legalistically matched the value of whatever God did or was expected to do in return. They were gifts, and presupposed a personal relationship between the giver and God.

They were sometimes gifts in the same fashion as the presents which one might give a king or high official when he passed through one's area, or one sought an audience with him (as in the use of *minḥah* in Judges 3:17, 1 Sam. 10:27, and 2 Kings 20:12). It could even be paralleled with the tribute which a nation paid to the king who had conquered them and become their overlord (*minḥah* in 2 Sam. 8:6 and 1 Kings 4:21 [Heb. txt. 5:1]; *mattanoth* in Ps. 68:18 [Heb. txt. 68:19]).

In Numbers 28–29, a detailed account was given of the regular

daily sacrifices: a fire offering *('ishsheh)* of lambs as a continuous burnt offering *('olah)*, a grain offering, and a drink offering *(nesek)* every day, with additional amounts and other animals (such as bulls and rams) added on sabbaths, new moons, and holy days. These daily sacrifices were important because it was believed that God's own presence was invisibly enthroned upon the ark of the covenant, supported by the wings of two *cherubim* (carved sphinx or griffin-like creatures on top of the ark) within the inner sanctuary of the temple. These sacrifices were "food" for God, who smelt the "pleasing odor" of their smoke (Num. 28:2) and was pleased by these gifts. It was a primitive ritual to ensure that the divine presence remained in the temple, so that it would be a sacred or holy place *(qadosh)*—a nexus connecting the divine world with the profane world of everyday human concerns.

Human beings who had committed sins, including moral offenses such as stealing or bearing false witness, but also including actions which broke taboos and incurred ritual impurity such as touching a corpse or giving birth to a child, were barred from contact with the sacred until they had gone through a special sacrificial ritual called (in the normal English translation) the "sin offering" *(ḥaṭṭa'th)* or the "guilt offering" *('asham)*. Leviticus 4–6 gives a detailed account of the two closely connected rites, including the ritual sprinkling of the blood of the victim. The basic purpose of the ritual was to make the recipient of the sacrificial action holy or sacred *(qadosh)*. So in Leviticus 8:14–15, the so-called sin-offering *(ḥaṭṭa'th)* was actually used to consecrate the new sacrificial altar (render it *qadosh*) and to "atone" for it *(kaphar)*. The blood of the so-called sin-offering was also sprinkled on a new priest and his garments at his consecration (Exod. 29:1, 29:19–21) to render both him and the vestments *qadosh* (sacred or holy). The special rituals of the yearly Day of Atonement (Lev. 16) showed the same pattern.

Therefore, even when one speaks of the concept of atonement in the Old Testament, and sacrifices for sin and guilt, it was still not seen as the mechanical paying of a *quid pro quo,* where the legal value of the sacrifice mechanically paid back the damages of the harm done. Rather, it was that God was holy, and that his temple, his altar, and everything that surrounded him had also to

be holy, including the human beings who wished to live in his presence and be in special contact with him. A new altar or a new priest had to be given special consecration to become holy enough to leave the realm of the everyday and the profane, and enter the divine presence. The Israelite who committed sin desecrated his own holiness and put himself outside the holy people of God, into the realm of the profane, the non-sacred. Basically the same ritual sacrifice used in consecrating a priest or a new altar had therefore to be applied to the sinner to reconsecrate him and render him once more holy, or he could not rejoin the people of God or enter sacred places. The sin-offering or guilt-offering was in no way a punishment *per se,* nor even, in itself, a paying of recompense or restitution at the fundamental level. It was simply that the sinner, by his actions, had put himself outside the sacred realm, and he could not come in contact again with God or anything sacred until he had been reconsecrated.

The New Testament authors were drawing on this Old Testament understanding of sacrifice when they proclaimed Jesus' death as sacrificial. The apostle Paul, for example, spoke in Romans 3:25 of Jesus' death as the "atonement *(hilastêrion)* in his blood." (My translation here is based on the fact that Greek words from the root *hilaos* regularly translated Hebrew words from the root *kpr,* "to atone"; see Septuagint [LXX] version of Exod. 30:15; Lev. 1:4, 16:2, 23:27; Num. 5:8.) 1 John 2:2 also says that Jesus' death "is the atonement *(hilasmos)* for our sins," and a few verses earlier in 1:7 says that "the blood of his son Jesus cleanses us from all sin," referring to the Old Testament concept that the sin-offering "cleansed" the sinner of his ritual impurity and reconsecrated him.

In appropriating this Old Testament heritage, however, early Christianity transformed these ideas of sin offerings and purificatory rituals by declaring that Jesus' death had been a final and conclusive sacrifice, which did not formally deny the validity of the Jewish sacrificial cultus, but which rendered it no longer necessary or appropriate for Christians to continue it. Speaking of Jesus' death as a sacrifice in this sense made it not only a profound symbol of the forgiving and cleansing character of God's love, as revealed in Jesus, it also liberated Christians to read the Old

Testament without having literally to perform all the ritual sacrifices prescribed there in such enormous detail.

The Epistle to the Hebrews in the New Testament dealt with all these issues in an especially interesting way. The author had some knowledge of Platonic philosophy, with its idea that reality at a higher ontological level (within the eternal realm) could cast a shadow or image of itself on a lower ontological level (that is, within the realm of time, space, and physical objects). This Platonic idea of "images" (the Greek word was "icon") was much fuller and richer than the normal modern concept of symbol or metaphor, because the Platonic icon actually participated in or shared in the being of that of which it was the image.

The this-worldly "image," the author of Hebrews said, was the once-a-year ritual performed in Jerusalem during the Old Testament period, in which the Jewish high priest performed the special sacrifices to sanctify himself and cleanse the sins of his people before he entered the veiled room at the back of the temple where it was believed God himself sat invisibly enthroned upon the cherubim. The eternal reality (of which all this Old Testament ritual was only the image) was Christ's death on the cross, where Jesus was paradoxically both priest and sacrificial victim, and where he entered, not the physical room at the back of the temple, but the real, eternal presence of God himself. More than that, the Epistle to the Hebrews said, Jesus was able thenceforth to take us by the hand and lead us into the reality of God's eternal presence as well.

In other words, the author of Hebrews knew that the real function of the ritual of sacrifice was to pull the worshiper out of normal, profane, everyday space and time, and lead him into sacred space and time. The primary concern was not forgiveness or expiation of a person's sins and offenses as a goal in itself, but that a person be enabled to leave the everyday world, with its profane (non-sacred) cares and activities, to enter the sacred realm where the holy dwelt. Jesus' "sacrifice" succeeds whenever other human beings are brought into a living, convincing awareness of God's presence around them. In modern language, one could say that Jesus' sacrifice succeeds whenever human beings realize in their hearts that God loves them, and that his grace and guidance

surrounds them at every moment. Sometimes it is called nowadays being "saved" or "justified" or "having the Spirit." Many ancient Christians referred to it as the vision of God. Having one's sins forgiven or cleansed was a necessary prerequisite to entering the sacred realm, but the ultimate goal was to enjoy the presence of God and live joyously in its fullness.

There were also many other Old Testament echoes in the early Christian concept of Christ's sacrifice. When Moses received the Law on Mount Sinai, a sacred convenant was set up between God and the people of Israel. He would be their God, and they would be his people. As long as they obeyed the Law, he would guide them, show all the riches of his favor to them, and defend them. Already by the time Paul was writing his first epistle to the Corinthians, the words of the liturgy of the Lord's Supper were reflecting, not just the idea of Jesus' death as an expiatory or propitiatory sacrifice, but also the idea of his death as a covenant sacrifice: "This cup is the new covenant in my blood" (1 Cor. 11:25, RSV). This new covenant with God wiped away the old covenant, which had required obedience to the Law of Moses. Under the new covenant, the Christian not only did not have to follow the sacrifice, kosher, and circumcision regulations of the Law of Moses, but in Paul's understanding, the Christian was not unalterably bound to any human set of moral rules and regulations at all. Christians were freed to a richer kind of love, without sterile legalism.

The leaders of early Christianity came from Jewish backgrounds, and both of these ideas of Christ's sacrifice—sin-offering and covenant sacrifice—freed them theologically to speak of a God whose free and gracious forgiveness could now be appropriated directly, without the Christian having to go through the complex ritualism of carrying out the Old Testament sacrificial regulations. At its deepest level of meaning, the idea of Christ as the final, unrepeatable sacrifice, freed them not only from ritual sacrifice itself, and from the kosher and circumcision regulations of the Law of Moses, but also from the entire legalistic mind-set of codes of moral regulations for whose infraction one had to pay specified penalties. Christians could center their lives around the two concepts of love and forgiveness, instead of the concepts of law and penalty. In this sense, the idea of Jesus' death as a ritual

sacrifice was an impressive theological *tour de force:* it was the sacrifice that destroyed the basic presuppositions of sacrifice. Any modern theory of the meaning of Christ's sacrifice must preserve this sense of paradox. Christ's sacrifice was not a sacrifice like any other sacrifice. On the contrary, it proclaimed a paradoxical tension, an apparent self-contradiction, an act which denied its own grounds for existing.

Another Old Testament echo, that of the Suffering Servant, was not a sacrificial concept itself, but became linked to the New Testament understanding of Christ's sacrifice, and expanded the idea to include, not just ritual actions performed before an altar or the like, but also sacrifice in the common modern English sense: that is, one human being "sacrificing" his own happiness, wellbeing or life for the sake of another human being. To understand fully the Old Testament references, it is necessary to remember the role the Suffering Servant played in an important theological debate in the Old Testament. Many passages in the book of Proverbs (for example 10:4, 6, 13, 27; 12:13; 13:21, 22) seem to state quite baldly that God will give earthly prosperity to good people, while sinners will invariably meet with poverty and disgrace.

Other parts of the Old Testament—for example, Ecclesiastes and Job—attack this idea that good men and women never suffer misfortune in their lives. But perhaps the most profound statement in the Old Testament about why the wicked can prosper while the good suffer misfortune, is contained in that part of the book of Isaiah which modern scholars call Deutero-Isaiah, in what are called the Suffering Servant passages: Isaiah 42:1-4, 49:1-6, 50:4-9, and 52:13-53:12. They are familiar to every Christian reader, because they were drawn upon so heavily by the New Testament authors, for example the section in Isaiah 53:5-6 (RSV):

> But he was wounded for our transgressions,
> He was bruised for our iniquities;
> Upon him was the chastisement that made
> us whole,
> And with his stripes we are healed.
> All we like sheep have gone astray;
> We turned every one to his own way;

And the LORD has laid on him
The iniquity of us all.

The Suffering Servant made himself "a sacrifice for sin" or "sin-offering" (53:10), even though he was innocent and guiltless. Modern scholars have debated at great length as to who the Servant was intended to be when the passages were originally written in the sixth century B.C. Some have argued that it was the prophet himself, some that it was the people of Israel, and others have presented yet different candidates.

The important thing however is that elsewhere in the Old Testament it was all too regularly assumed that when a human being suffered it was for his own guilt that he was being punished. But the Suffering Servant passages introduced a completely new idea. It was possible that an innocent person might have to suffer for the wrongdoing of other people, and that by so doing he could save them from the punishment they deserved. When a good person suffered because of the wrongdoing of evil people around him, this was not some form of cosmic unfairness or injustice—he could well be the means of ultimately healing them of their evil-doing.

When the earliest Christians began taking these verses from Isaiah and applying them to Jesus, and combining this with the concept of Jesus' death as a sacrifice, they were in the first instance attempting to answer the theological problem of why Jesus, a good and innocent man, was allowed by God to suffer such a painful and disgraceful end. But as Dennis Groh has pointed out in a comment on the social world of early Christianity, they came equally to understand by the end at least of the first century, that the ethic and theodicy of the Suffering Servant passages applied not only to Jesus, but to themselves as well: "In this we know love, that he laid down his life for us; so also *we ourselves* ought to lay down our lives for our brothers and sisters" (1 John 3:16). "It is a fine thing if a man endure the pain of undeserved suffering because God is in his thoughts. . . . To that you were called, because Christ suffered on your behalf, and thereby left you an example *(hypogrammon,* pattern or model); it is for you to follow in his steps" (1 Peter 2:19–21, NEB, compare 2:22–25 and 3:17–18).

So in searching for metaphors, analogies, and images to describe what Jesus' death had meant for them, Christians of the New Testament period drew on a variety of sources: the traditional Jewish sin-offerings, the covenant sacrifice which referred back to the meeting between Moses and God on Mount Sinai, the Suffering Servant passages in Isaiah, and the idea of the closed room at the back of the Temple in Jerusalem where God's presence had its earthly throne.

For the first few centuries after the New Testament period, Christians tended to use this biblical phraseology rather automatically, without ever thinking explicitly about the nature of sacrifice, or what these passages were saying in more formal terms. But gradually theologians began to develop more highly conceptualized doctrines of the atonement. That English word literally means "at-one-ment," becoming "at one" with God. It therefore refers to the removal of that which separates human beings from God, so that they may be one with him again; or in other words the act of reconciliation which permits a return to God's presence. As a technical term in the history of Christian thought, the phrase "doctrine of the atonement" refers in particular to the attempt to explain theologically how Christ enables human beings to return to God and be saved. There have been several important types of atonement theory in Christian history. Three of these will be discussed in the present chapter: the ransom to the devil theory, Anselm's substitutionary doctrine of the atonement, and the more modern history-of-religions theory of sacrifice as ritual permitting entry into the realm of the sacred or holy. A fourth—the physical theory of the atonement—will be considered in the seventh chapter, where it is more appropriate.

But the development of these formal doctrines was a process of many centuries in length. J.N.D. Kelly is surely correct, for example, in insisting that the use of sacrificial imagery in, say, an early fourth-century theologian like Athanasius, should not be taken to mean that he had a developed doctrine of sacrificial atonement. In fact, as Kelly points out, Athanasius for one put his real emphasis on the physical theory of the atonement, which linked the saving work of Christ more to the incarnation than the crucifixion.

It is normally said that the first theologian of the early church

in the period after the New Testament to speculate in any great detail on the role of sacrifice in the Christian doctrine of the atonement, was Gregory of Nyssa, in his *Great Catechetical Oration* in the latter part of the fourth century. (This is not to discount the foreshadowings of many of his ideas in the work of Irenaeus in the second century.) Gregory did however raise a profound question about the nature of Christ's sacrifice, which suggested a radical reinterpretation of it. It is called the "Ransom to the Devil" theory of the atonement. Instead of Jesus' sacrifice being to God—and there is a certain peculiarity in the notion of a father requiring the sacrifice of his own son to himself—Gregory argued, explicitly and in great detail, that the sacrifice was made to Satan. In sinning, human beings had in effect sold themselves to the devil. They had done this willingly, but they were now Satan's property. In an ancient slave-holding society, a man's slaves belonged to him in the same way as his house, his pigs, or his living-room couch. They could be purchased from him, but a simple violent repossession would be theft.

God, who was totally just, could not steal, even from the devil himself. And so the devil's slaves had to be bought back, paid for, or at least taken from him by tricking him into illegal action himself. In a vivid metaphor, Gregory therefore spoke of Christ as the bait on the fishhook by which God caught the devil. Jesus, as a completely sinless man, was not the devil's property. But when Satan was tricked into killing Jesus on the cross, and claiming him as his own, he bit upon God's fishhook, and had to spew back out, not only Jesus himself, but also all his captives whom Jesus had now claimed as his own. In this way, hell was forced to vomit out all the souls of those whom Jesus had come to save, and Jesus was able to lead them back to the heavenly home of his Father, where they could dwell in eternal peace.

The next major thinker to deal with the problem of sacrifice, after Gregory, was Anselm, who became Archbishop of Canterbury in 1093, not long after the Norman Conquest. His greatest theological writing, the *Cur Deus Homo,* asked the central question of the atonement, "Why the God-Man?" But it was by this century a very different world from that of early Christianity. It was now the high Middle Ages, and the medieval warrior ethos

structured Anselm's thought at a fundamental level. To the medieval knight, the single most important matter was honor, that is, what would now be called a sense of inner dignity and total personal integrity. In the famous medieval English story, Sir Gawain voluntarily submitted to having his head chopped off by the Green Knight rather than break his word. In works like the *Prose Lancelot* the deepest spiritual dimensions of honor were explored, as King Arthur's knights strove to preserve their honor and achieve purity as warriors, fighting against all the temptations of the world—against desire, fear, confusion, and physical pain—until two of the knights successfully reached their goal: the Holy Grail, symbol of the ultimate vision of the sacred.

As Thomas à Becket proclaimed against King Henry II, after he had become Archbishop of Canterbury half a century later, God himself was ruled by honor too. One dishonored God at one's total peril.

God did not break his word. Having promised to punish sin, he could not renege on that promise. He neither violated the code of total moral purity himself, nor tolerated it in others. A breach of honor against him, as against any person of honor, required satisfaction. This was a stern and unyielding warrior's code. Since he was our liege lord, and we human beings owed him absolute obedience, any sin we committed, no matter how small, was an affront to his eternal honor. But since we human beings already owed him total obedience in every moment of our lives, there was no way we could do additional works to atone for past misdeeds. And God, for the sake of his own honor, could not violate his own rules of justice, and forgive men and women gratuitously. It was this which created the necessity for the God-Man.

Jesus Christ as man was completely without sin, hence his death would be a free gift to God's offended honor and justice. Jesus Christ as God was a being whose infinite divinity would make his death an infinite satisfaction, capable of atoning for all the sins of the whole earth. So, by his free and willing death on the cross, cosmic justice was satisfied, and all human beings who called on him in faith could use his death to atone and gain forgiveness for their own sins.

Anselm's interpretation is called the "substitutionary doctrine

of the atonement," and it dominated western thought for centuries afterwards. One could perhaps argue that it was over-intellectualized. The train of logic came out at the right conclusion in one sense, but it lost much of the feeling of paradox in the biblical notion of the sacrifice which destroyed the presuppositions of sacrifice, and the new covenant which totally overthrew the old covenant of law and works. In some of its later formulations, it frequently seemed to regard forgiveness of sins and avoidance of future retribution as the goal itself, rather that as simply a means to the true end of reestablishing, here and now, a living and meaningful relationship with God and the realm of the sacred. It obviously was rooted—in Anselm's original formulation at any rate—in a medieval chivalric code which viewed the world in a way very different from the perspective of the New Testament.

In another sphere, medieval western Christianity did however keep alive what was in some ways a more profound understanding of Christ's sacrifice—one closer at least to the ancient understanding of sacrifice. The medieval Roman Catholic mass was itself regarded as a sacrificial ritual. The celebrant was a priest who performed the rite on a stone altar. But Christ was not repeatedly resacrificed every time a priest said mass. For the medieval Christian, Christ's sacrifice was clearly once for all, and could not be repeated. What happened instead was that the priest and his congregation left the world of profane space and profane time when they entered the church, and as the mass was recited, they entered the realm of sacred space and sacred time, where normal historical chronology disappeared. In sacred time, we and the sacred ancestors are simultaneously present. Mythic events (as understood in the technical language of social anthropology) do not have historical dates, *qua* primal events, because they are immediately present whenever we ourselves enter sacred time by the performance of the appropriate rituals. Christ himself was regarded as genuinely sacrificed in the medieval Catholic mass, but it was the one sacrifice, made once for all in sacred time, which the human participants were temporarily allowed to enter.

The Protestant Reformation in the sixteenth century caused a great weakening in this sense of the Lord's Supper as itself a sacrifice in many (but not all) parts of Protestantism. Protestants

in general however continued to accept Anselm's substitutionary doctrine of the atonement as the normative description of Christ's own sacrifice.

The Protestant corrective to what would have otherwise been the over-intellectualization and over-legalism of the Anselmic doctrine was to combine it with the doctrine of justification by faith. The human being who accepted Christ's sacrifice on the cross with "faith"—which to the Reformers meant "trust," not merely surface intellectual assent—was "justified," that is, restored to the right relationship with God. One was saved by faith alone, not by good works or by following any set of moral laws. This restored several important parts of the New Testament understanding of Christ's sacrifice: The paradox of the sacrifice which destroyed the need for sacrifice; the idea of a sacrifice which established a new covenant abrogating an older covenant (one which had been based merely on the mechanical fulfillment of ritualized laws); and the idea that the basic purpose of sacrifice was to return human beings to a full relationship with God and to enable his reacceptance of us into his presence. On the other hand, the Anselmic idea of Jesus' death as a mechanical and legalistic, *quid pro quo* acceptance of the legal punishment due to us for our sins, continued to appear in Protestant hymns and sermons, which meant that the sacrifice itself still continued to be construed as primarily punitive and retributive, rather than as a ritual of reconsecration whose primary function was to ritually resacralize and rehallow that which had gone away from God.

In the eighteenth century in the English-speaking world, in both the Great Awakening in North America and in the parallel evangelical movement led by the Wesleys and others in England, a technique of open-air revival preaching was developed which also laid its central stress on an only slightly modified Anselmic doctrine of the atonement. Jesus' blood cleansed us from our sins, so that we who turned to Christ in faith would have our sins forgiven. By his redeeming death on the cross, Christ bore the punishment for our sins instead of us. The importance of the revival movement in American frontier Christianity in particular, means that most American Christians at least have come out of a tradition which has unselfconsciously regarded the Anselmic

understanding of Christ's sacrifice as the only correct and truly
biblical one. Historically speaking, this is not totally so. It is in
many ways a very medieval understanding of the faith, possibly
a bit too rationalistic to do full justice to the biblical concept of
Christ's sacrifice, and has been truly important only for the past
nine centuries or so of Christian history.

In the nineteenth century, however, the more radical Protestant
theologians began to move away from the Anselmic doctrine of
a substitutionary atonement, and by the middle of the twentieth
century, most of the theologians who were writing had completely
discarded it for alternative explanations of the way in which Jesus
can lead men and women back to God. Although fundamentalists
and certain other conservative Christian authors have continued
to insist that the Anselmic doctrine is the only correct reading of
the New Testament message and a necessary part of the Christian
faith, even so conservative a theologian as C.S. Lewis, for exam-
ple, has stated in several of his works that he did not believe it was
either doctrinally required (it has never been defined as catholic
doctrine by any general council of the church), nor was it even the
best way of describing Christ's atoning work.

One of the most important things which has served to give
modern theologians a completely new perspective on the idea of
sacrifice and atonement, is the work on comparative religions
which has been carried out by social anthropologists, writers on
mythology, and historians of religion over the past hundred years.
The creation of the great colonial empires of the nineteenth centu-
ry, where western European nations controlled large parts of Afri-
ca, Asia, and other parts of the globe, put western Christianity in
contact with truly alien cultures for the first time in centuries. The
"dream time" of Australian aborigines, the world-renouncing doc-
trines of the Hindu sacred scriptures, the ecstatic visions of Siberi-
an shamans, and tales from Trobriand islanders of *baloma* spirits
sailing to Tuma, the island of the dead, confronted Europeans
with a strange religious world which presented the whole idea of
the sacred in new and exotic ways. And yet, all these religions of
the world could be seen on closer study to be dealing with the
same sets of fundamental issues, in such a way that their underly-
ing similarities often proved to be more striking than their
differences.

The idea of sacrifice turned out to be a motif which ran like a thread through most of the religions of the world. The earliest attempts to make sense of this particular practice tended to be partial and oversimplified, naturally enough, but the issue was recognized quite early. Sir Edward Burnett Tylor, a British anthropologist, tried in 1871 to systematize sacrificial ideas in terms of gifts given to the gods, and W. Robertson Smith, a Scottish Semitic scholar, attempted to derive all other forms of sacrifice and religious ritual from the sacramental meal in which a clan in a primitive tribe killed and ate the particular kind of animal which was that clan's own symbolic "totem" figure. Sigmund Freud, the founder of modern psychiatry, asserted (in 1913) that the totem animal subconsciously represented the Oedipal father figure, and that even the God of the Judeo-Christian tradition was simply a projection onto the cosmos (at the subconscious level) of the human father whom the small child hates and fears, but also loves and regards as having superhuman powers.

The French sociologist Émile Durkheim, also active around the turn of the century, said that the true object of ritual (and all religion) was to claim supernatural sanction for the belief system of a particular society. God or the sacred was simply society worshiping itself. The "functionalists," who came later, gave more complicated sociological and psychological analyses of religion—such as group support to individuals in time of crisis and indoctrinating the young with the society's moral code—but basically they also tended to "explain away" religion to a great extent.

None of the above theoretical avenues to the comparative study of religions seemed to give much aid or comfort to Christian theology. But then, in the early part of the twentieth century, what was called the history of religions approach began to be developed. Beginning with Nathan Söderblom's study of "holiness" in 1913 and Rudolf Otto's book in 1917 on *The Idea of the Holy,* and continuing in the work of Gerardus van der Leeuw and Mircea Eliade, this method of studying religion started with the assumption that human religious experience of the "holy" or the "sacred" was a reaction to a transcendent reality which genuinely existed. Indeed, this sacred realm was ultimate reality itself. In the Judeo-Christian tradition, of course, this transcendent sacred reality is

called God, and so a route was finally opened for Christian theologians to use the insights of the modern comparative study of religions without reducing theology to the sociological study of cultural indoctrination and the psychopathology of the clinically neurotic.

Basic to this history of religions approach was the distinction between the sacred and the profane. Profane literally means in Latin *pro fanum,* "outside the temple." The profane realm was the everyday world, the realm of normal chronological time, three-dimensional physical space, and cause-and-effect. That was the secular world, outside the religious sphere, where human beings carried out their everyday worldly concerns. On the other side, the sacred realm was (strictly speaking) totally transcendent. It could be intuited or apprehended by human beings in some fashion, but never described literally in words. Nevertheless, things within this profane world could take on a kind of sacredness when they served as symbols pointing towards some part of the sacred realm.

Rituals conducted at sacred places customarily retell a "myth," a technical term in the history of religions which does not mean a story which is necessarily untrue, but a story which is in some sense *foundational* for the special, peculiar overflowing of the sacred into the profane at that particular place, or foundational for the establishing of the people who worship at that shrine and their cosmos. Many religions retell "myths" which recount how the world was created in the beginning. The Hebrews also frequently told the story during their religious rituals of the Exodus from Egypt, because that was where they were saved by God and selected as his chosen people. The story recited during the ritual could be grounded in a real historical event as long as it was foundational in some sense for the existence of that group as a religious community.

The retelling or reenacting of this myth or sacred foundational story allowed the divine power in that constitutive event to be released again. New power, energy, and life were thereby given to the world. What had been corrupted, defiled, depleted, and polluted was repurified and given new energy.

The Latin word for sacrifice, *sacrificium,* literally means *sacer facere,* "to make sacred." A sacrifice always makes something

sacred or holy. The victim itself of course is removed from the profane world and turned into something sacred. But sacredness flows from the ritual to the human participants as well. They are put in contact with the holy, and are purified and reempowered by it.

Rituals can never be totally rationalized. They are always symbols, vehicles of nonverbal communication and meaning. The cause-effect relationship stated in the words of the ritual may not make rational sense in the language of the profane world. If the ritual states that the ashes of a red heifer will remove guilt or water sprinkled on a baby's head will remove the sin of his primal ancestor Adam, we misunderstand what is going on if we try to make sense of this in terms of this-worldly cause-effect relationships. The ritual is designed to reestablish a right relationship with the sacred realm. Its effectiveness is measured only in this regard. But if the symbols do have power, then the sacred—which does truly exist and lie behind the things of this world at every moment—will be able to flow out and produce real effects in this world.

So the idea that we are saved by Christ's sacrifice on the cross can still be meaningful in the modern world. It cannot as long as the phrase "Jesus died for our sins" is regarded as a mechanical, legalistic *quid pro quo*, but it can when the original meaning of sacrifice as *sacri-ficium* is recovered: a "making holy," a reconsecration of those who have defiled themselves with sin and evil, so that they can once more enter the living presence of God without being destroyed by the vision of his holiness.

When early Christians said that Christ's death was a sacrifice, they meant that, even though it was a normal public execution of a purported criminal by the secular government of Roman Palestine, it functioned in fact as a religious ritual for Jesus' followers in years to come. Through repeating and reenacting portions of the story of Jesus' last days—reading the story of his trial and execution during the Good Friday or Easter Vigil service, recreating his last meal of bread and wine in the communion service, and so on—they strangely found their own fears and guilts lifted from them, and felt the love and majesty of God shining through those tragic events more strongly than through any other part of Jesus' life on this earth.

Retelling and reenacting the story of Jesus' arrest and death still
has the same uncanny power today, full of countless paradoxes,
but all the more effective because of them. It was not a ritual
sacrifice by a robed priest on a stone altar, but it functions in fact
like a religious ritual whenever the story is repeated or the event
portrayed in drama or visual art. It functioned like a sacrifice, but
it brought an end to the whole world of Old Testament sacrifice
which was its presupposition. The death of a single man two
thousand years ago could not logically pay a penalty for a sin
committed by you or me, here and now, but in fact the ritual
works, and we find ourselves freed to approach the presence of
God without fear of condemnation. This is the crucial issue—it
is not whether we can explain how a profound and compelling
symbolism works at a legalistic, logical level, but whether its
power can be felt effectually at a deeper, non-verbal level of com-
munication. Jesus' death on the cross indeed still strikes us at this
deepest level, in the present century as much as any other, strip-
ping us of our pretenses and excuses, lifting away our guilt and
fear of condemnation, and liberating us to live with God and for
God, full of power and renewed life.

The lesson inherent in Jesus as Suffering Servant is also still as
relevant in the present century as it was two thousand years ago.
Christians often slip into a too facile view of forgiveness. But even
in our own personal relationships, we are aware that forgiving
someone else's sin does not necessarily prevent that person or us
from having to live with many of the consequences. If someone
acts so as to injure another human being in any way—physically,
psychologically, socially, or economically—even total forgiveness
will not necessarily repair all the damage. A life that has been
snuffed out, a marriage that has been totally broken up, or a career
that has been completely ruined, cannot be reconstituted by any
amount of love and forgiveness. There is a dreadful permanence
to the consequences of sin, that requires human suffering as part
of its aftermath. This is a necessary part of the nature of things,
of the cosmic justice of the universe, as Anselm would have said.
Without this, human freedom would have no real meaning—our
decisions would only be playacting in a child's fantasy world
without consequence.

On the other hand, God's forgiveness prevents this from being the total, irredeemable destruction one sees portrayed in so many of the classical Greek tragedies. In the Christian view, human beings are never totally crushed like Antigone, or the Trojan Women. From the ruins of the fallen Jerusalem, so the Judeo-Christian tradition has always proclaimed, a New Jerusalem can always be built. But not without suffering. Central to every doctrine of the atonement is the realization that God is actually willing to participate, himself, in our own well-merited suffering, and take as much as he can upon himself, even to allowing the death of his own son. Atonement means forgiveness, but God is willing to do more than just forgive. If we can be saved by it, he will even draw the most dreadful consequences of our sins into himself, and transform them, and give them some genuinely meaningful role in his own providential guidance of history.

Whether Christ was sacrificed "to" God, as Anselm said, or "to" Satan as Gregory of Nyssa said—whether the proper understanding of sacrificial ritual in the ancient world even makes this a meaningful question—Christ was sacrificed *for* us.

In all doctrines of the atonement it is God himself who must save us, because we human beings are caught in sin in such a way that we cannot save ourselves by ourselves. God himself has to break through from without, a genuinely transcendent force penetrating from outside our human realm, to negate the power of sin, resanctify us, and give us the life-giving power of his own presence. It is in the cross of Christ above all that this force of the holy breaks through; for our salvation, not our condemnation.

The cross is the *sacri-ficium,* the making holy, where we are washed clean of all our defilement, no matter how gravely we have sinned, and led by Jesus' guiding hand once more into the holy and loving presence of God. The old revival hymn is a prayer that any Christian ought to be prepared to utter, because it still has the same old power to enable us to approach the mighty judgment seat of God:

> *Just as I am, without one plea,*
> *But that thy blood was shed for me,*
> *And that thou bidst me come to thee,*
> *O Lamb of God, I come, I come!*

CHAPTER TWO

✤

The Messiah

In 1 Samuel 9–10 one finds the story of how Saul became the first king of Israel. The young Saul had been sent out by his father to search for some lost donkeys which had strayed from their pastures. Saul eventually decided to consult an old holy man named Samuel, who was priest, judge, and seer in that region. To Saul's surprise, Samuel gave him the place of honor at the sacred feast that was being prepared in the hill shrine above the town. Samuel took the entire haunch and leg from one of the sacrificial victims which he had offered that day, and laid it before Saul as his portion. At dawn the next day, when Saul was leaving, one reads (1 Sam. 10:1, NEB) that "Samuel took a flask of oil and poured it over Saul's head, and he kissed him and said, 'The LORD anoints you prince over his people Israel; you shall rule the people of the LORD and deliver them from the enemies round about them.' "

This strange ceremony was the ancient Israelite equivalent of a coronation ritual. In western Europe in the Middle Ages, the symbol of kingship was the crown, and the long, elaborate ceremonies in which the crown was first placed on the new king's head marked his formal accession to that office, and the official beginning of his reign.

In ancient Israel, however, it was not a crowning, but a ritual anointing of the new king's head with sacred oil that formally

20

announced his rulership over all the people. For this reason, the king of Israel could be referred to simply as the *Mashiaḥ,* a Hebrew word which meant the Anointed One, normally rendered in English simply as "the Messiah." The Greek word *Christos* is a literal translation of this term (from *chriein,* a Greek verb meaning to anoint) which comes over into English simply as "Christ."

Saul, for his disobedience, was eventually renounced by God as king of Israel, and it was left to his successor David to establish a permanent line of Israelite kings. It is important to note that the regular, most common meaning of the term Messiah (or Anointed One) in the Old Testament is as a reference to the actual head of state in the five-hundred-year-long Israelite monarchy. David (1 Sam. 16:13, 2 Sam. 2:4, 12:7 and 19:21), Solomon (1 Kings 1:39), Joash (2 Kings 11:12), and Jehoahaz (2 Kings 23:30), were all "Messiahs" in that sense, not to mention Absalom (2 Sam. 19:10) and Jehu (1 Kings 19:16 and 2 Kings 9:1–13).

After his conquest of Jerusalem, the concept of David's kingship took on a striking new dimension. The prophet Nathan proclaimed the word of the Lord to David (2 Sam. 7:8–16, NEB) and announced that his was an eternal kingdom:

> I took you from the pastures, and from following the sheep, to be prince over my people Israel.... When your life ends and you rest with your forefathers, I will set up one of your family, one of your own children, to succeed you and I will establish his kingdom. It is he shall build a house in honour of my name, and I will establish his royal throne for ever. I will be his father, and he shall be my son My love will never be withdrawn from him as I withdrew it from Saul.... Your family shall be established and your kingdom shall stand for all time in my sight, and your throne shall be established for ever.

There may have been pre-Israelite motifs included in this idea of the eternal kingdom. Before David's conquest of the city, Jerusalem was the home of a Canaanite group called the Jebusites, who worshiped a god named El Elyon (God Most High), the creator of heaven and earth. El was normally the high god in the Canaanite pantheon, but for some reason, the god worshiped in Jerusalem by the Jebusites could easily be identified with Yahweh, the

God of Israel, and was so identified as far back as Abraham's time
(Gen. 14: 18–24). Many modern scholars believe that 2 Samuel
5:6 may reflect a modification of an ancient Jebusite tradition of
the eternal inviolability of the city of Jerusalem, and if so, the
subsequent Israelite tradition of David's eternal kingdom would
have been simply a taking over of the Jebusite faith in an eternal
Jerusalem. Many other Jebusite names and motifs were clearly
reflected in later Israelite kingship ideology.

Certainly, what modern form critics call the Royal Psalms, and
other similar hymns from the book of Psalms, that were sung
during the temple liturgy at Jerusalem and during the sacred festi-
vals of the city, show a profound faith in the eternal kingship of
David's royal line. God was praised in these hymns because "in
all his acts" he "keeps faith with his anointed king, with David
and his descendants forever" (Ps. 18:50, NEB). The people of
Jerusalem sang to their king, "Your throne is like David's throne,
eternal" (Ps. 45:6, NEB; compare Ps. 72:5). The promise to David
was eternally secure: "If your sons keep my covenant and heed the
teaching that I give them, their sons in turn for all time shall sit
upon your throne" (Ps. 132:12, NEB; compare also verses 17–18).
And the promise clearly seemed to go back even before David:
"The LORD has sworn and will not change his purpose: 'You are
a priest for ever, in the succession of Melchizedek,'" this man
being the ancient priest-king of pre-Israelite, Jebusite Jerusalem
(Ps. 110:4, NEB).

The problem for this centuries-long Israelite faith in the eter-
nality of David's kingdom, came when the Babylonian king Nebu-
chadrezzar besieged Jerusalem and carried off the last king of
Israel blinded and in fetters in 587 B.C. For the next six hundred
years, Jerusalem was normally under the control of one or another
of the great ancient empires: Babylonia, Persia, the Seleucids, or
Rome. There was never again to be a king of the line of David
sitting in actual political and military control of the city.

For patriotic Israelites the situation was often intolerable, and
the divine promises came increasingly to take on revolutionary
form. It came to be believed that somewhere, at some time, a
new military leader would appear, descended from the royal
house of David, who would drive out the foreign conquerors and

reestablish the Israelite throne, whereupon he would reign as the new Messiah, the anointed king of Israel. As the actual opportunity for armed rebellion seemed more and more futile in normal military terms, the hope of a more miraculous divine intervention grew. The Messiah in popular hope became a figure who would be aided by armies of angels, and who would lead the true sons of Israel in a great war which would destroy the forces of evil forever. The New Jerusalem which he created would be a return to the simple pleasures of the Garden of Eden. The plants would bear fruit and grain marvelously without the need of human cultivation, the lion would lie down with the lamb, war would be no more, and all the true children of Israel would spend their time eating and drinking and living quietly with their families, while utter righteousness prevailed over the whole earth.

In the spring of 1947 two shepherd boys, members of the Bedouin tribe called the Ta'âmireh, were grazing their sheep and goats near the Dead Sea in the vicinity of Qumran. One of them, Muhammed ed-Dîb, threw a rock into a small cave, and heard the sound of breaking pottery. In this accidental fashion, the first of the famous Dead Sea Scrolls were discovered. They give a fascinating insight into the kind of messianic speculation that was going on in Judaism around the time of Christ.

As scholars have worked on these ancient scrolls over subsequent years, the picture emerged of an entire community living there by the Dead Sea, waiting for the Messianic Age to begin. All the way from 125 B.C. down to the arrival of the Roman Tenth Legion in 68 A.D., this religious group pored over the scriptures and tried to decipher the prophecies of the last times. A nation of warriors called the Kittim (the Roman legions) would end the rule of the Last Priests of Jerusalem, and then a forty-year-long war would begin between the Sons of Light (that is, their own group and any last-minute converts whom they could make) and the Sons of Darkness. Streaks of lightning would flash from one side of the sky to the other, until the whole sky glowed with a brilliant blue-white light. Angels would fight side by side with human beings. In the final battle, good would finally triumph, and all wickedness would be wiped off the face of the earth forever.

In their messianic speculations, interestingly enough, the Dead
Sea Scroll community read the Old Testament prophecies as pre-
dicting two Messiahs. When the war at the end of this world
began, a leader called the Messiah of Israel would command the
forces of good in battle. Meanwhile, a second figure, called the
Messiah of Aaron, would become the true High Priest who re-
placed the wicked and apostate priests who had taken over the
temple in Jerusalem. The notion of two Messiahs was not normal
Jewish belief of the period around the beginning of the Christian
era, but the essentially military function of their so-called Messiah
of Israel was typical of the Jewish faith of that period. (The dis-
tinction between a Messiah ben David and his forerunner, the
Messiah ben Joseph, is essentially a medieval Jewish belief, and
does not apply to first-century Palestine.)

When Christians and Jews engage in discussions about their
faiths, Christians are often quite perplexed as to why the Jews
ignore what seem obvious prophecies of the Messiah in the Old
Testament, which to the Christians seem to have been clearly
fulfilled with the coming of Jesus. To comprehend the Jewish
position accurately, it must be understood that most Jewish exe-
gesis of the Old Testament has applied to the Messiah only those
passages which refer to his coming in glory to rule the earth. There
is another set of passages, which Christians have traditionally
viewed as prophecies of the Messiah's suffering, but which Jewish
interpreters have more often viewed as referring to the sufferings
of the whole people of Israel.

The famous Suffering Servant passages, as modern scholars call
them, are a case in point. These are the four passages in Deutero-
Isaiah, as this part of the book of Isaiah would now be regarded,
which refer to the sufferings of the *Ebed Yahweh,* the "Servant of
the Lord" (Isaiah 42:1–4, 49:1–6, 50:4–9, and 52:13–53:12). These
familiar passages have become a standard part of Christian wor-
ship and devotion: "He was pierced for our transgressions, tor-
tured for our iniquities; the chastisement he bore is health for us
and by his scourging we are healed. We had all strayed like sheep,
each of us had gone his own way; but the LORD laid upon him the
guilt of us all" (Isa. 53:5–6, NEB). Jewish interpreters have tradi-
tionally pointed to Isa. 49:3, also within this set of passages, which

seems clearly to identify the Servant as a metaphorical figure representing all the people of Israel: "He said to me, 'You are my servant, Israel through whom I shall win glory'" (NEB). This "collective theory," as it is called, has claimed the allegiance of many modern Christian scholars as well. Others have tried to bridge the gap by speaking of a "corporate personality," where the thought continually switches back and forth between the nation and a single person or group who especially embodied the true mission of the Servant. Other modern Christian scholars have tried to identify the Servant with one of the Hebrew kings (such as Hezekiah, Uzziah, or Jehoiachin), or Cyrus the Persian, or a prophet (such as Isaiah, Jeremiah, or Deutero-Isaiah himself). The notion of the leader having to suffer vicariously for the sake of his people's sins was clearly paralleled in Babylonian sacred kingship ritual.

Nevertheless, it is at any rate clear that parts of the Old Testament contain a strong messianic belief. The teaching of the Old Testament leads one to expect the coming of some sort of Messiah, who will rule with divine aid. The question as to whether it was clearly prophesied that the Messiah must suffer is a far more ambiguous one. Early Christians read the scriptures with the eyes of faith in exactly this fashion, and the idea of the suffering Messiah is a necessary part of basic Christian belief. But Jesus' Jewish contemporaries did not, for the most part, believe in a Messiah who would suffer and die, and it seems wrong to fault modern Jews with a damnable stubbornness in this regard. It is a quite tricky matter of interpretation, and discussions between Christians and Jews would possibly be better served by concentrating on clearer issues.

The messianic hope did not disappear in Judaism after the coming of Jesus and the splitting off of Christianity. Again and again through subsequent centuries Jewish leaders appeared and were proclaimed as the long-awaited Messiah by bands of Jewish adherents. The Jewish revolutionary Bar Cochba led a fierce war against the Romans from 132–135 A.D., and was proclaimed as the Messiah by the great Rabbi Akiba himself. David Alroy was the leader of an important messianic movement in the twelfth century, and Shabbetai Tzevi in the seventeenth century. The latter

lived and worked in Turkey, but had Jewish followers all over the world. When the Turkish sultan finally gave him the choice of conversion to Islam or execution, he became a Muslim. Even this did not weaken the faith of many of his followers, whose descendants still exist as a tiny sect in Turkey today. Jacob Frank claimed to be the Jewish Messiah in a closely connected movement which he began in Podolia in the western Ukraine in the middle of the eighteenth century, and it was not until a generation later that all his followers were dispersed.

Belief in the coming of the Messiah has therefore been a perennial component of Jewish belief for well over two thousand years, and the force of this idea was strongly felt in first-century Palestine. It is important to realize, though, that in the normal first-century Jewish understanding of the messianic hope, Jesus did not fit smoothly into the category. The Messiah was believed, by most, to be a man of war; Jesus taught an ethic of nonviolence and pacifism. The Messiah, it was commonly held, would lead Jewish troops to victory over their oppressors and reign as king over Jerusalem and Israel; Jesus suffered and died on the cross and taught a kingdom not of this world.

In Jesus' own public sermons he seems never to have proclaimed himself to the general populace as the awaited Messiah. In Mark 14:61–62, Jesus seems to have answered the High Priest's question unequivocally, and is reported to have said unambiguously that he was the Messiah. But in the parallel accounts of his trial in Matthew 26:63–64 and Luke 23:2-3, he is reported to have said only *su eipas,* or *su legeis,* exactly equivalent expressions which could, in totally ambiguous fashion, be translated to mean either "The words are yours," or "It is as you say" (NEB). Out of the work of Wilhelm Wrede on the "Messianic secret" in Mark (*Das Messiasgeheimnis in den Evangelien,* 1901) came the theory, held by some modern scholars, that Jesus never believed himself to be the Messiah at all. According to this theory, Jesus' Messiahship had to be presented fraudulently as a "secret teaching" of Jesus when his disciples came to believe, after his death, that he had in fact been the hoped-for Messiah. Most contemporary scholars would hardly support this interpretation as a proven historical fact, but many would hesitate to say unequivocally that Jesus

definitely believed himself to be the Messiah. At any rate, it was certainly not part of his public message when he spoke to the masses of his followers.

On the other hand it is equally clear that Jesus' followers began, almost immediately after his death, to proclaim him as the Messiah. For the earliest generation of Christian believers, it was one of their two or three most important images of Christ. This was in spite of the fact that he had not come as a great general, nor had he led Jewish troops to victory over the Romans; he had instead taught only of a heavenly kingdom, and was executed by the Romans as a common criminal without lifting a hand in his own defense. When Paul wrote that "Christ nailed to the cross" was "a stumbling-block to Jews and folly to Greeks" (1 Cor. 1:23, NEB), he was merely stating the obvious paradox in the Christian claim that this man Jesus had been the long-awaited Messiah.

Yet Paul went on in that same sentence to say, that "to those who have heard his call, Jews and Greeks alike, he is the power of God and the wisdom of God." Whenever Christians have tried to proclaim the meaning of God's act in Christ, they have found the sheer reality of that divine incursion into human history to be so incomparable, so immense in its consequences, that all the old categories have been either shattered or totally transformed. In subsequent chapters of this book, this will be seen happening again and again. Even the term Messiah itself, in spite of all its rich connotations and profound hope, was not a large enough category to hold the totality of the reality of God in Jesus. Paul recognized quite well that the old idea of the Messiah could be applied to Jesus, but only by being utterly transformed. The early Christians took the common Jewish understanding of the messianic hope, and forced it to transcend itself into a new concept, that of the Suffering Messiah, who reigned over a kingdom, not of man but of God. Old Testament passages could be cited to attach this new concept back to other parts of the biblical tradition, since the Old Testament had always recognized suffering as a mysterious but sometimes necessary part of the divine providence.

But it was a bold move and one fraught with paradox. It was a *skandalon,* the scandal of the cross. When we proclaim today that Jesus was truly the Christ, the Messiah of God, we must

never forget the totally startling and unexpected character of the application of this Old Testament image to Jesus. Otherwise the strength of this image—and the lesson it teaches—is utterly lost. As Martin Luther pointed out in his Christmas sermons, God did not send Jesus to us in any way which we would have expected. He was born to be laid, not in a golden crib in a king's palace, but in a manger in an ox's stall. He triumphed, not by armed might, but by confronting us with the offense of the cross, and thereby jolted us out of all our preconceptions and old ways of thinking. If we could have worked it out in advance all by ourselves, had God not played such an enormous surprise on us, we could have saved ourselves without Jesus. But God does not save us in the way we sinners want to be saved. He offers us the total surprise of his own salvation, which is always immeasurably greater than anything we could have imagined on our own. This is the great scandal, the overturning paradox, in the proclamation of Jesus as the Messiah who rules the world.

The idea of Jesus as the Messiah is still a rich image in the modern world. It is first of all the proclamation by Christianity that Jesus is our true king, the only human figure to whom Christians owe genuinely unconditional loyalty. In western Christianity in particular, this evolved into the doctrine of the separation of church and state which has affected fundamental attitudes in the west for centuries. It began in the early Middle Ages, with Pope Gelasius's doctrine of the two swords and Augustine's idea of the Two Cities. Both men stated, in different ways, that there was a realm of human activity which the state had a right to control, with laws and punishments, and demands for loyalty. But there was another area of human life where the state had no right to intrude in any way, shape, or fashion. There the Christian served another master, and in case of irreconcilable conflict, his duty to God and Christ infinitely outweighed his duty to obey the secular government.

In early Christianity this principle meant that a Christian was obligated to become a criminal in the eyes of the state by refusing to put a pinch of incense on a brazier in front of an icon of the Roman emperor, because that action would have been an acknowledgment that the emperor was God. The Roman

government saw the refusal of the Christians as political disloyalty—as treason to the state. In Nazi Germany, the great theologian Bonhoeffer finally realized that patriotism and duty to his native land did not square with Christian duty, and participated, along with Field Marshall Rommel, in the famous attempt to assassinate Adolf Hitler. In the civil rights movement in the United States in the 1960s, blacks and whites together violated scores of local laws and ordinances in the belief that to obey them was a sin against God's law. All these Christians, in whatever century or part of the world, were affirming that Christ was their Messiah—the only anointed king to whom they owed ultimate loyalty.

Another peculiarly western idea that ultimately grew out of this doctrine of the separation of church and state was the concept of freedom of conscience and freedom of religion. The idea that the jurisdiction of the secular government did not extend to matters of religion, which was so deeply ingrained in western Europeans over the course of the Middle Ages, was the soil in which the modern idea of religious liberty was planted. Again, the assumption is that the individual has religious obligations which are ultimate. In these issues the state has no right at all to intervene or coerce. The secular government has no right to make an orthodox Jew eat pork or a Hindu eat beef. It cannot decide whether its individual citizens should be atheists or Buddhists, Protestants or Catholics. The idea of religious liberty arose partly because Christians finally realized, that if they had the right to give their ultimate, inner allegiance to the King-Messiah Jesus, then other people had an equal right not to do so, as long as the right of Christians to practice their faith was not abrogated. But even more importantly, it was finally realized more clearly what it meant to say that Jesus' kingdom was not of this world. Confessing Jesus as the King-Messiah did not give Christians the right to legislate secular governmental coercion against non-Christians. That would have been a total distortion of the true kingship of Christ, losing both the scandal and the paradox of the King who let himself be executed as a common criminal. Acknowledging Jesus as the Messiah is, when understood in its true sense, the way the Christian proclaims his own freedom, not a subterfuge for inflicting his ideas by force on others.

There are many other things also buried in that idea of Jesus as the Messiah. The messianic promises were contained in the Old Testament, and Jesus, according to the Christian claim, was their fulfillment. This is the reason why we Christians can claim that the Old Testament is "our" book too. Muhammad of course also acknowledged his debt to both the Old Testament and the New, but the nature of the connection was totally different from the Christian messianic proclamation. In Islam, consequently, the Old Testament is neither studied nor read in worship. Christians, on the other hand, unselfconsciously read from the Old Testament in church whenever they wish, and sprinkle their liturgies liberally with countless quotations and reminiscences of the Old Testament. When a Christian confesses that Jesus is the Messiah, he is saying that the Old Testament is "my" book too, and not a book read and cherished only by Jews. The Christian attitude toward the Old Testament—and its link with the Christian confession that Jesus was in fact the promised Messiah—is nowhere better stated than in the Seventh Article of Religion of the sixteenth-century Anglican reformers:

> The Old Testament is not contrary to the New: for both in the Old and New Testament everlasting life is offered to Mankind by Christ, who is the only Mediator between God and Man.... Wherefore they are not to be heard, which feign that the old Fathers did look only for transitory promises. Although the Law given from God by Moses, as touching Ceremonies and Rites, does not bind Christian men ... yet notwithstanding, no Christian man whatsoever is free from the obedience of the Commandments which are called Moral.

This basic statement of faith would be accepted by almost any branch of Christianity—Protestant, Catholic, or Orthodox—at any period of history. Confessing Jesus as the Messiah means that the Christian is *forced* to acknowledge the Old Testament as a *Christian* book.

To say that Jesus was the Messiah in the Christian fashion is also a compelling way to proclaim the universality of Christ. The prophets, judges, and lawgivers of the Old Testament normally had quite particular tasks assigned to them. Moses was sent to

lead the people of Israel out of a particular Egyptian slave-labor camp. The prophet Amos was sent to deliver a particular message of doom to the ten northern tribes at a specific point in their history. Deutero-Isaiah was assigned to preach a special message of hope to the Babylonian exiles at the quite extraordinary point when Cyrus the Great appeared on the scene of history. The task of the Messiah was quite different. It had a universality and finality that went beyond all particular historical contexts and temporary divine instructions. To proclaim Jesus as the Messiah meant then—and still means in the modern world—that his significance was universal, not particular. His message was for all the world, and his task was to prepare the human race for the end and goal of all human history. To say that Jesus is the Messiah means that he is not just another in the long string of Old Testament prophets and religious teachers. He is, paradoxically, both universal and unique. Or better, one should say that because his messianic task is universal, he is totally unique.

Finally, one must not forget the scandal and the ultimate paradox of Jesus as the King-Messiah. It is a very peculiar statement when one says that a man who had no army, no golden crown, and no glittering palace, who was executed as a common criminal, was nevertheless the King of the Universe. When Christians confess Jesus as the Messiah, they should heed the warning implicit in that. God is telling us that getting power and authority over other people is not the proper ultimate goal of the true Christian. If the true king is the servant of all, then we shall not reign with him unless we learn this very different understanding of what true royalty means. If our king had no jewelled diadem, but a crown of thorns, then what should we be looking toward?

The image of Jesus as Messiah is still rich indeed in the modern world. When we confess Jesus as our king, we are reminded where our ultimate loyalties must lie. We furthermore reaffirm the Old Testament as our book too, and the people of Israel as our true spiritual ancestors. Abraham is our father also. In addition, we proclaim that Jesus was more than a lawgiver or a prophet. As Messiah, he was a figure of universal and final significance. He speaks to every land and every age, preparing us for the final consummation of all human history, where at his name, every

knee shall bow. And finally, the image of the crucified Messiah must be engraved on our hearts as a perpetual reminder of the way God works through the lowly and the despised. God does not call us forth to lord it over other human beings, to aggrandize our own power and force people to accept our beliefs with prison and the sword. We are called to reign as Jesus did, and whoever can look on the crucified Christ and say, with understanding, "this was indeed the eternal King," will know exactly how he must live his own life here on earth in order to reign with his lord and master at the consummation of the ages.

✣

The Word of God

T he Gospel of John opens with the familiar words we have all heard again and again (Jn. 1:1–18, RSV):

> In the beginning was the Word, and the Word was with God, and the Word was God all things were made through him, and without him was not anything made that was made. In him was life, and the life was the light of men. The light shines in the darkness, and the darkness has not overcome it.
>
> And the Word became flesh and dwelt among us, full of grace and truth; we have beheld his glory, glory as of the only Son from the Father.
>
> No one has ever seen God; the only Son, who is in the bosom of the Father, he has made him known.

The author of the gospel was deliberately pointing us back to the first chapter of Genesis, which described God's creation of the world. Darkness lay over the empty void, when suddenly the word of creation was spoken: "Let there be light." And a light shone out in the darkness, and then, as each subsequent word was spoken, dry land, trees, birds, animals, and even human beings appeared, and the whole earth was filled with teeming life. The word of God was the primordial creative power of light and life.

But now, John was saying, the all-creating word of God had been spoken again, and this time it had taken a more concrete

form, shining through in the life and deeds of the man Jesus. In the first days of creation, the light which appeared had been a purely physical light, visible to the senses, and the life which had been given had been the purely physical life of eating and drinking and moving about the surface of the earth. Now in Jesus a new kind of light had shone forth, which revealed to man the heavenly world of God and truth and love, and the life which was now offered was the eternal life of those who dwelt in the knowledge of God's eternal and immediate presence. John was saying that the central meaning of Christ's coming was the reappearance of the creative power of God in a new and totally different way.

Again, the actual reality of God's act in Jesus Christ was something far greater than any of the old categories could contain. Jesus as the Word of God was something qualitatively different from any of the previous manifestations of God's Word. The old ideas and concepts could be used to point to the power of God in Jesus Christ only by transmuting them and turning them into images and symbols of a transcendent and totally new reality. In the Genesis story, God had spoken a word of physical creation. Now, in Jesus, this word was made "incarnate"; it had taken the form of flesh and blood, and had thereby, paradoxically, given to humanity a light and a life that went beyond the merely physical.

There were other Old Testament echoes in the prologue to John as well. When the prophets announced their messages, again and again it was prefaced with the statement, "the word of the LORD came to me" (Jer. 1:4 and Ezek. 7:1; compare Isa. 2:1, Hos. 1:1, Joel 1:1, Mic. 1:1 *et passim*). This *debar Yahweh* could take different forms in different situations. The prophet sometimes spoke the word of condemnation on the social injustice and rank superstition into which the people of Israel had fallen. Sometimes it was the word of judgment, that Jerusalem or Samaria was to fall in punishment for its sins. But sometimes it was the word of forgiveness, grace, and the promise of new life, as the return of the exiles and the rebuilding of the homeland was announced. Jesus was all of these to John as well. As men and women were confronted with Jesus' life and message, it was always a judgment on them and their old way of life, but, depending upon whether they accepted or rejected him, it could be either for condemnation, or for grace

and the beginning of a new life. But again, Jesus was the Word *incarnate*. He was far more than a prophet. Again, the old categories had to be transcended in order to talk about what God had done in Christ.

The immediate and obvious reference of John's "Word of God" was to the Old Testament. But John was written in Greek, and in that language "word" was *logos*. The term Logos had a long history in the Greek-speaking world—which at that time meant not only Greece itself, but the entire eastern end of the Mediterranean, and even the early Christian community in Rome itself—so as missionaries spread the gospel across the Roman world, these other meanings of the word Logos came to be equally important.

The pre-Socratic philosopher Heraclitus had been the first to use it as a technical term. He was one of the Ionian rationalists who appeared in the sixth and fifth centuries B.C., and attacked the old mythological world view in favor of a more rational and scientific interpretation of the universe. The beginnings of modern science lay with those philosophers, and the names of the various sciences still reflect the Logos concept even today. Biology, geo-logy, psycho-logy and all similar studies have the word Logos enshrined etymologically in their very description. The Logos meant then what today would be called the laws of nature, where nature was now viewed, not as the capricious workings of gods who sent lightning, earthquake, and disease wherever they wished, but as an orderly process which human beings could analyze, discuss, and understand.

The other etymological inheritance of the pre-Socratic Logos theory comes in such English words as "logic" and "logical." These Ionian philosophers were an extremely rationalistic sort, who believed that human reason and logic could explore and understand all the secrets of the universe. The world, to them, was basically a logical system. Since the human mind was logical as well, they proclaimed with extreme confidence that human beings could understand the world in which they lived. All the subsequent discoveries which science has made — Newton's laws of motion, Einstein's theory of relativity, the discovery of the periodic table of the elements, the deciphering of the genetic code — have been based on that initial declaration of faith, that nature

operated according to logical rules and that human beings could find them out. The Logos was the basic logical structure of nature as a whole, and all science was the study of one aspect or another of the universal Logos.

By the beginning of the Christian era a philosophy called Stoicism had taken over large parts of the Roman world. The ruling class of the empire had turned to this as a philosophy of life to inspire them to duty and comfort them in times of trouble. Stoicism had taken the gods of traditional mythology, and turned most of them into merely poetic figures for natural phenomena. Hera was simply a poetic way of speaking about the upper air, and Aphrodite only a symbol for the power of the natural sexual drive. Only Zeus, the supreme god, had any true reality to him anymore, and Zeus, they believed, was simply another name for the Logos. In modern terms, one would say that these Roman Stoics believed that God was just the laws of nature.

This must not be trivialized, however, since the Stoics also believed that all of history was governed by God's providence. In the same way that the laws of science were the logical structure of nature, history also had its Logos and could be studied in logical and rational fashion by the human mind. Stoicism believed deeply that God's providence was always, ultimately, beneficent. Philosophers like Epictetus and Seneca stressed again and again, that if God directed history so that a Roman government official was given the governorship of a province, that this was a call from God to do his duty and carry out his responsibilities justly and to the best of his ability. If, on the other hand, God's providence caused him to fall into disgrace with the emperor so that he was dismissed and forced to wander poverty-stricken through the streets, then this was God calling him to display the dignity and fortitude of a brave and noble man. Either way, the Logos of history gave the good man opportunity to prove and display his own virtue. Those whom God tested most severely were normally the bravest and the best.

The Stoics also believed that true virtue was the ability to act logically and rationally. They were like modern psychiatrists in that respect. Neurosis, it is believed today, is simply an especially irrational working out of the dark desires of the libido and the

aggressive instinct. Sanity comes from putting the conscious, rational ego back in control. The sane person knows consciously and rationally what his or her emotions are, and thereby has some control over them. This is achieved only by a patient, careful process of self-analysis and self-knowledge. What a modern psychiatrist would call sanity, the ancient Roman Stoic would have called the life of virtue. It was learned by long self-analysis in Stoic schools of the sort conducted by teachers like Epictetus. Virtue meant true self-knowledge, and the freedom from the self-destructive passions which followed upon true self-knowledge.

When a first- or second-century Roman heard the word Logos, therefore, it represented an extremely rich and complex idea. There is no one word in English which could even begin to translate it adequately. It is like the concept of the Tao (the cosmic order) in Chinese philosophy, which is similarly important and similarly untranslatable. The Logos meant the laws of science, which governed all of nature. It meant the divine providence, God's plan for human history. It meant the moral law, the shape of any good man or woman's life. And most importantly of all, the Logos was part of God himself.

The force that governed the falling of the rain, the sprouting of the wheat, the rising of the sun, and the arc of an arrow shot from a bow, was the hand of God. The good scientist or the superb athlete was one who was in perfect tune with the divine Logos. Every opportunity and every disappointment that came to a human being in his life was a call from God, to do one's duty, or to turn away from foolish things, or to be brave and unflinching. The moral law was God's law, and the virtuous man's mind was a mirror-reflection of God's mind. The virtuous man shone with the light of a real, though reflected, divinity in all his good and noble actions.

It may seem terribly unrealistic to imagine that such a complicated idea could have been held by any save a few learned philosophers in the ancient Roman world, but this is simply because the idea of the Logos is so foreign to us today. In fact, any survey of Roman literature from the Early Empire will show that the major motifs of Stoicism were utter commonplaces. One might compare the commonplace nature of basic Freudian and Marxist

terminology in our own period. Even totally uneducated people of our own time will use words like "subconscious" in everyday speech. It does not mean that they understand the fine nuances of various schools of modern psychiatric theory, but on the other hand, it does not mean that they do not basically understand what is at stake in postulating subconscious in addition to conscious mental processes. Even illiterate peasants can speak the language of "class warfare" and "the revolution of the proletariat," which does not imply a doctoral degree in economics, but which does involve some real understanding of the practical differences between a Marxist and a capitalist or a quasi-feudal society.

When a second- or third-century Christian theologian spoke of Jesus as the incarnation of the Logos or Word of God, he and his listeners therefore understood enough of the Logos doctrine to know basically what was implied. By the incarnation of the Logos in Jesus Christ, he meant to say that the power that ruled all of nature had acted in a special fashion now through an individual human life. He meant that Jesus was the very embodiment of God's plan for all of human history, and that Jesus was the embodiment as well of all the virtues of the perfect moral life. Jesus' human mind was such a perfect mirror of the mind of God, that his every word and action shone with the full divinity of the Lord of the universe. When Jesus spoke, it was God speaking through him; when Jesus acted, it was God himself touching, healing, forgiving, and comforting. Any moderately educated Roman immediately knew the claims that were being made here about Jesus, even if he did not agree with these claims.

This was not the Christology of all the subsequent fathers of the early Church, but it showed up repeatedly in some of the most formative figures. Jesus' human mind as the perfect reflection of the divine Logos was the center of Origen's Christology in the third century, and of that of his disciple Eusebius of Caesarea, the Father of Church History. As Robert Gregg and Dennis Groh have shown, in their recent book, *Early Arianism—A View of Salvation,* the Arians tried to alter this Logos Christology in significant ways in the fourth century. The Logos became the model for the human struggle for Christian perfection, and lost its metaphysical, cosmological status in the process. This did not

become normative Christianity, however, and even in the fifth and sixth centuries, figures as diverse as Nestorius, and the greatest of the monophysite teachers, Severus of Antioch, all held what were only more sophisticated versions of the basic second-century Logos Christology, interpreted now in terms of Platonic images linking different ontological levels.

It would be a cheap shot to insist that this Logos doctrine was merely a product of the over-Hellenization of Christianity, without biblical foundation. There is enough clear Stoic and Platonic terminology in the New Testament already to make Greek philosophical interpretations justifiable. But even more importantly, the decision to put the Gospel of John in the New Testament canon (and leave out, for example, the Gospel of Thomas, the Gospel of Philip, and the Gospel of Truth) was made over a period of centuries by the fathers of the early church. When Eusebius summed up this slow canonization process in his *Church History* in the fourth century, he pointed out that the works which had come to be regarded as canonical were those which had been (a) quoted by the orthodox Christian writers of the second and third centuries and (b) traditionally used in the liturgies of all the orthodox churches around the Mediterranean. Those thousands of early Christians who decided, in faith, over the early centuries, that the Gospel of John truly represented their faith, read the first chapter through the eyes of Stoic and Platonic Logos theory. It is not legitimate to deny, as un-Christian, the interpretation of those who decided on the contents of our present New Testament. The Bible is the book of the Church, and as such, one cannot play off the Bible against the Church without reopening once again the whole question of the canon and the nature of scriptural infallibility on matters of faith and morals.

No truly basic attack was made on the fundamental idea of the Stoic-Platonic Logos concept until the Protestant reformer Martin Luther in the sixteenth century. This reinterpretation of the notion of the Word of God was so fundamental, however, and so full of consequence, that it affects the contemporary understanding of Christ at the deepest level.

The medieval Catholicism that Luther attacked had had, at its best, a profound understanding of visual and physical symbolism.

The entire physical world was held to be only an imperfect image, in the Platonic sense, of an ideal and heavenly world. One used the world of the five senses only to point toward that higher, eternal world where the human soul had its true home. One can feel that symbolic power by simply walking into a medieval church. The sculptured figures of the twelve apostles around the door were symbols of the twelve parts of the Apostles' Creed, which revealed the articles of faith needed to reach the heavenly world. The figures in the stained-glass windows were all largely symbolic: The dove stood for the Holy Spirit, the pelican feeding its young with blood from its own breast stood for Christ's sacrifice. In the depiction of Noah's ark, the door in its side represented the hole pierced in Christ's side at the crucifixion, and, like Christ, the ark had carried its passengers over the waters of eternal destruction to salvation on the other side.

When the priest muttered the words of the Latin mass over the altar at the rear of the church, with his back to the congregation, it is doubtful that many of the illiterate peasants (or the equally illiterate medieval nobility!) could have understood much of what he was saying. But they did understand, intuitively, that the ritual was a re-creation of sacred space and sacred time, as a historian of religions like Mircea Eliade would put it. The bread and wine were in some way truly Christ's body and blood, and on the altar, Christ was being truly sacrificed before their very eyes. It was not a repetition at another time and place of Christ's sacrifice, which had been once and for all; it was a reentry into that sacred time and space where the sacrifice had been eternally offered. It was the "dream time" which the Australian aborigines ritually dance out in their corroborees, the realm of the sacred ancestors which the Hopi Indians re-create with their masked Kachina dancers. As medieval men and women left the church after the mass, and reentered profane time and space, a little of that sacred world could still remain in their hearts.

The modern world is so verbally oriented, that it is often difficult to comprehend the importance of purely visual and physical symbols. Nevertheless, the symbolic quality of an event like the raising of the American flag over the Iwo Jima battlefield has still a visual impact greater than any words which could have been

spoken at the time. A friend's hand, warmly grasping one's shoulder, can mean more to a patient going in the hospital for a serious operation, than any number of verbal reassurances. Inviting another family to one's home for dinner can express the desire to share friendship better than any words could ever accomplish.

At its best the medieval world understood better than any subsequent age the role of such visual and physical symbols in religion. But by the beginning of the sixteenth century the medieval world was hardly at its best. The great thirteenth-century synthesis had disintegrated. Occamist nominalism now ruled the theological faculties of the universities with an antimetaphysical and Pelagian hand, the Avignon captivity and the Great Schism had destroyed much of the papacy's moral claim to international authority, bishoprics had become increasingly simply a convenient shunting place for the younger sons of the nobility, and the sellers of indulgences preached on the street corners. "For every coin which in the coffer rings, another soul from purgatory springs."

Martin Luther rejected all this, and tried to return the church to the purer Catholicism of the Apostle Paul and St. Augustine. The recent invention of the printing press and similar forces had produced a more verbally oriented society. Men were no longer confident that one could know something which could not be explained in words, and in simple, literal, univocal words at that.

Luther said that the Word of God meant, not the cosmic Logos, but the proclamation of the gospel, the good news that we are justified by faith alone and not by works of the law. Or in simpler terms, the gospel was the announcement that God loved us and accepted us in spite of our unacceptability. A mass muttered in unintelligible Latin could not speak these words. The services of the church had to be translated into the language of the people. And at the center of the liturgy had to be the proclamation of the gospel. Wherever Protestantism spread, a complete remaking of the mass followed.

The Christological implications of this were not realized for several centuries. As Gustav Aulén pointed out in his book *Christus Victor,* Luther's own doctrine of the atonement often moved back beyond Anselm into the teachings of the early Greek fathers. Hymns like "A Mighty Fortress Is Our God" were heavily

reminiscent of the "ransom to the devil" theory of the atonement, and Luther's 1520 treatise on Christian liberty suggested a kind of mystical identification of the believer and Christ. The Lutheran and Calvinist orthodoxy of the seventeenth and eighteenth centuries was impeccably traditional in its detailed dogmatic interpretation of Christ's person and work.

But if the Word of God is simply a set of words, even if these words are the gospel message itself, then certain Christological consequences follow, and the present century has seen these implications come home to roost. If it is words rather than actions which are important, then New Testament scholarship should devote itself to reconstructing the actual words of Jesus rather than discussing his actions. In the present century, true to this implicit principle, the overwhelming energies of New Testament scholarship have been devoted to source, form, and redaction criticism of the words of Jesus and the authors of the three synoptic gospels. Since Albert Schweitzer's book on *The Quest of the Historical Jesus* appeared at the beginning of this century, there has been a nearly complete moratorium on any even quasi-biographical studies of Jesus. When James M. Robinson attempted to revive a *New Quest of the Historical Jesus* in 1959, it was immediately met with the skepticism of such scholars as Van A. Harvey. But one might ask whether this purely verbal orientation matches the actual experience of Christian piety. If one did not know the stories about Jesus eating and drinking with the outcasts of society, if one did not remember the account of the sinful woman weeping on Jesus' feet and wiping them with her hair, if there were no narrative describing Jesus forgiving his enemies even in the face of his own death, surely his purely verbal parables and apophthegms would not have a tenth of their compelling power. But the ververbalization of the concept of the Word of God has driven modern scholarship to disregard Jesus' life to an astonishing degree.

If the Word of God is simply a set of words, even more serious consequences follow. Karl Barth attempted to stave off some of this earlier in this century. Barth insisted that God's Word was spoken only when the listener was truly convicted in his or her heart. Only when a person suddenly truly realized his own sinfulness, but also simultaneously felt God's love and acceptance in

spite of this burden of sin, was the Word of God truly at work. If this happened while hearing a sermon, for example, one could record the actual human words of the preacher's message and analyze them afterward. But these human words would not be, per se, the Word of God. The divine Word was a truly supernatural force in the original meaning of the word, a force coming from outside our natural human world, and impinging with explosive power directly on the human heart. The purely human words which had served as its vehicle were left like the bomb crater after a tremendous explosion had gone off. No amount of analysis of the empty crater itself could be equivalent to the actual experience of the detonation. Barth set himself against the reductive naturalism of the modern period, which was attempting to reduce the Word of God to a purely verbal statement of principles that could be as adequately understood on purely psychological or existentialist grounds without any reference to a totally other and divine power.

To an unfortunate degree Barth was like King Canute ordering the tide not to come in. The dominant trend of this century's Protestant theology has continued to be a purely verbal interpretation of the Word of God. If Jesus' message was simply a verbal message that could be repeated by any preacher from the pulpit, then there was no reason to believe in Jesus' divinity. The Jesus of the more radical wing of the Bultmannians and other similar recent theological movements has tended often to be a purely human teacher, who preached the gospel message surpassingly well. But, as Barth put it, one does not produce a God by speaking of man in a loud voice.

Those theologians who have used the later Heidegger and others in that philosophical tradition, have spoken of "speech events" or "language events," in an attempt to reconstruct the sense in which our human words about God "fall" out of an authentic encounter with the divine abyss. For Heidegger himself, however, the ground of the universe was an abyss of Nothingness, and any sense of moral direction which "fell" out of the encounter with it was a purely human, existentialist ethic, with no ultimate divine referent. In the philosophy of the early Christian fathers on the contrary, the divine abyss which underlay the world of our mental constructs, categories, and language games, was the One which

was also *the Good.* Without severe modification, Heidegger cannot serve as a vehicle for a truly Christian theology.

In spite of Barth and the use of the later Heidegger, the dominant tendency in modern Protestant theology, therefore, has been to regard Jesus as simply a human being who spoke the words of the gospel, that is, that we are accepted by God in spite of our unacceptability. From this perspective it is difficult to construct any kind of traditional Christology at all. Even if part of Martin Luther's teaching was indirectly responsible for this, surely he would be the first to protest were he alive today. It violates at the deepest level the whole spirit of Luther's all-consuming faith in the power of Christ.

It hardly seems practicable, granted, to instruct the laity in the metaphysical mysteries of the Stoic-Platonic Logos from the average modern pulpit. In this sense, there is no way back to the fourth century. But the component parts of the Logos doctrine are perfectly understandable in the present century. There is no difficulty with such concepts as the laws of nature, the moral virtues, or God's plan for human history. These ideas are not so alien as to be totally incomprehensible, and they provide a path back to some of the statements that absolutely have to be made about the person and work of Christ.

If the concept of the Logos means, among other things, the structure of nature itself—that which modern science attempts to describe with its laws and theoretical models—and Jesus is the "incarnation" of the Logos, this means in present-day language that Jesus is the true Natural Man. His life was the highest embodiment of humanity viewed as natural creature. Too many modern psychological and sociological theories, from Social Darwinism to Freud, have regarded basic human motivation as irredeemably selfish, egocentric, and violent. Jesus does not destroy human nature, however, but shows what human nature can become when raised to its natural perfection. And this, in turn, may make us revise what we think we have proved "scientifically" about the laws which govern human behavior. Loving, moral behavior does not necessarily produce neurotic guilt, Freudian psychiatry to the contrary. Human life is not totally dictated by a grim battle for the survival of the fittest—fang against fang, claw against claw—in

spite of various quasi-Darwinian theories which proclaim the opposite. Human beings are not like caged rats, directing all their activity toward seeking the piece of cheese and trying to avoid the electric shock, even though behaviorist psychologists perform a thousand experiments in their laboratories to try to prove that that is all that life is about. Simply as natural creatures, working within the structures of nature and their own biological capacities, human beings can live a Christlike life. This is a gospel of freedom that needs to be preached to the modern age also.

If the ancient idea of the Logos included the moral law and all the virtues of the perfect moral life, then the story of Jesus' life incarnates these values in ways that are perfectly understandable in the present world as well. One learns not just from what Jesus says, but from the way he in fact lived his life, that the virtue of being fair to other people *(justitia, dikaiosunê)* means being compassionate also, and giving people more than they deserve. The virtue of thinking before one acts *(prudentia, phronêsis)* means being sensitive to other people's hurts and fears, and genuinely listening, not only to what they say, but also to what they leave unsaid. Bravery *(fortitudo, andreia)* does not refer just to the virtue of a soldier who stands firm in the line of battle, but also to the innocent man who can cry out "Father, forgive them, for they know not what they do" while the ignorant rabble jeer him as he hangs dying on the cross. Self-control *(temperantia, sôphrosunê)* is the virtue of the Lord of the Ages who refused to seek fine clothing, expensive delicacies eaten off golden platters, ivory palaces, or any of the other luxuries that so many men and women look at with envy and desire for all their lives.

Faith *(fides, pistis)* meant trusting the mercy of God enough to forgive other human beings unhesitatingly in the name of God himself, on his authority. Hope *(spes, elpis)* meant seeing people, not in light of the ruin which they had made of their lives, but in terms of the persons they could become; it meant seeing desperate situations, not as irredeemable loss, but as the opportunity to build something new. Love *(caritas, agapê)* meant a man who "gave his life for us while we were yet sinners" (Rom. 5:8). In so many ways, Jesus showed over and over again, in the manner of both his life and death, the basic shape of the good human life.

Finally, the Logos meant the providence and the plan of God. One of the best modern discussions of providence is found in the writings of Herbert Butterfield, the great Cambridge historian, who wrote on various theological topics in his later years. Providence does not mean the problem of why one person, whose car stalls and who therefore misses an airplane flight, is saved from death while the other passengers are killed in a horrifying crash. The providential interpretation of history means reading the events of our own past (as individuals or as a nation) in moral terms such that we can see our own moral responsibilities in the present. The cutting edge of providence is always in the present tense, not the past. If my interpretation of the past shows me sins for which I must now repent, evils for which I was responsible and which I must now try to undo, or unmerited blessings for which I must now show my gratitude by unconditionally loving others in my turn, then I have in truth seen the hand of God's providence.

The Judeo-Christian tradition believes that God has a plan or purpose for every human being, every nation, and for history itself. The nation of Israel, for example, was chosen in Abraham's time to carry the worship of the one God and his moral law to all the world. Individual human beings are given a wide variety of tasks by God: To this one he assigns the job of leading a revolution, to that one the chore of becoming a physician and healing the sick. One person is called to be a fearless newspaper reporter; another is called to mother a special child. No one person can do all the worthwhile tasks there are in this world. By the time a person had gone through law school, medical school, secretarial school, the police academy, an apprentice program as a plumber, and learned how to cook and sew like a professional, he or she would have reached retirement age and never have done anything with the life that had been given.

The story of a good man or woman's life is the account of how they slowly learned what it was that God wanted them to do, often by painful trial and error. It is the story of how they sometimes failed even then to do what they knew they ought to do—led astray by desire for money or prestige, or simply paralyzed by fear and lack of self-confidence. But ideally it is also a story of repentance, of getting back on the track, and of gaining ever progressive insight into what God intended for their lives.

In modern existentialist philosophy the central goal or purpose or ultimate concern, which serves as an integrating axis for the individual's personality and values, is called a pro-ject. In this sense, a Christian could say that each individual human being is a project of God. The Logos is God's project for all of human history, and every man and woman's project is an integral part of that whole. The essence of sin is to deny one's God-given project and attempt to live by some man-created project which falls infinitely short of the glorious end for which God created each of us.

One preaches the Logos in the modern world simply by calling people to look into their hearts to see what they already, at some level, know very well. We human beings already understand a good deal more about what God wants us to do than we pretend we do. We know painfully well, on occasion, what tasks we would be performing if we truly loved, and were truly courageous and responsible. Jesus went where God called him—we are therefore without excuse. God does not call us to copy Jesus mechanically, to gather twelve disciples, ride into Jerusalem on a donkey, and preach in the streets. He calls each of us to do something different, but like Jesus, we can listen to this call and then obey.

The ancient proclamation of Christ as the Word or Logos of God can be recovered in the modern world, not necessarily in fourth-century terms, but by simply speaking once again of Jesus' life and deeds as the revelation of the truth of human nature, the character of the moral life, and the shape of God's providential plan for each of our lives and for all of human history.

The crucial thing is that one must go beyond Jesus' words alone to speak of his life and actions as well. It is not that the words of Jesus in proclamation of the gospel were not true, or that form criticism should not be applied to reconstruct his exact words, or that the words of the gospel message should not be announced in every worship service of the Christian church. "God forbid!" as the apostle Paul would have said. But if one argues that the gospel is only a verbal message, then it is almost impossible to avoid reducing Jesus to a purely human teacher—nothing more—who preached the gospel message surpassingly well. If it is simply a verbal message which is at stake, then it could be argued that

Heidegger, Whitehead, or the "Peanuts" comic strip have done it as well or better. In the past twenty years, in fact, all three of these co-contenders have been seriously advanced by some of their partisans. As Paul would say again, "God forbid!" Jesus was the incarnation of the Word, not just the spokesman for the Word.

This is why Jesus was different from a prophet. The Word was actually fully incarnate, displayed in the story of his life. Perhaps the prophet Hosea moved partly this direction, if the story of his marriage, separation, and reconciliation is totally autobiographical (Hosea 1–3). Many of the prophets performed symbolic actions. But Jesus' life and death became, *in itself,* his message. To understand this at all, the modern period must somehow recapture the sense of purely nonverbal communication. In a far lesser way, one saw the same phenomenon with the life of President Kennedy. A cold, hard look at his speeches showed no extraordinary brilliance. Yet in the way he looked and the way he acted, he came to symbolize to the rest of the world a youthful, idealistic, vigorous America. The thousands who mourned his murder around the globe were weeping not so much for his death, as for the end of the era which he symbolized. At a deep level, everyone realized, I believe, that the dream of Camelot died with him.

President Kennedy was more than a merely historical figure. He represented a myth. He became a living legend. That is why talk of Camelot and the King Arthur tale seemed so appropriate to connect with him. In ordinary English, of course, the word myth means a story about imaginary beings—something unscientific and untrue. In the technical language of Jungian psychology and the scholars who work in comparative religion, however, the term has a totally different meaning. In this specialized meaning, a myth is a story which symbolically represents certain fundamental, archetypal truths about human life. The life of John F. Kennedy, although perfectly historical, functioned as a myth in this manner. His life stood for something much greater.

In a far deeper sense the story of Jesus' historical life and deeds stood for something far, far greater than the bare account of the false accusation and execution of an itinerant preacher would ever indicate. The historical figure of Jesus the Galilean was a profound symbol, the concretization of a cosmic myth, the revelation

of archetypal truth, the continually renewable ritual entry into sacred space and sacred time. His life "speaks" for itself, and reveals the Godhead lying behind the world of physical, historical events. The word of God can be "spoken" also in such totally nonverbal ways.

The Word of God was spoken for the first time at the creation of the universe, the book of Genesis tells us. Atomic nuclei formed and began drifting in clouds of gas that coalesced into stars and galaxies. Implicit in the design was the eventual appearance of intelligent life, by apparent chance but by ultimate necessity. In Jesus Christ, the Word of God was spoken once again, to reveal the New Creation.

> *The Church's one foundation*
> *Is Jesus Christ her Lord;*
> *She is his new creation*
> *By water and the word.*

Through Christ, we human beings can be remade, re-created. In the old hymn by Earl Marlatt, who taught (before my time, of course) where I went to seminary, the question is asked, " 'Are ye able?' said the Master." The answer is

> *Lord, we are able.*
> *Our spirits are thine.*
> *Re-mold them, make us,*
> *Like thee, divine.*

In the Word of God we can be transformed into our full natural potential as creatures of God: compassionate, sensitive, brave, self-controlled, trusting, hoping, loving, and carrying out the specific task which God has assigned to each of us. In the process, we too become to a degree divine.

In Jesus the power of the New Creation was not only displayed in his own words and deeds; he made this enormous energy available to us as well. He proclaimed in his words our forgiveness and acceptance by God, and recapitulated in his actions (as Irenaeus would say) the transformed life which could result. In both his preaching and his deeds he still reveals the eternal Word of God as much in the modern world as in the first century, or the fourth, or any era of Christian history.

❧

The Vision of God

In Christian teaching of any era Jesus Christ has always been the proclaimer or mediator of that knowledge which saves us and returns us to God. Different forms of Christianity have had very different interpretations of the kind of knowledge involved and how it was obtained. It has been held by many Christian thinkers, however, that salvation (or at least the height of the Christian life) required a special sort of direct, immediate awareness of God which was totally different from ordinary knowledge about the world. By ordinary human thought processes, these theologians have said, one could indeed know a tree, a horse, a chair, the name of a particular color, a subjective emotional state, a geometric proof, a psychological theory, or the experimental verification of a hypothesis in one of the natural sciences. But there was in addition, they said, this special kind of direct, intuitive knowledge of God which was obtained in a manner quite different from the way these other things were known.

Even here there have been three very different traditions as to what this special knowledge of God was. By far the most important in the early Church and in the Middle Ages was the mystical tradition.

Mysticism can be found in many of the religions and philosophies of the world. Christian mysticism is only one form. In Judaism one had the great theologian Philo around the time of

Christ, the secret teachings of the medieval Cabbala, and the eighteenth-century Hasidim. In Islam, Sufi mysticism has been especially famous. The ultimate reality which is apprehended is not necessarily called God in all mystical teachings: Hinduism can speak instead of the Brahman or the Atman, Buddhism can refer to the experience of Nirvana, and Neo-Platonism calls the ultimate the One.

In the narrowest sense mysticism means the use of techniques of meditation to free the mind both from the physical world of the five senses, and from the realm of intellectual concepts and abstract reasoning as well. A common technique is to have the person meditating concentrate his or her gaze on something such as a candle flame, or the smoke from burning incense, or a small flower. The objective is to focus so hard on this that all other sensory experience is blocked out. Concentrating on the breath moving in and out the nostrils can also help turn the mind's attention away from the sensory input coming in from the rest of the body. What is even more difficult is to quiet the "inner dialogue," that is, to free oneself from involvement in the steady stream of conscious thoughts which normally fills the mind, à la James Joyce and Virginia Woolf, every waking moment. Silently reciting a mantra (a sacred word or phrase) over and over in one's mind can be of aid here. Only when the mind is finally quiet can it contact the ultimate. Perhaps the best-known modern version of this method is what is called Transcendental Meditation, which was brought over from India to the western world and popularized here in the 1960s.

One must be careful, however. There are many religious thinkers, who have normally been referred to as mystics, but who nevertheless have not used elaborate meditative techniques of this sort. Particularly with Christian mystics, there has frequently been no sharp dividing line between meditation, in the narrower sense, and ordinary Christian prayer. St. Teresa of Avila would be a case in point.

It should always be remembered that the majority of Christians in the first five, formative centuries were deeply affected by mysticism, even though only a few, like Evagrius Ponticus or Augustine immediately after his conversion, used full-fledged meditative

techniques. One reason was that the basic metaphysical levels into which they normally sliced reality almost necessarily implied a mystical experience of some sort at the top.

The lowest level was that of *chronos*. This word is usually translated into English as "time," but this is misleading because that word frequently had a far narrower and much more specific meaning in Greek. A better translation would often be "chronological time." In constructing its personal world, the human mind takes only a relatively few, highly selective events out of its memory and weaves these key events into a chronological story about the past. The events are not only highly selective but their conscious memory is also enormously simplified and loaded with value judgments. An individual's whole personality structure and character is defined by this set of conscious memories, and that individual's everyday decisions are determined by the value structure implicit in it. This chronological sequence of *phantasiai* is what early Christian theologians habitually meant by the word *chronos*. It was the realm of ordinary, discursive thought about the world.

The second level was that of Mind or Logos. This meant a more abstract, universal, and theoretical level, including what one might call the realm of timeless truths. The laws of nature were known at this level, along with general ideas about what was moral and what was virtuous. God's universal plan for history, and for each person's life, was also understood at this level of thought. But it also included all other general human categories and concepts, including space, time, and causality. All human language operated at this level, along with what the Cambridge philosopher Ludwig Wittgenstein called "language games," because all common nouns, verbs, adjectives, and most of the other parts of speech referred to generalized ideas.

The third level, that of God the Father or the One, was above the other two. Hence it was not only impossible to paint a picture or carve a statue which would truly represent God, one could not describe God literally even in words. God in his essence was ineffable, incapable of being described literally in any human words or concepts whatever.

The third and topmost level was however knowable in a certain

derivative sense because the second level, that of Mind or Logos, was like a shadowy and partial reflection in a mirror of God's essence. One could talk at that lower, second level in human words and concepts about the image of God reflected there, but his true essence always remained above all human language.

In the normal Christian teaching of the first few centuries, the vision of God was therefore regarded as the awareness of the *achronos.* This word is usually translated "eternal," but it is simply the negative of *chronos,* "chronological time." It did not mean that God in his essence was eternal in the same sense as the timeless truths of the Pythagorean theorem or Einstein's energy equation, because he was as far above the second level (formal knowledge) as he was above the lowest (chronological time). The vision of the divine transcended all that. One could interpret this to mean that the person meditating was raised to a pure "now," an immersion in pure process itself, where he "perceived" objects but without categorizing them, and "experienced" change without conceptualizing it. Or one could read this experience as a shutting out of all sensory input and conceptual thought, leaving the mind totally absorbed in a wordless contemplation of God's indescribable beauty, peace, and goodness. Or finally, one could interpret this vision as being raised to a transcendent view of one's own life and values, and all one's theories and concepts, "from the outside" as it were. From this vantage point one abandoned all particular vantage points and personal attachments, and looked simply, clearly, and critically at the overall shape of things. One could stand in judgment over the shape of one's own life, and see the flaws in one's own value system. One could contemplate the possibility of totally different personal value systems. One could see the whole sweep of human life and human history, without attachment to any person, inherited tradition, or place. It was a standpoint of radical freedom and authentic openness to all possibility.

Some of the teachers of the early church seemed to have emphasized one of these interpretations rather than another, but many seem to have mixed the different ways of understanding this vision of the eternal, sometimes in confusing fashion.

The Christian understanding of Christ comes into this picture

because the third-century theologian Origen, who was a mystic, dominated the discussion of Christ's work and nature for generations afterward. Origen (or at least some of his disciples) believed in some strange ideas like the transmigration of souls, but shorn of this mythological language, the Origenistic Christology was simple. The human soul of Jesus dwelt continually in this vision of the eternal, and he was the only human being who had never fallen from this primordial vision of God. The thoughts of his human soul were therefore perfect reflections of the divine Mind or Logos. In him, God's own laws, values, and plans were reflected at the level of human thought and human language. His task in the world was to lead the rest of humanity back to this vision of God. The fourth- and fifth-century theologians who put together the Nicene statement of faith and the definition of Chalcedon were nearly all of them working within this basic Origenistic framework.

They regularly read the Bible in the language of mysticism. When it said in Exodus 24 that Moses walked up Mount Sinai and disappeared into the impenetrable clouds that covered its top, Gregory of Nyssa, for example, insisted that this was only a symbolic way of speaking about the mystical experience itself, where all contact with the everyday world dropped away. Elijah's encounter with God was read in a similar way. The mystical experience was symbolized for these theologians by either darkness or light, because from the standpoint of this world, moving into the divine realm could seem to be a journey into impenetrable blackness; from the opposite standpoint, the entry into the divine presence seemed an entrance into a realm so filled with light that all this world looked dark as night by comparison.

In the story of the Transfiguration (Matthew 17:1-8), Jesus suddenly shines with bright light all over, and his face shines like the sun. Moses and Elijah suddenly appear as well, talking with Jesus. Byzantine theologians particularly read this passage to mean that Jesus was the greatest mystical visionary of all. He had had a vision of the uncreated light of God, even greater than Moses' or Elijah's.

One way or another, Christian mysticism has normally been

heavily Christocentric. The reference to Christ can come in a fascinating variety of places, however. In one important tradition of Russian Orthodox mysticism, the mantra repeated over and over in the mind was the Jesus Prayer, "Lord Jesus Christ have mercy on me a sinner." The medieval legend of the quest of the Holy Grail used that object (which was thought of as either the dish from which Christ ate the last supper, or the cup which caught the blood flowing from his side on the cross, or the wine-filled communion chalice) as the focus of knightly meditation in a sort of western version of the Zen warrior. The fourteenth-century work called *Piers Plowman* culminated with Langland's vision, while attending Easter mass, of Jesus in the form of Piers, stained with blood and bearing a cross.

To give another example, involving more theoretical elaboration, the Franciscan theologian Bonaventure, in *The Mind's Road to God,* set out a detailed, philosophically oriented program of meditation with six successive stages of illumination. The sixth stage, which led to the ultimate mystical vision, was however a contemplation of the union of the divine and the human in Christ. "Christ is the way and the door," Bonaventure said, "Christ is the stairway and the vehicle."

Finally, one could never omit from this list what was certainly the finest description of the divine vision in all of western literature, namely Dante's, at the end of the *Divine Comedy* (Canto 33, ll. 82–90):

> *O abounding grace whereby I presumed*
> *To fix my gaze into the Eternal Light,*
> *So deeply that my sight was there consumed!*
> *In its abyss I saw ingathered,*
> *Bound by love in one single volume,*
> *That which is dispersed in separate leaves*
> *throughout the universe.*

All the seemingly dissonant multiplicities of the world were

> *As though fused together in such a way*
> *That what I speak of is one simple Light.*

Dante saw the Trinity itself, appearing like three circles of mutually reflecting light. Then as he looked more closely, appearing in a separate color of light, *mi parve pinta de la nostra effige:* he saw painted there a likeness of our own human form (1. 131). In the second person of the Trinity, in Christ, the human was somehow brought into total union with the divine, thereby opening the path for all humanity to be rejoined once more with the divine.

As Dante continued to meditate upon the incarnate Christ, he suddenly was catapulted into the ultimate vision, beyond all human words and symbols;

> *Here power failed all lofty mental imagery;*
> *But already my desire and will were revolved*
> *Like a wheel that is turned at constant speed*
> *By the Love which moves the sun and all the*
> *other stars.*

This mystical tradition has still had echoes in the present century. Paul Tillich, one of the three greatest theologians of the first half of the twentieth century, explicitly acknowledged his indebtedness to the medieval mystics, Hugh and Richard of St.-Victor, and by implication to the Pseudo-Dionysius who lay behind them. Tillich's talk of the "God beyond God," and his preoccupation with the issue of whether the statement that one can make no literal statements about God, is itself a literal statement about God, point clearly to his membership in the Pseudo-Dionysian tradition. Martin Buber gave a more highly personalistic interpretation of the mystical tradition, and pointed out that a Jew or a Christian could never reduce God to an impersonal ultimate. The vision was always of a Thou, not an It. In the 1920s, the existentialist philosopher Heidegger painted a darkly atheistic and nihilistic version of the ancient mystical vision. For him, the ultimate was a Nothingness which was totally nonmoral. There was no longer any of the ancient Christian Platonist's sense of the ultimate One who was also the Good. The ultimate vision was no longer one of infinite Love. Heidegger promised a vision that would bring freedom, but it was an atheistic freedom and an immoral one, defined without reference to any transcendent standard of moral goodness. Heidegger can be—and has been—used

by Christian theologians, but this can only be done with far-reaching and fundamental modifications.

It should also be said that mystical interpretation can distort the biblical message if done improperly. The Old Testament does speak frequently of men having visions of God, but in the biblical tradition this vision culminates in a call to action, not a flight from this world into total absorption in some otherworldly experience. When Moses, for example, sees God in the form of a burning bush (Exodus 3), the encounter ends with Moses being sent out by a highly personal God—a Thou, not an It—to carry out the task of leading the people of Israel out of their bondage in Egypt. God says to Moses, "I have seen the affliction of my people who are in Egypt, and I have heard their cry. . . . Come, I will send you to Pharaoh that you may bring forth my people." When Isaiah has his vision in the temple (Isaiah 6), God gives him a task to perform as well, and Elijah has the same experience (1 Kings 19:11–18), for God commands him to instigate a truly violent political revolution. This is a strong contrast to classical Buddhist, Hindu, and Neo-Platonic mysticism, where the vision of the ultimate was the goal itself; mysticism was there the attempt to escape the world of history. In true biblical religion, on the contrary, God appears and speaks so that he himself may enter the world of history, acting through the human beings who have seen and heard him. The vision is a means, not an end.

The mystical tradition has nevertheless been of enormous importance in Christian history, particularly in the Middle Ages, and in that formative period between the council of Nicaea in 325 and Chalcedon in 451, when the basic framework of orthodox, Catholic Christian theology was being laid down. It is still very much alive today, although no longer in the dominant mainstream.

There is another important tradition however, which should probably be separated from it, what one might call "nature mysticism." The English Romantic poet Wordsworth, in *My Heart Leaps Up,* called it "natural piety," as distinguished from the piety derived from the reading of the Scriptures. It began to appear in authors with strong evangelical leanings in the eighteenth century, and became fully developed in nineteenth-century Romanticism. It is so different from the classical Oriental and

Platonic variety of mysticism, which is all that has been talked about up to this point, that it should certainly be divided off and discussed as a second major stream of thought about this special, direct awareness of God's presence.

In classical Oriental mysticism, in Neo-Platonism, and in Eastern Orthodox and medieval Catholic mysticism, the language which is used always speaks of abandoning the physical world of the five senses and blocking it completely out of the mind. One is taught how to move away from the world of the five senses and up to the level of abstract thought, and then how to move even beyond that. But in this tradition of "nature mysticism" or "natural piety," there is no talk of "shutting out" the world of the five senses. One sees a beautiful clump of bushes as one comes around a bend in a country road, or a magnificent mountain peak, or a multicolored sunset, and then—while continuing to see these natural objects as an integral part of the world of nature—one somehow apprehends God directly in and through them. It is the divinization somehow of the finite world itself. There is no talk of having to move to higher, more abstract levels, as in Bonaventure for example. The experience is immediate and direct.

The English theologian John Wesley, using an ancient Jewish and Christian technical term, spoke of this as nature suddenly revealing God's "glory" (Hebrew *kabod,* as in Exod. 33:18 and Isaiah 6:3, see Wesley's *Standard Sermons,* Sugden ed., Vol. 1, p. 361). C. S. Lewis, drawing upon the tradition of English poetry of the Romantic period, called this same momentary revelation, the experience of "joy." Herbert Butterfield, in his essays on the Christian understanding of history, also used the same imagery in speaking of his sense of God.

One can find innumerable examples in the poetry of Wordsworth. In his *Ode* on *Intimations of Immortality,* he begins with the lines:

> *There was a time when meadow, grove, and stream,*
> *The earth, and every common sight,*
> * To me did seem*
> * Apparelled in celestial light,*
> *The glory and the freshness of a dream.*

Or in his poem, *The Excursion,* Wordsworth gives a more specific description (Book I, lines 198-200, 203-207, 211-213):

> *What soul was his, when from the naked top*
> *Of some bold headland, he beheld the sun*
> *Rise up, and bathe the world in light! He looked—*

> *Beneath him:—Far and wide the clouds were touched,*
> *And in their silent faces could he read*
> *Unutterable love. Sound needed none,*
> *Nor any voice of joy; his spirit drank*
> *The spectacle*

> *In such access of mind, in such high hour*
> *Of visitation from the living God,*
> *Thought was not; in enjoyment it expired.*

The Romantic tradition as a whole had dangers in it of course for any balanced Christian position. In their radical individualism, there was often a Faustian, Promethean arrogance, refusing to admit to any limitations. The true genius, they sometimes said, was filled with the sense of his own divinity, seizing the divine prerogatives of creation and autonomy from God and giving them to the human soul. Their emphasis upon feeling and emotion (as in Wordsworth's famous definition of poetry as "the spontaneous overflow of powerful feelings" and "emotion recollected in tranquility") raised the uncomfortable suspicion that their kind of religion might be no more than the projection of subjective human emotion upon a blind and unfeeling cosmos. Friedrich Schleiermacher, the nineteenth-century founder in many ways of modern theology, tried to create a theological system based upon "feeling" *(Gefühl)* in the Romantic sense, but the specter of Feuerbach (who came later in that same century) has continued to haunt this variety of modern theology with the fear of pure subjectivism. Neither the existentialist theologian Bultmann in the present century, nor the history of religions approach of Otto and Eliade, has been able completely to exorcise that ghost of fear.

Yet the problem of subjectivism must be met, if real modern religious experience is to be taken seriously. William James, in

The Varieties of Religious Experience, which he first wrote for the Gifford Lectures at the University of Edinburgh in 1901–02, gave a number of vivid firsthand accounts from a variety of people of their personal experiences of this sort of "nature mysticism" or "natural piety," one of which is worth quoting at length (from Lecture III):

> I remember the night, and almost the very spot on the hill-top, where my soul opened out, as it were, into the Infinite, and there was a rushing together of the two worlds, the inner and the outer. It was deep calling unto deep—the deep that my own struggle had opened up within being answered by the unfathomable deep without, reaching beyond the stars. I stood alone with Him who had made me, and all the beauty of the world, and love, and sorrow, and even temptation. I did not seek Him, but felt the perfect unison of my spirit with His. The ordinary sense of things around me faded. For the moment nothing but an ineffable joy and exultation remained. It is impossible fully to describe the experience. It was like the effect of some great orchestra when all the separate notes have melted into one swelling harmony that leaves the listener conscious of nothing save that his soul is being wafted upwards, and almost bursting with its own emotion. The perfect stillness of the night was thrilled by a more solemn silence. The darkness held a presence that was all the more felt because it was not seen. I could not any more have doubted that *He* was there than that I was. Indeed, I felt myself to be, if possible, the less real of the two. ... Then, if ever, I believe, I stood face to face with God, and was born anew of his spirit. ... Since that time no discussion that I have heard of the proofs of God's existence has been able to shake my faith. ... My most assuring evidence of his existence is deeply rooted in that hour of vision, ... and in the conviction, gained from reading and reflection, that something the same has come to all who have found God.

James himself, in his concluding lecture, interpreted all the personal religious experiences he had investigated as the work of the subconscious, but did cautiously claim that this part of the subconscious was the "hither side" of a larger reality which, on its "farther side," could be equated with God if enough minimizing qualifications were added. The ghost of Feuerbach may still be felt however by many to haunt James' interpretation with the specter

of a purely subjective illusion—Freud has made many of us uneasy about any claims of objective, external reality for anything which can only be apprehended through the subconscious.

One would not think the empiricist tradition of philosophy would be of any aid and comfort here, yet one of the best defenses for the reality of this sort of religious experience has come from a philosopher in this tradition, William P. Alston ("Religious Experience and Religious Belief," *Nous,* March 1982). Alston argues very persuasively that all of the standard arguments purporting to show that religious experience is merely subjective, could be levelled with equal validity at the claims of normal sense experience. The maple tree which I see outside my window could be merely the fruits of an overexcited subconscious, or a systematic delusion. People who are clinically insane sometimes claim to hear God speaking to them, but they also sometimes see bugs and snakes crawling up the wall when no one else can see them. In spite of the epistemological problems involved for any modern philosophical theology in accounting seriously for personal religious experience—and Alston does show that these problems may have been greatly overexaggerated—Christianity in its modern form dare not give this issue over to the pagans by default, because nearly all modern Christologies and doctrines of scriptural inspiration, and the greater number of modern doctrines of God, hang upon the reality, in one way or another, of our human experience of direct, immediate contact with a real God who is truly external to ourselves.

In America in particular, one form of this "natural piety" or "nature mysticism" has had widespread impact. The landscape architects who built America's enormous national park system (Yellowstone, Yosemite, and the rest) spoke explicitly of their task in terms of seeing God in and through the world of nature, and many of the great nineteenth-century American painters of wilderness landscapes articulated their aesthetic theories in the same way. To the dismay of their pastors, many Americans even today use this basic argument to justify golfing or fishing on Sunday mornings instead of attending church, insisting that they "feel closer to God there." They should not be faulted utterly. Their delight in God and understanding of his presence may be greater

than that of many a perfunctory pew-sitter, and even though they may not realize it, they are part of an important American intellectual tradition. It goes without saying of course, that this intuitive understanding of nature as the seat of the holy lies behind the ecological activists who are fighting today to preserve the virgin forests of America, the unpolluted streams, and the freedom of the bald eagle. They know in their hearts that what they are defending is sacred, in more than the trivial sense, and that the thoughtless despoilers of nature do more than create ugliness—in some real manner they also commit blasphemy.

Mysticism in the classical sense, and what has been termed here "nature mysticism," therefore give two important ways of speaking about the special, immediate knowledge of God. There is a third way which, in the modern world, has been equally important. The Protestant understanding of salvation through faith alone is often expressed in terms of a direct, intuitive awareness of God as loving and forgiving. Even though Protestantism has normally vehemently rejected contemplation and meditation of the sort represented in the classical mystical experience of the Orient, saving faith itself is a kind of special knowledge which is surprisingly like mystical knowledge in some ways. The person who has been saved knows that God loves him or her, but not in the same way that he or she knows a tree, a chair, or the correct answer to a problem in physics or chemistry. It is a direct, intuitive awareness that goes beyond all the normal bounds of human knowledge.

There is good biblical basis for this. In the New Testament, for example, Paul clearly did not use the word faith to mean intellectual acceptance of a set of religious dogmas, although he has been misinterpreted this way in many centuries. For him the faith by which we are saved, was a kind of direct knowledge, mediated through the Spirit, that God loves us and regards us as his beloved children, in spite of all our sins and failures. In the Gospel of John, salvation is spoken of as "eternal life," a technical term in John's thought that means a kind of direct awareness or knowledge of God's eternal presence which surrounds us at every moment.

In Martin Luther's 1520 treatise *On Christian Liberty*, the believer was said to be saved by mystically identifying with Christ,

so that Christ took on his fear and guilt, while he took on Christ's joy and courage. This is a little different from what Paul and John were actually saying. Calvin's statement of justification by faith in the *Institutes* was more in line with Pauline theology when he clearly stated that salvation comes through a kind of direct knowledge of God as a loving God who forgives us and accepts us.

In the eighteenth century the philosophers of the Enlightenment attacked Christianity vigorously, and to aid in this, rejected metaphysical argumentation, the authority of all religious books, and every other source of knowledge except for experience and experiment. All knowledge had to be tested by the individual himself before it could be accepted as true. Jonathan Edwards in America and John Wesley in England—both very much aware of all the currents of Enlightenment thought—became the theoreticians of what was called the revival movement. If no knowledge was to be accepted except for personal experience, then they would devise a method of preaching Christianity which appealed, not to ancient authorities or philosophical argument, and not even, in the final analysis, to the authority of the Bible itself, but to direct, personal experience of Christ as a loving savior.

Particularly on the American frontier, Protestant revivalism became the dominant form of Christianity. In what was basically a Calvinist understanding of justification by faith, read through the eyes of Edwards and Wesley, revivalism insisted that one has to have a "conversion experience" in order to be saved. The person who experienced this felt the sudden overwhelming force of a direct, personal awareness, above sense experience or any human words, of God's love for him personally. God spoke somehow—certainly not in words—but truly spoke directly to his heart.

In the present century Karl Barth has been the greatest representative of this Calvinist understanding of salvation by faith. In his commentary on the epistle to the Romans, he explained Calvin's idea of justification as a direct apprehension, both of God's No to our sin and presumption, and of his Yes to us in spite of that. Barth criticized Protestant liberalism for trying to turn faith into a merely subjective human feeling. He saw where the crucial issue lay: A real salvation could only come through some kind of genuine human contact with a God who was truly out there. It did

no good to appeal to a God who was simply a projection onto the cosmos of subjective human emotional needs. Some of Barth's early critics understood well how close this was to the classical mystical tradition, and they accused him of "Byzantinism." Barth replied that he rejected mysticism in the narrower sense, but that he had to defend the proclamation that salvation came through direct contact between the human mind and the totally other of the divine. What Barth did was of enormous importance, because he, and the Neo-Orthodox movement which he helped found, came to play a shaping role in most of the theology written in the twentieth century.

All three of these Christian traditions are therefore important. Mysticism in the classical sense dominated most Christian theology from the second century to the twelfth, if not beyond. What one might call nature mysticism has had a strong effect on England and America. And the Protestant doctrine of justification by faith has been the normative understanding of Christian salvation for millions since the sixteenth-century Reformation. All three traditions say, in their own way, that God can be known directly by human beings, through a kind of immediate awareness that transcends all ordinary knowledge.

Each one of these traditions has something to teach modern men and women. The long history of Christian mysticism tells us that there is nothing wrong with a Christian of today using Oriental meditative techniques, such as transcendental meditation, yoga, or Zen teachings. The Fathers of the Church used similar techniques on occasion. The important thing to remember is that Christ must play some role in any truly Christian discipline for meditation, and that the meditative experience should never become an end in itself, only another means, ultimately, to serving God more fully in the world. It should also be remembered that good, old-fashioned, Christian prayer is a form of meditation. When people worry too much about whether God answers prayers, the question which bothers them is normally that of whether the right kind of prayer will make God give me what I want. Attempting to cajole or coerce God into fulfilling my own selfish desires is not a good way to think about prayer. There is a meditative aspect which should also enter our prayers on occasion, described

quite well in the old nineteenth-century Protestant hymn by Clara Scott, even if the language is a bit dated:

> *Open my eyes, that I may see*
> *Glimpses of truth Thou hast for me;*
> *Place in my hands the wonderful key*
> *That shall unclasp and set me free.*
> *Silently now I wait for Thee,*
> *Ready, my God, Thy will to see;*
> *Open my eyes, illumine me,*
> *Spirit divine!*

The object of prayer, in other words, should be to contact God, to see what he is like, and to stop and hear what he says to me at least part of the time, rather than concentrating so much on what I am saying to him.

There are other lessons for the modern age to learn as well. The second tradition, what was called nature mysticism, has a particularly valuable one to teach. The modern world is marked by nothing so much as the *absence* of God. It was on these grounds that Nietzsche issued his famous proclamation that God was dead. Too many philosophers, sociologists, and psychologists have given us too many ways of "explaining away" every religious feeling we ever have. This century needs to regain the courage to say once more that God is in the beauty of the mountain peaks and the song of the birds. This is not fuzzy-minded romanticism; he truly is there, and always has been. This beauty is God's glory, and our joy. It should also be said that if the divine cannot be seen in the finite, then Jesus could not have been divine, and that furthermore, the inescapable finitude of our own human lives can never be a dwelling place for God.

The modern world needs to regain the sense of presence, of the divine mystery that surrounds us at all times. It can come in the awe one feels before an enormous waterfall, or looking at the earth from a space ship thousands of miles out, or at the birth of a child. It can take a homier form. When Christians say grace over a meal and thank God, they are saying that the goodness of the food, and the human pleasure which results, is yet another manifestation of the divine goodness which continually surrounds us, in even the simplest, everyday things.

But perhaps the most important kind of knowledge of God is the knowledge that God loves me, and that I am his child. This is the gospel, the good news which frees us from the darkness. We can hear it proclaimed in a thousand sermons, but until we are quiet and listen for God himself, we will not believe it or understand it. This is itself what salvation is—living in the love of God. We are too frightened to let go and love anyone else until we learn this. God's love for us always comes first, and he must reach out to us before we can even love him back, let alone love any other human being. This is the foundation of all Christian ethics. It has to come through some direct contact with God himself.

God speaks to us not only of his unconditional love, but also of our duties and our failures. When the words of the preacher's sermon suddenly strike home, or when a Bible passage which we have read a hundred times before suddenly comes alive, this is God speaking. Karl Barth reminded us of that. Sometimes God makes us ashamed of a particular sin; at other times he gives us a specific task to perform. He does not speak these messages to us in actual words, but we know quite well what he means, often painfully well.

God does not often speak to us in things so showy and glamorous as burning bushes, but when we are confronted with some fellow human being in desperate need of food, or clothes, or comforting, we had better be aware that God is speaking the same message here which he spoke long ago in the burning bush of Moses: "I have seen the affliction of my people, and I have heard their cry." When people complain that they cannot understand how God could speak to anyone, it may be that they just do not wish to hear what he is saying.

Not everyone can be an Elijah or an Isaiah, whose words are still remembered almost three thousand years later, but every good man or woman, and every minister of the gospel, can be a little bit of a prophet, and can be at times a spokesman for God. When a good man or woman speaks words of disapproval, we should always be aware that this may be the path God has taken to speak to us. When a good man or woman comforts us when we are in despair, and lets us know that we are loved and forgiven, and that we are not despicable or worthless, this is almost

certainly God trying to reach us. It is not just a human forgiveness and reaffirmation, but God's compassion and love, spoken through human lips so that we can understand it even in our despair. If we can hear *behind* the human words, in this place also we can hear God.

The Gospel of John said that salvation was in fact simply the awareness of being continually surrounded by the eternal life of God. Love and beauty are around us at all times. The great tragedy is that we human beings are so often like men who stand in bright sunlight, with eyelids clamped tightly closed out of fear, so that we stumble through the world as though it were dark. Opening one's eyelids is terribly difficult when one is afraid. All our sins will show in this particular kind of light, and we know, though we lie to ourselves about it, that our own death and finitude will show up in those powerful rays as well. So we are afraid, and will not open our eyes, and stumble through the darkness all our days. If we would but summon up our courage to open our spiritual eyelids just a fraction, we would see that there is an infinity of love and beauty, sufficient to wash away all our sins as though they were nothing, and we would learn that love conquers all fear, even the fear of death.

Jesus walked in this light. Whether one calls it the mystical knowledge of God, or the faith which saves, or living in the eternal life of God, this is the way which Jesus tried to open to all human beings. This particular image of Christ, as he who reveals to us the living presence of God, may be the most important of all.

CHAPTER FIVE

❖

The Humanity of Christ

Affirming the real humanity of Christ has raised as many problems in fact through most of Christian history as the assertion of his divinity. The central issue is why it was necessary for God to be incarnate in a human being at all. Would there not have been far simpler ways for God to communicate his Word to us? Through an angel, for example? Or if Jesus was a real human being, how far should one go in that direction? Can his life be investigated by the same historical tools which are used by historians in general, and if so, what are the consequences?

The New Testament itself deliberately stresses Jesus' humanity over and over. He was born amid the straw and manure of a stable, and laid to rest in an animal's feed trough for a crib (Luke 2:7). He wept (John 11:35); he grew tired and had to sleep (Mark 4:38); he liked to drink wine and enjoy a good meal (Matthew 11:19). The crown of thorns and the nails in his wrists and ankles caused as much pain as would be felt by any man or woman. He did not have superhuman intelligence or emotional control. On Gethsemane he wept and grieved in horror and inner agony as he realized that he must die, and "his sweat ran down like clots of blood falling on the ground" (Luke 22:44, Mark 14:33–34, Matthew 26:37–38). He told Peter, James, and John at that point, that deep inside he was frightened to death (*heôs thanatou*, Matthew 26:38 and Mark 14:34).

The fact of his full humanity is stated repeatedly, but there is very little tendency in the New Testament to go beyond that point and speculate as to why the human nature of Christ should have been necessary. There are still, however, some provocative suggestions in a number of places, which helped to guide subsequent generations of theologians. Two of the most interesting ways of answering the question are proposed in the Epistle to the Hebrews (2:14–18):

> Since therefore the children [whom God committed to Christ's care] share in the same flesh and blood, he himself likewise shared in these, so that through death he might destroy him who has the power of death, that is, the devil, and set free all those who, through fear of death, had been held in slavery. It is not angels, certainly, whom he takes for himself, but the descendants of Abraham. Therefore he had to become like his brothers in all things, so that he might become a merciful and faithful high priest to God. . . .For since he himself has suffered under trial and temptation, he can help those who are under trial and temptation.

The first answer comes from the recognition, by the author of the Epistle to the Hebrews, that God can be very frightening when we truly encounter him. This is assumed throughout the Old Testament (see for example Isaiah 6:6, Ezekiel 1:2, and Exodus 20:18–20). "So terrifying was the sight that Moses said, 'I tremble with fear' " (Heb. 12:21, RSV). The very structure of human fallenness itself, as Heidegger showed, is a deliberate attempt to deny, to explain away, and to flee from that divine abyss which we nevertheless, at some deep level, must continue to be aware of. This is especially true when we are overcome by guilt and are so deeply aware of our own sins that we cannot face God out of shame and fear. Like Adam and Eve, we simply try to hide in the bushes from the face of God (Genesis 3:8–10, compare Isaiah 2:19). "It is a fearful thing to fall into the hands of the living God" (Heb. 10:31, RSV). But since Jesus was a human being like ourselves, sharing in the same flesh and blood, and subject to the same trials, temptations, and mortality, he can serve as a sort of priest, the Epistle to the Hebrews says, who can take us by the hand and lead us back into the presence of God, when we would be too terrified otherwise.

An angel or a voice from heaven would only frighten us the more. But the gentle, compassionate voice of Jesus gives us the courage to face both God's majesty and the character of our own sins, secure in the confidence that there is human kindness and sympathy within the otherness of the divine. When we are faced with the sudden threat of death—a violent storm at sea, or trapped in a room on an upper floor in a hotel on fire, or are lying wounded in war or dreadfully injured in an automobile accident—to whom do Christians turn and pray? How many times is it instinctively Jesus, or the Virgin Mary, or some other human representative of the divine, rather than God the Father? That was why God sent his Son, to serve as the human mediator whom he knew we needed in our fear.

A second kind of answer is contained in that same passage quoted earlier from the Epistle to the Hebrews. It was not angels whom God sent his Son to save, but human beings. Angels do not have bodies of flesh and blood, and they do not have to die. An angel could not effectively communicate what Christians call salvation, because the heavenly messenger would not share, and could not even truly understand (from within) the root of our problem—namely our physicality, our human finitude, and our mortality. This answer was to be further developed in the fourth century as the theological rule that "that which is not assumed is not saved."

So these two tentative answers, together with a third observation, that the New Testament understanding of Christ's sacrifice on the cross makes no sense if he was not a mortal human being, furnished subsequent centuries of Christian thinkers with many of their basic ideas of how the humanity of Jesus played a necessary role in our salvation.

It was not at all clear, however, to many Christians in the first three hundred years, that the savior needed to be human at all. What is called the gnostic movement sometimes actually pushed for a solution to the Christological problem, particularly in the second and third centuries A.D., which asserted that Jesus was a bodiless phantom who came down from heaven and only pretended to be a real, flesh-and-blood human being. This is called a "docetic" Christology, from the Greek word which means to seem or appear.

"Gnosticism" is a term used by modern scholars to refer loosely to what were in fact a number of very different religious movements, sects, and teachers who flourished within and on the fringes of Christianity during that period. These people regarded themselves as Christians, but believed that this physical, material world had not been created by the good, supreme God who was revealed in Jesus Christ. Hence they sometimes asserted that Jesus himself had been a purely spiritual messenger from the divine realm who had not been contaminated by what they regarded as the unmitigated evil of a flesh-and-blood, material, physical body. The discovery in 1945 of an entire library of assorted gnostic religious writings buried in the sands of Egypt at a place called Nag Hammadi has revolutionized modern scholarly knowledge of these groups.

Since some gnostics did not regard Jesus as having a material body at all, they often had difficulties with the traditional accounts of his birth, life, and death, or all three. Sometimes gnostics argued that the spiritual Jesus, after appearing in Mary's womb, had simply poured out of the mouth of her womb "like water out of a tube." Some gnostics said that he did not really need to eat and drink, but merely pretended to do so, so as not to alarm his disciples. One ingenious gnostic theorist said that when Simon of Cyrene was pressed into carrying Jesus' cross, that Jesus, as a bodiless phantom, simply changed his form so that he looked exactly like Simon. The Roman soldiers, confused, crucified the wrong person, while Jesus himself crept quietly off to a nearby hill and watched the proceedings, laughing.

Even those gnostics who believed in a fully human Jesus tended to adopt theological positions which prevented the crucifixion from being regarded as a true sacrifice, in which the divine itself was involved. One of the most common gnostic positions for example was that the human Jesus gained his divine powers when a pre-existent "spiritual Christ" came down on him from above. This spiritual Christ departed from the human Jesus just before his death and returned to the divine realm, leaving Jesus to die alone (the gnostic interpretation of Luke 23:46). At the most, a gnostic might allow the thought of the crucifixion as permitting the ascension of Jesus' own spirit to the divine realm (freeing it

from captivity in the world of matter), but this was in no way construed as a redemptive sacrifice enabling other human beings to be saved.

The earliest versions of both the Apostles' Creed and the Nicene Creed were designed in part to keep gnostics out of the orthodox Catholic churches. The beginning statements about "God the Father Almighty, maker of heaven and earth," or "maker of all things visible and invisible," were designed to counter the gnostic assertion that the spiritual realm had been created by the supreme good God, but that the physical, material universe had been created by some lesser, incompetent or malevolent deity. The phrase about "born of the Virgin Mary" was not originally primarily a statement about Mary's virginity, but an insistence that Jesus had been born of a human mother in the way any other flesh-and-blood infant was born. The reiterated phrases about Jesus suffering physical pain, being crucified, genuinely dying, and actually being buried, were again put in for antignostic reasons. They were intended as the fullest possible assertion of his genuine, total, flesh-and-blood humanity, and the significance of this for our salvation.

It is worthwhile laying out one of the more important gnostic systems, the Valentinian one, to show how this kind of theology worked. In Valentinianism, in place of a single Godhead there was a whole assembly of divine beings called the Pleroma. The individual beings who composed it were called aeons. They were arranged in pairs, male and female. At the top of the system there were two aeons who were named Abyss (or Fore-Father) and Silence (or *Ennoia*, that is, Thought). Abyss, who was masculine, caused Silence, who was feminine, to conceive and give birth to Mind (*Nous*, mas.) and Truth (*Aletheia*, fem.). Mind was also called Father and Only-Begotten. These four aeons (Abyss and Silence, Mind and Truth) comprised the first Tetrad.

Mind then caused his consort Truth to give birth to Word (mas.) and Life (fem.), and they in turn produced Man (mas.) and Church (fem.). This made eight aeons in all, called the Ogdoad. Further emanations produced further pairs of aeons, to the total of thirty in the standard system. The last female aeon to be produced was *Sophia* (Greek for Wisdom), who therefore stood lowest in the divine hierarchy of the Pleroma.

Fore-Father, the highest of the aeons, could be known directly only by his son, the Only-Begotten Mind. He was necessarily unknowable and incomprehensible to all the other aeons. But Sophia, the lowest of the aeons, dared to try to comprehend Fore-Father, and fell into the unknowable Abyss of his greatness. Out of her passion, she generated a formless entity which was forced outside the Pleroma, where it took on a host of passions from its ignorant creator: presumption, foolishness, ignorance, grief, fear, anguish, bewilderment, terror, and the like. This shapeless "abortion," arising from the desire of Sophia, became the lower Sophia or Achamoth (from the Hebrew *Hokmah,* which also means wisdom). The lower Sophia then gave rise to the Demiurge, who created everything psychical and material. He created the entire physical universe which we inhabit, including the seven beings called "archons" or rulers, who directed the movements of the seven planets. It is this Demiurge who is identified with the creator God of the Old Testament. The fact that the creator was such an inferior divine being was responsible for all the flaws of this physical universe, with its pains and terrors.

As part of this material creation, human beings were created. The body and "soul" (by which a gnostic meant the emotions, such as fear and anger) came from the ignorant Demiurge, but by one route or another (gnostic theories varied) sparks of light from the divine Pleroma became captured in these newly created human beings down on earth. Gnostics called this truly divine part of humanity the "spirit," as opposed to the "soul." The true home of the spirit was in heaven, not on earth. Body (the purely physical) and soul (the emotions) were held totally captive by the seven planetary archons though the forces of astrology, which most gnostics took very seriously. But the human spirit, if it could be awakened, could be freed from the power of the Demiurge's henchmen, the seven planets and their rulers, and could be made aware of its divine origin, outside the material universe in the unfallen Pleroma.

At various stages separate aeons named Christ, Holy Spirit, and Jesus entered upon the scene to try to rescue the tiny sparks of the divine which we call the human spirit, attempting to free them from their entrapment in this material universe which the Demiurge

created. Human spirits will be reincarnated in physical bodies over and over again, until the saving gnosis (the secret knowledge of our true origin) is brought by the gnostic Redeemer, the cycle of continual reincarnation in material bodies is broken, and our spirits are able to reascend to the divine Pleroma and leave this fallen, material universe behind forever. There are so many variants, of course, on all of the above, among different thinkers in the Valentinian movement, that this can serve only as a rough sketch of the way Valentinian gnostics thought.

The important thing to note is that this is obviously mythology, even if one uses that term in its technical rather than its pejorative sense. It is like the mythological genealogies of the Greek gods which Hesiod recorded: Uranus was the father of Cronus, who was the father of Zeus, whose female consort was Hera, and so on. Gnostic systems of this sort furnished Christianity with a serious choice. Was Christianity to become a mythological religion, like most of the other religions of the Mediterranean world, with their multitude of gods and their timeless statements of mythical truth, or was it to continue to uphold the Old Testament understanding of the one God who ruled both nature and history? Salvation for this kind of gnosticism was in fact a flight from both physical nature and the world of history, that went even beyond the typical pagan mythological system. The material world was not good, and human bodies were evil. All of human history on this physical earth was an unfortunate accident, from which the gnostic redeemer had come to free us.

The Old Testament, on the other hand, taught of a single, good God who had created this material universe, and had stated repeatedly that it too was good (Gen. 1:4, 10, 12, 18, 21, 25, and 31). The simple physical pleasures of food and drink, home and family, were part of God's design. Humankind was created good, but when human sin brought evil into this good world, God acted in history and used the forces of history itself as a power for good, to bring the world back onto the path he had charted for it. The Old Testament taught, not a flight into a realm of myth, but a solid, earthy emphasis on a world of nature that was good, and a kind of salvation that was worked out in the everyday realm of human history, with God himself as a constant participant.

One of the most important orthodox opponents of this kind of gnosticism was Irenaeus, who seems to have recognized intuitively that the best defense against the gnostic rejection of history and the world was a resolute insistence on the full humanity of Jesus. After narrowly missing being caught in a local but extremely violent persecution in 177 A.D. in Lyons in France, he returned to that city as a missionary bishop, and at some point wrote a work *Against Heresies,* in which he laid out his doctrine of "recapitulation" (*anakephalaiôsis,* compare Ephesians 1:9–10). The first Adam had sinned against God, and had refused to live as God had created human beings to live. Christ, as the Second Adam, showed in his life what true human existence had originally been designed to be. Jesus "recapitulated" every step of human life—infancy, childhood, youth, and mature adulthood—and showed at every stage what God had intended as the full human potential.

On the one hand, Jesus in his humanity became a model for how human beings can communicate with God and live in perfect communion with God. On the other side, he showed as well how God can be truly present in a human life, speaking through human lips and working with human hands, in a human being of any age. Jesus showed that the whole of human life can be sanctified. When we look at Jesus and what he did, we become ashamed at how low we set our own goals, how little-minded we are in our understanding of the true human potential, and how cowardly we are in our notions of what we really could do. Because Irenaeus insists that we aim as high as Jesus: "He became like us that we might become like him." This becomes meaningless if Jesus was not a human being like ourselves.

If one takes Irenaeus's doctrine of recapitulation out of the overall context of his thought it can be turned into a Pelagianism, of course, where sin is viewed as simply the "bad habits" that come from following "bad examples," without even a hint of the power which sin has to enslave us so that we cannot free ourselves by ourselves. Likewise, taken out of context, the idea of recapitulation can be used to teach a naively mechanical "imitation of Christ" which refuses to engage in serious ethical reflection. Simply because Jesus drove the money-changers out of the temple, for example, does not mean that I must "imitate" him by jumping

up and running to the nearest church, dressed in a long robe and sandals, so that I can throw all the collection plates on the floor. But there is no need for the doctrine of recapitulation to imply either Pelagianism or a naive imitationism in any reasonably sophisticated theological system. The important thing about the idea of recapitulation, properly guarded, is the fact that it does emphasize human life and action as opposed to the concept of a merely verbal message of salvation.

The gnostics did believe that salvation came totally from hearing a verbal message, and the history of gnosticism shows that a redemption of that sort required no human messenger at all. The saving gnosis—the verbal message describing how one attained salvation—could have been delivered just as well by an angelic figure from heaven who only appeared to be human. But Irenaeus showed that the full Christian gospel, in order to be efficacious, had to be embodied in a real human life.

The basic problem continued to come up in different forms for several more centuries. In the late fourth century, Apollinaris taught that Christ had the divine Logos in place of a normal human rational soul. His Christology was rejected by orthodox Christianity on the principle that "that which is not assumed is not saved." If part of human nature was left out of the incarnation, then part of human nature could not achieve salvation. The repudiation of Apollinaris was simply a vindication of what Irenaeus had basically set out two hundred years before.

An earlier fourth-century movement—Arianism—raised some of the same problems. As Robert Gregg and Dennis Groh have shown in their recent book, *Early Arianism—A View of Salvation,* Arius did in fact take part of the Irenaean system seriously. Christ was a "second God," who, unlike God the Father, did not have perfect knowledge and total power. Christ had free will, and could choose to obey or disobey his Father's command. Arius said that Christ did use his free will to obey the Father, and so perfected himself in obedience. He thereby became the model for us human beings, who also have free will and imperfect knowledge, and are his "brothers" in that regard.

Arianism was ultimately rejected at both the Council of Nicaea in 325 A.D. and the Council of Constantinople in 381 A.D. The

phrase in the Nicene Creed which says that Christ is *homoousios* to the Father—that is, of the same substance or essence as the Father—shows that the orthodox attack on Arianism centered around the threat to monotheism which was felt to be involved. Arian talk of a "second God" *(deuteros theos)* who was not truly or completely divine seemed like a lapse into pagan polytheism or worse. Also, it was argued, if it were not the one true God himself who was present in Jesus, then human life was not genuinely divinized, sanctified, or blessed by the real divine presence. But the basic Irenaean scheme was presupposed by both Arius and his orthodox opponents, and Arius's solution, though ultimately unworkable because of what it did to the doctrine of God, showed a good understanding of the way in which Christ must be a model for our human struggle to obey God's will.

The theological struggles that both preceded and followed the Council of Chalcedon in 451 raised some of these same issues as well. The two-nature party felt that the "monophysite" or one-nature party was imperilling Jesus' humanity by saying that there was only one nature—the divine nature—left in the incarnate Christ after the union. The monophysites seemed to them to have completely destroyed any notion of Christ's real humanity. The monophysites on their side felt that the two-nature party was destroying any idea of the true divinization of human life by insisting on such a rigid separation of the divine nature and the human nature. If they were so totally distinct and separate, the monophysites argued, then how could the divine nature truly sanctify or divinize the life of the human Jesus? The two sides of Irenaeus's fundamental insight were threatening to come apart.

The best solution to the problem, in ancient theological terms, was probably that devised by Maximus the Confessor in the seventh century. He showed real sympathy for the monophysite position, but chose for himself the Chalcedonian definition, which he expanded to speak, not just of two natures, but also of two operations or activities *(energeiai)* and two wills (one divine and the other human) united in complete harmony in a sort of moral unity in the person and work of Christ. In modern language this means that the full humanity of Christ is preserved by insisting that the human center of personal consciousness in Jesus was not the same

as God's knowledge and will. Basically, the Irenaean understanding of a divine, but still fully human Christ, was being supported again.

The Byzantine emperor, who did not find good theology politically expedient at that point, had Maximus's tongue and right hand cut off to prevent any further preaching or writing in defense of the humanity of Jesus. The bishops who met in the Sixth General Council (Constantinople III in 680 A.D.) vindicated Maximus however, and declared that the union of God and man in Christ was as he said, a divinizing of Jesus' human life without destroying any of his essential humanity, even to the level of his finite human consciousness, which was preserved in its totality.

When Anselm in the eleventh century recast the Christian doctrine of salvation in terms of the doctrine of the substitutionary atonement, a different model of redemption was raised. His doctrine went back to the New Testament as well, and continued to defend the full humanity of Jesus. If the biblical teaching of Christ's sacrifice on the cross was to be taken seriously, then Jesus had to be mortal or he could not die, and he had to be fully human or he could not act as our representative and accept in our stead the punishment which we as sinful men and women had deserved.

At the level of popular piety in the Middle Ages, the understanding of Christ's humanity had a rather more checkered career. A typical western European church in the Middle Ages was all too often dominated by a portrayal in fresco, stained glass, or stone of a terrifying Christ in Judgment, sitting stern-faced on a high throne and implacably condemning sinners to be dragged off to hell by grotesque devils. The equally foreboding portrait of Jesus as Pantocrator (Ruler of All) staring implacably down on the worshipers in Byzantine churches of the same era, showed force and strength, but no more mercy or human sympathy than the western medieval version. When such judgmental figures were used as the central image of Christ, it was difficult to see him as one who had shared in our human weaknesses, or who could be counted on to deal sympathetically with our failures and our fears. There was often a turning, therefore, in medieval Catholic and Eastern Orthodox piety, to the more human and forgiving images

of Mary and the saints in a way that went beyond any proper theological balance. On the level of popular medieval piety, therefore, the centrality of Christ was often gravely weakened. Ironically, the attempt to give him greater honor had tended in practice to dehumanize him.

On the other side, in medieval Roman Catholic piety, the crucifix continually held before people's eyes the image of a suffering human being meeting his own death with agony and the strain of tortured muscles showing under his skin. This was a very human Jesus who was portrayed here. The stations of the cross, which one still sees arranged along the walls of every Roman Catholic parish church, and many Anglican churches as well, also reaffirmed the humanity of Christ and the tragic drama of his last hours. The Franciscans played an important role in popularizing devotion to the stations of the cross in the later Middle Ages. One sees in this reemphasis on the humanity of Christ some of the spirit of St. Francis himself, with his simple faith, his love of nature, and his passionate concern for the suffering of other human beings.

The devotional work called the *Imitation of Christ,* which first appeared in 1418, was also a product of medieval piety. In it, Thomas à Kempis showed how the Christian can pursue spiritual perfection by using Christ as the model for his own life. Modern Roman Catholic devotion to the Sacred Heart of Jesus, which has its roots in the thirteenth and fourteenth centuries (in the spiritual writings of people like St. Bonaventure and Julian of Norwich), has been yet another way in which men and women have used the compassionate, human love of Jesus as an entry to the throne of God. One should also not forget the meditation on the passion of Christ in the third week of St. Ignatius Loyola's *Spiritual Exercises.* The humanity of Jesus and the whole area of human feeling are the subjects there of an intensely visual style of meditation which focuses one's entire emotional store upon the objects of contemplation.

The sixteenth-century Protestant Reformers totally accepted the church's traditional teachings about God and the person and work of Christ, so the humanity of Christ continued to be affirmed. As Luther put it in "A Mighty Fortress":

Did we in our own strength confide,
Our striving would be losing,
Were not the right man on our side,
The man of God's own choosing.

The Lutheran and Calvinist orthodoxy of the seventeenth and eighteenth centuries confined itself largely to discussion of detail, such as the long dispute between Lutherans and Calvinists as to whether Christ's descent into hell mentioned in the Apostles' Creed was the last stage in his degradation or the beginning of his exaltation.

It was only at the very end of the eighteenth century that the problem of the humanity of Jesus entered an entirely new phase, one in which the very nature of the issues and the presuppositions of the disputants took a form never seen in Christian history before. During the years 1774–78 Gotthold Ephraim Lessing carried out the posthumous publication of some very skeptical writings of a professor of Hebrew and Oriental languages named Hermann Samuel Reimarus, under the title of the *Wolfenbüttel Fragments.* Reimarus rejected any notion of miracle, and insisted that one must put aside all dogmas of the church in order to study the human, historical Jesus, who was a man of his own, Jewish thought-world, far removed from the world of later Christian doctrine.

Lessing himself then made his own attempt to analyze the sources for the life of Jesus, carried out on purely historical grounds, which he also did not dare to publish during his own lifetime. It appeared posthumously in 1784 as *Neue Hypothese über die Evangelisten als blosse menschliche Geschichtsschreiber betrachtet,* or "New Hypothesis Concerning the Evangelists Regarded as Merely Human Historians." The title itself tells the story: rather than regard the four gospels as sacred text, they were to be considered as purely human creations which could be investigated in the same manner as any other historical documents. Lessing himself believed that there was an earlier (now lost) version of Jesus' life, written in Aramaic, which was modified in four different directions over a period of time by the early church to produce the four divergent gospel accounts we now possess.

Lessing was a representative of that eighteenth-century move-
ment called the Enlightenment, which included such people as
Voltaire, Hume, Kant, Thomas Jefferson, and Benjamin Frank-
lin. There were two factors at work in producing the basic charac-
ter of Enlightenment thought. On the one hand the wars of religion,
which had set Protestant against Roman Catholic through the
course of the sixteenth and seventeenth centuries, with all its
attendant persecutions, inquisitions, and atrocities—on both sides—
had sickened intelligent and sensitive men and women all over
Europe. Those who spoke of the necessity for "correct Christian
doctrine," or "the right interpretation of holy scripture," were
automatically suspected of simply being another group of Chris-
tian fanatics looking for someone to burn at the stake. The En-
lightenment thinkers themselves were revolting against this kind
of intolerance out of a spirit of humanitarianism, concern for the
oppressed, and love of their fellow human beings. No religion,
they felt, was worthy of respect, which did not put its central
emphasis on love, compassion, tolerance, and respect for all human
beings, regardless of their social class or ways of worshiping God.

The other issue for the Enlightenment was the importance of
demanding proof for all beliefs before the bar of reason and com-
mon human experience. They rejected any notion that one must
accept an idea or a statement of fact without proof, simply be-
cause some authority commanded it, whether that authority was
a king, a religious leader, or some text (Aristotle, the Bible, or
what have you) which one was not allowed to question. The
fundamental issue here has been put with exceptional clarity in
a book that Van A. Harvey wrote, some seventeen years ago,
entitled *The Historian and the Believer*. Harvey speaks of "the
morality of historical knowledge," and points out that the En-
lightenment position was, and still is, a deeply felt *moral* judg-
ment. To bend (or invent) historical fact to support any set of
a priori presuppositions—religious, political, or whatever—is in-
tellectually dishonest, and is therefore in the same category as
theft, forgery, fraud, adultery, and any other kind of dishonesty.
The theories must be made to fit the facts, rather than lying about
the facts, or using intricately contrived special pleadings, to force
the facts to fit the theory.

In somewhat ironic fashion, therefore, in the eighteenth and nineteenth centuries there occurred a whole sequence of attacks on traditional Christianity in the name of morality itself. In terms of Christology the most important part of this was the "quest for the historical Jesus," to borrow the words of the English title of the book which Albert Schweitzer first published in 1906. In that work he catalogues all the Continental attempts to write a life of the historical Jesus, from Reimarus in the eighteenth century to Wrede at the beginning of the twentieth. Some of these attempts were naive rationalizations, where the story of Jesus walking on water, for example, was explained away by the hypothesis of a slightly submerged sandbar, or a ground fog which obscured the boundary between sea and beach. Many of these nineteenth-century authors romanticized the life and deeds of Jesus in ways which completely lost any sense of his own Palestinian world of thought. Until the end of the century, for example, these attempts to reconstruct the historical Jesus characteristically ignored the eschatological component of early Christian thought, that is, the radical urgency with which New Testament preaching taught the imminent end of this world in the fire of the divine judgment.

Lessing's belief in a lost Aramaic gospel lying behind the present four gospels created an intense investigation during the nineteenth and early twentieth centuries into the literary relationships between the gospels. At one point it appeared to be arguable that Mark at least was an eyewitness account, even if the other three gospels were not. But then Wilhelm Wrede, Albert Schweitzer, and others showed that Mark could not have been an eyewitness either.

The patient work of historical research eventually showed clearly that the gospel accounts as we now have them were the consolidation of individual pieces of material, remembered and passed along through oral tradition for at least a generation or two before anything was put down in writing. The majority of modern scholars would put the writing of Matthew, Mark, and Luke (the most important for historical purposes) at some point after the destruction of Jerusalem by the Romans in 70 A.D., but probably before 90 A.D.

But then Martin Dibelius (in 1919) and Rudolf Bultmann (in 1921) tackled the problem of dealing with the long period of purely oral tradition that stretched between the historical Jesus (crucified around 29 A.D.) and the writing of our present gospel accounts. The technique which they adapted to New Testament studies was called *Formgeschichte*—literally "history of forms," but commonly translated into English as "form criticism." It was the study of the forms or genres of oral transmission and the ways in which oral traditions were modified in transmission, first developed by nineteenth-century medievalists and folklorists like the brothers Grimm to deal with epics, ballads, and folk traditions.

Bultmann offended many conservatives with his assertion that the basic message of the historical Jesus was developed in terms of a "myth," that is, the idea of the apocalyptic destruction of this world at the end of time, and the last judgment. Bultmann insisted that this idea had to be "demythologized," or read symbolically in the modern world as a statement about the human existential confrontation with the reality and certainty of one's own death. But even Bultmann showed, in his *Jesus and the Word* (first published in German in 1926), that his techniques of form criticism could be used to reconstruct a quite dependable account of what Jesus actually said and taught. It was soon realized that one could use form criticism to recover Jesus' actual message without necessarily having to accept Bultmann's ideas about how that message should be interpreted in modern terms. Many New Testament scholars began to use the new form critical method, therefore, and although many accepted Bultmann's thesis that the New Testament teaching of the end of the world, and Jesus' resurrection, were best understood in the modern period as myths which needed to be read as meaningful but certainly not literal statements of religious truth, other scholars used the methodology purely as a neutral historical technique to discover what Jesus had actually originally said.

As a result of this, a surprisingly tight consensus now exists among most New Testament scholars, Protestant and Catholic alike, as to what the real historical Jesus actually said and preached, and what in the gospel accounts he nevertheless almost certainly

did not say or do. After all of the trauma of the nineteenth- and early-twentieth-century disputes, where many feared that the quest for a historical Jesus might totally dissolve him into unhistorical myths and legends, it turned out that one had a quite large collection of historically verifiable material, giving a detailed picture of his teaching and something of his life. At this point, the bulk of New Testament scholars have assumed the matter as settled to such a degree that they have turned their efforts for the most part to completely new areas: redaction criticism, fourth gospel research, gnosticism, the relationship of first-century Christianity to the Judaism of that period, and similar studies.

In the nineteenth and twentieth centuries the historical, human Jesus therefore became more important than he had been in any previous era of Christian history, although on new and different grounds. It seems always true, that as we see Jesus, so we see ourselves. So from this reemphasis on the humanity of Jesus, there came a new concern for humanity as a whole.

The same Schweitzer who wrote the *Quest for the Historical Jesus* went on to become a medical missionary in Africa. In fact, the entire modern missionary movement which developed during this period has had a breadth and organization beyond that of any earlier period of history. Significantly, wherever the missionaries have gone, they have also built such things as schools and hospitals, in concern for the total human needs of the people they came to serve.

It was the new nineteenth-century Christianity which motivated the New England abolitionists. More recent years have seen an especially intense Christian involvement in the American civil rights movement of the mid-twentieth century. One thinks of leaders like the Rev. Martin Luther King, Jr., for example, or less well-known people like the members of Koinonia, the interracial community at Americus, Georgia, founded by Clarence Jordan (author of the "Cotton Patch" translation of the New Testament), and countless other Christians, black and white, who braved lynchings, crushing economic reprisal, social ostracism, and gunshots fired from passing cars in the night, as they struggled to reincarnate the humanity of a loving and compassionate Jesus in their own social context.

More recently, "liberation theology" as it is now called, has moved beyond securing the rights of black people to fighting for the rights of women, Latin American peasants, and every group of human beings whose essential humanity has been de facto denied by the powers that be. Although one thinks of the first three hundred years of Christianity as the Age of Martyrs, by actual statistical count the present century has seen many times the number of men and women going to their deaths for the sake of their Christian faith, from wholesale massacres of thousands at a time in Africa and Asia, to the countless others who disappeared into Latin American jails, or were raped and killed by soldiers there, or were shot or lynched here in the United States, or were condemned to "psychiatric wards" in the Soviet Union.

Again it must be said, as we see Jesus so we see ourselves. The idea of a human Jesus, whose words and deeds can be reconstructed by modern historical methodology, and who is seen as a man of his own historical era, is not the destruction of Christian faith, but as we can see in the lives of millions in our own century, the call to bring the love of Jesus to all our fellow human beings in respect for their very humanness. In Jesus' own life and suffering, in his human compassion and his courageous acceptance of his own human fear of death, he still continues to show us the authentic possibilities of our own humanity. This was what Irenaeus's doctrine of recapitulation was trying to say.

Oddly enough, even in the present period, when probably the majority of theologians writing would reject any notion of Jesus' divinity in the Chalcedonian sense, Jesus still seems to work this way. Even for the great number of modern Christians who would regard Jesus as simply a good man who did God's will, or proclaimed the gospel, or taught the Golden Rule, or confronted us with the existential possibility of authentic existence, he still serves as the de facto mediator who leads us back to God.

This may be because, in fact, a God without Christ would be no easier to know in the modern world than he was in the time when the Epistle to the Hebrews was first written. It is possible to know God without the mediation of Jesus—otherwise the Old Testament figure of Abraham could not be the New Testament paradigm of the faith which saves (Romans 4)—but that does not

mean it is easy. The real God is the one who rules the depths of interstellar space, where even light takes millions of years to travel from point to point; he is the one who reigns within the complex forces and bewildering array of particles inside the nucleus of the atom.

When it is not completely terrifying, the idea of God at best is apt to seem incredibly remote and abstract. When university students go to read philosophy of religion, and explore the proofs for the existence of God and the metaphysics of Thomism or process philosophy, they so often return with a peculiar, wistful sadness. What they found did not help them in what they were really looking for.

What they wanted was a human face: not the God who makes the rain fall on the just and the unjust, but the God who feels pity on the poor woman who is confusedly, awkwardly wiping her tears off his feet with her hair. Philosophy teaches us about God the ruler of nature; Jesus Christ shows us God the ruler of human history. We have, as it were, two windows for looking at God, each with a differently tinted glass. Through the window of nature, God appears in the language of physics, chemistry, and philosophical metaphysics. Through the window of human history, God appears in the actions and ideals of good men and women who have seen his goodness and who act as agents of his call to unconditional love.

And in Jesus above all we are able to see behind the "blazing fire, the darkness, gloom, and whirlwind" (Heb. 12:18, NEB). God does have a human face, and Jesus, as the bearer of the divine, still serves in fact as the human face of God, for our age as much as for any other.

❖

The Divine Man

The Greek and Roman world had believed in divine men long before the coming of Christ. One of the most beautiful and sensitive accounts of this idea was set forth by the first-century Roman moralist and playwright, Seneca, in a short piece (Epistle 41) entitled *On the God Within*.

One does not need to pray to some distant god in heaven, Seneca says there, nor to an idol in a temple. "God is near you, he is with you, he is within you." The place where God is truly to be found is in other human beings—if they are wise and good. The "sacred spirit makes its seat within us," in the midst of our humanity, so that "in every good man, 'A god doth dwell.'"

Seneca explains what he means by the divine in language that was borrowed from him in our own century by the theologian Rudolf Otto in his influential book *The Idea of the Holy*. If one goes deep into a dark forest, to where the towering trees completely surround one with their ominous height and mysterious shadows, one may suddenly feel a tremor of fear and awe that brings with it a frightening sense of the infinite. There is something in the dark forest which is other, greater, and more ancient than the merely human. Whatever it is, human beings by themselves are weak and powerless by comparison. It was there before humanity had even come to existence, and it will be there after every human being alive today is dead and totally forgotten. This awareness of

"the numinous" is the primordial sense of the Holy, according to Rudolf Otto; it is the feeling upon which all religions were built in their beginnings. Seneca says that it is the way one knows that God is present.

But a truly wise human being can evoke that same feeling of numinous awe, Seneca goes on:

> If you see a human being who is not terrified even in the midst of dangers, not touched by the passions of desire, who regards himself as fortunate even in the midst of misfortunes, who is at peace in the middle of the storm, looking down on other human beings from a higher, godlike plane, will you not find yourself looking on him with veneration? Will you not say, "This thing is too great and too high to be anything like the petty human body in which it dwells? A divine power has descended upon that person."

The soul of the divine man touches the things of this world with an almost imperceptible lightness, like the sun's rays glancing off a solid surface. The true center of his soul remains above, in that realm where the gods live, and he never releases his hold on that sacred homeland, even while he acts here below as the this-worldly nexus where the divine and the human can momentarily meet and interpenetrate.

The ancient world was deeply preoccupied with this idea of the *theios anêr,* the divine man. The oldest marble building still standing in Rome is the round temple to Hercules in the Forum Boarium. Statues and frescoes of him, and temples dedicated to his worship, are uncovered in every excavation of a Roman town. He was the man who became a god, and stood as the symbol of the triumph of the human soul over adversity, the passions, and even death itself.

He was not the only divine man by any means. Asclepius and Dionysus for example, were worshiped all over the Greek world, and Romulus had his important role in Roman legend as founder of the city itself. A set of standard motifs appeared in the stories of these divine men with great regularity. Heracles (or Hercules), Asclepius, Dionysus, and Romulus all four had human mothers but a god for a father (Zeus, Apollo, or Mars). There was often a

miraculous birth: Asclepius was said to have been snatched from his dead mother's womb by the god Apollo while her body was being laid on the funeral pyre, and Dionysus likewise was taken from his dead mother's womb by Zeus, who sewed up the infant in his own thigh, from whence he was born again. There was normally a story about the divine man's miraculous escape from death during infancy: Heracles strangled the snakes which the goddess Hera sent to kill him in his cradle, Asclepius was suckled by a goat when he was exposed to die, and Romulus was similarly suckled by a she-wolf.

The divine man customarily worked miracles during his life on earth. Asclepius was said to have brought a dead man back to life, for example, and Heracles descended to the Land of the Dead and returned again. The divine man received his full divinity only at death, however, when he received immortality and full status as a god. Heracles ascended to heaven when he stepped alive onto his own funeral pyre and the wood was set ablaze. Romulus also was said to have ascended bodily to heaven at the end of his life. Other Roman legends added that Romulus later returned from heaven in the form of a star and seized his wife, whom he lifted up to heaven to reign with him as a goddess. There was also a tale of a sort of "resurrection appearance," where Romulus appeared after his ascension to a man named Proculus Julius on the road from Alba Longa.

Many of the same motifs appeared in the Greek and Roman world in the legends which grew up around genuinely historical figures after their death. Alexander the Great was sometimes said to have been the son of a human mother and the African desert god Zeus-Ammon. According to one legend, the great philosopher Plato was really the child of the god Apollo and a human mother. Iamblichus *(Life of Pythagoras* 8) said that Pythagoras's soul had come down from heaven, where it had been a companion of the god Apollo, to be incarnated as a man on earth. Lucretius, in his poem *On the Nature of Things* (beginning of Book V) described his master, the great philosopher Epicurus, as "a god, a god indeed" for his discovery of what Lucretius regarded as the true answer to all the problems of life and the universe.

One can see the deep pathos of even ordinary people in the

Greco-Roman world proclaiming on their tombstones, that in death at least, they had taken on a kind of divinity and entered the realm of the gods:

> Mother, do not weep for me. What is the use? You ought rather to reverence me, for I have become an evening star, among the gods.

The great Roman orator Cicero, though a skeptic in many ways, was so distraught when his only daughter, Tullia, died, that he seriously attempted for a while to build a temple to her where she could be worshiped as a goddess, or at least something as close to this as contemporary Roman law allowed.

One of the most interesting of these divine men, from the point of view of New Testament scholarship, was the Neo-Pythagorean philosopher Apollonius of Tyana. He lived about the same time as Jesus, and was said by the inhabitants of Tyana to have been the child of a human mother and the god Zeus. Swans surrounded his mother in a ring and flapped their wings and honked to bring about his birth, while a bolt of lightning struck the earth nearby. Apollonius wandered about the world, preaching and teaching and performing healing miracles, including driving out demons and raising a young girl from the dead. He was believed by many to have ascended bodily to heaven at the end of his life, standing alone inside a locked temple to Artemis, when the voices of young women singing were suddenly and miraculously heard from within. There was even a story about a sort of "resurrection appearance" to one of his disciples afterward.

A man named Philostratus wrote a biography of Apollonius, and as late as the fourth century A.D. there were pagans who insisted that he was much more impressive than Jesus, and that if anyone were to be regarded as the true divine man, it was he and not Christ. Judaism was affected by the basic idea of divine men as well. The Jewish philosopher Philo, a contemporary of Christ, wrote a life of Moses in which the great Old Testament lawgiver was portrayed as a typical Greco-Roman divine man. The basic form and structure of the ancient divine-man biography—miraculous and divine birth, childhood precocity,

teachings, godlike miracles, encounters with enemies, and ulti-
mate triumph over death—had enormous influence on the writing
of the New Testament accounts of Jesus' life as well. The four
gospels at least partly fit the literary form of contemporary pagan
and Jewish divine-man biographies.

One area where the idea of the divine man had particular im-
portance in the Greco-Roman world was in their belief in divine
kingship. It began in the fourth century B.C. with Alexander the
Great himself, when his divinity was proclaimed by the Greek
cities of the Corinthian League after his return in triumph from
India. The Hellenistic monarchs who followed him regularly
claimed to be divine. Plutarch made fun of some of their excesses.
They would carry golden thunderbolts in public appearances to
show that they were the incarnation of Zeus, or wear rayed crowns
to symbolize their identity with Apollo. "Is not almost any king
called an Apollo if he can hum a tune, and a Dionysus if he gets
drunk, and a Heracles if he can wrestle?" The ruler Cleitus sank
three or four enemy warships in a naval battle, and promptly
started carrying a trident like Poseidon, Plutarch scoffed.

The famous Rosetta stone, key to the modern rediscovery of
Egyptian hieroglyphics, proclaimed the Hellenistic monarch Ptol-
emy V as a "visible god," who was the son of the Sun god and was
the "living image of Zeus." The Jewish holiday called Hanukkah
celebrates the victory of Judas Maccabaeus in the second century
B.C. over the Hellenistic ruler Antiochus IV, who titled himself
Epiphanes: "God revealed to human eyes." His predecessor Anti-
ochus I gave himself the title of "Savior" *(Sôtêr)*, and that king's
son, Antiochus II, simply called himself "God" *(Theos)*.

When the Roman empire began spreading into the eastern end
of the Mediterranean world, many of these customs of divine
kingship slowly but inexorably were transferred over into their
practice as well. The temple still stands in the forum in Rome
where the emperor Antoninus Pius and his wife, Faustina, were
worshiped as gods. The ruins of similar temples and cult statues
for the worship of the divine emperor have been found by arche-
ologists all over the Roman world.

Augustus, who was emperor at the time of the birth of Christ,
was portrayed by the Roman poet Horace *(Odes* 1.2) as the

incarnation of the god Mercury. The Roman biographer Suetonius *(Lives* 2.94.4) said instead that he was the son of the god Apollo, who impregnated his human mother in the form of a snake. A resolution of the provincial assembly of the Roman province of Asia was less specific, and simply proclaimed the "gospel" *(euangelion)* of the birthday of "the god" Augustus. One remembers that the crucial test, which came ultimately to be applied when Christians were singled out for persecution, was to ask the suspect to put a pinch of incense on a charcoal brazier in front of an icon of the emperor, and thereby to acknowledge him as god.

The excessive claims to divinity of two of the first-century emperors, Gaius Caligula and Nero, especially raised the issue at that time, of whether there was any intellectual justification for this practice. Roman philosophers like Seneca, Plutarch, and Philo became deeply involved in the question of whether a rationale could be devised for regarding the true ruler as divine. They found a tradition they could build on and continue, which went back to the third century B.C., to the Pythagorean philosophers who wrote under the names Diotogenes, Sthenidas, and Ecphantus.

In this philosophical justification of divine monarchy, it was argued that only the king or emperor who was also a truly wise philosopher could be truly divine. But the good ruler who was also a philosopher-sage would know God, and imitate his virtues here on earth. His human soul would be such a perfect reflection of the Law or Reason or Logos of God, that he would shine with a powerful reflected divinity himself. The good ruler would be the Living Law, or the Sacred Thought, or the Divine Logos of God brought down to earth—the precise term varied from author to author, but the basic idea was essentially the same. The good king or emperor then acted as a savior figure to the ordinary people of his realm, who could see all the divine virtues expressed here on earth in physical form by their ruler, and could then imitate these godly virtues in their own less educated way. But virtue was the hinge, and there was the catch. Only a perfectly good and moral ruler could be divine in this way. It was virtue and morality which enabled human life to achieve divinity.

As Diotogenes put it, the king who was totally just was

"transformed into a god among men." He became the Living Law *(nomos empsychos),* the incarnation of God's law of justice here on earth. Ecphantus said that because the divine Logos was so deeply implanted in the good king's mind, all his human thoughts were also sacred and divine. Plutarch likewise said that the good and virtuous ruler had the divine Logos so thoroughly enshrined in his mind that he himself became the Living Logos *(empsychos logos),* the incarnation of the Word of God on earth. The Logos was to be like a voice, Plutarch said, speaking within his mind and pointing out to him all his specific royal responsibilities. There was of course an implied critique of the contemporary Roman emperors in this message. An explicit attack on the morals of the reigning emperor would have cost a philosopher his life. But men like Caligula and Nero clearly did not shine out as exemplars of wisdom, justice, compassion, and clear-sighted reasonableness, and any intelligent Roman knew that all too well.

Among educated Romans, therefore, terming someone a "divine man" meant that that person was so wise, good, virtuous, and just, that his human mind was a perfect reflection of God's mind. It did not mean that he was not a human being in the fullest sense, but it did mean that one could see a mirrored image of God's goodness shining out in his purely human words and deeds with such intensity that awe and worship of the reflected glory of God was a perfectly appropriate response.

Jesus of course was born and carried out his work at the very peak of this divine man, divine monarch speculation. The entire pagan world was looking desperately for a man in whom the divine had truly appeared. There was a deep poignancy to this— the elegantly proportioned classical temples and the polished marble statues of idealized mythical beings no longer satisfied people's deepest longings. The abstract metaphysical God of the Philosophers seemed so distant and impersonal that this gave no genuine alternative either. There was an insatiable thirst instead for some real, contemporary humanization of God. The pagan world wanted a wise and good man, who could incarnate here on earth all the divine wisdom and justice of God. Words of this sort, which were clearly a grotesque travesty when applied to an Antiochus Epiphanes, a Caligula, or a Nero, suddenly made sense when

applied to the figure of Jesus. Christian missionaries traveled the length of the empire, proclaiming their gospel: God has at last truly become man, in the person of Jesus of Nazareth. Come join us in the worship of Christ our God, they cried, for the wisdom, the power, the virtue, and the love of God has taken flesh and dwelt among us.

There were dissident voices of course. The small Christian group called the Ebionites, who were possibly descendants of that original Jewish Christianity which flourished in Palestine before the Romans took Jerusalem and burnt the Temple in 70 A.D., taught that Jesus was simply a human being who was not in any sense divine. But the majority of early Christianity rejected their position as heretical—that is, as a theological system which did not adequately express the nature of God's act in Christ or the kind of salvation offered there to all humanity.

That early Christian theology which became the dominant one— that is, the theological tradition which proclaimed Jesus as the divine man—understood salvation itself in this same light. The goal of every Christian was to become divinized himself, so that God dwelt in him as well, and he in God. That was what it meant to be saved, and that was the purpose of Christ's incarnation. As Irenaeus put it in the second century, "he became like us, that we might become like him." Athanasius, the great fourth-century defender of the Nicene faith, said it even more explicitly: "He was humanized (made man), that we might be divinized."

The idea of salvation as divinization, and the concept of Jesus as the human incarnation of God himself, went hand in hand therefore in the dominant strand of early Christian preaching. There were issues raised here, however, which did not become fully explicit until the fifth century.

By that point there had come into being two groups of Christian theologians, one centered around the city of Alexandria in Egypt, the other connected with the city of Antioch in Syria, who differed fundamentally in their understanding of the incarnation. The Alexandrines were pushing in the direction of a complete denial of Jesus' humanity. Apollinaris, an early representative of that group, taught that Jesus had no human rational mind, that in him one encountered what one could describe as more or less God's mind

in a human body. He was condemned as a heretic, although there are many pious Christians in the modern world who still believe that Jesus was omniscient and that anyone who denies that is attacking the faith. They have unfortunately neither read their church history, nor their New Testament (see for example Matthew 24:36 and John 11:34), because this is not a workable or an orthodox Christology.

The later Alexandrians preferred to use imagery like that of a drop of ink dissolved in an ocean of water. Though the ink had not been destroyed, it lost all its visible inkiness as it dispersed through the infinite volume of seawater. Jesus did have a real human mind, they continually affirmed, but it was so totally absorbed in the union with God, that there was only one nature left in the incarnate Christ: he was completely divine, with no separate humanness left at all. The mystical strain was coming out strongly here, since mystics have continually spoken at all periods of history of the human mind's total "absorption" in the vision of God, so that all notion of self or individuality was completely lost. This imagery may be better poetry than it is metaphysics, however, without some more complicated explanation of why the man Jesus—unlike the drop of ink—was clearly still there.

The Antiochene theologians, on the other side, had such a high doctrine of God that they regarded it as blasphemy to say that a human being could "become" divine in such an apparently literal fashion. God was totally different from man. There were two completely distinct natures involved. Neither could simply be turned into the other. God had to remain immortal, infinite, and invisible; man had to remain physical and finite. The Antiochenes preferred to talk of the union between God and man in Christ as a union of wills. Jesus was the man who was obedient unto death, and because his human will was perfectly conformed to the will of God, his words were the word of God, and his actions were God's actions. This language is also capable of misuse, however— as much so as the Alexandrian language about Christ. If the Antiochene Christology is construed to mean that each separate decision made by Jesus at every point in his life was in effect a make-or-break decision about his Christhood, then one has fallen into what Henry Chadwick once termed a sort of Christological

Pelagianism. At 9:13 A.M., Jesus can make the right decision in a particular circumstance and be the Christ; at 9:17 he can decide selfishly in the next situation and fall out of his Christhood; but then at 9:24 he can repent and be the Christ again.

This particular Christological heresy—a sort of extreme Antiochene position—is called Nestorianism. When a theologian is accused of Nestorianism it often implies in addition a whole complex of associated ideas: that Jesus was divine only in the sense that an ambassador to a foreign nation was able to speak in the "person" *(prosôpon)* of the human king who sent him, that no adequate distinction was made between Jesus and the prophets of the Old Testament, and that God was in Jesus only in the way that he indwelt in the temple in Jerusalem. But the important point was that Nestorianism as a heresy meant the reduction of the divine-human union to something totally determined each time by every decision of Jesus' every waking moment for his entire life. Some of the Antiochene theologians themselves understood that the central problem in avoiding Nestorianism was to construct a union in which Jesus' human will played a decisive role, but in which some ontological continuity kept this union of God and man from disintegrating into a set of moment by moment decisions. It was not however until Maximus the Confessor in the seventh century distinguished between two kinds of human willing that a good solution was suggested for this problem. In modern language, to avoid Nestorianism but still retain a human will in Jesus, one must distinguish somehow or other between the action of the human will in ordinary, everyday decision-making, and that act by which an individual human being constitutes himself as the specific, continuing self who he is, vis-à-vis both God and the world. Both are acts of "willing" in some sense, but they are very different in kind.

Nestorius himself, after whom the heresy was named, was an Antiochene theologian who was made Patriarch of Constantinople in 428 A.D., and deposed for heresy three years later at the Council of Ephesus in 431. When his own theological writings were rediscovered at the end of the nineteenth century and published in 1910 as the so-called *Bazaar of Heracleides,* most modern scholars came to the conclusion that Nestorius himself had

not truly been guilty of the heresy of which he had been accused. He seems instead to have been a rather tragic victim of fifth-century ecclesiastical politics. But the problem continued to simmer even after Nestorius's condemnation, and came to a boil again less than twenty years later.

The Council of Chalcedon was called to deal with the whole set of issues in 451 A.D., and the bishops who convened from all over the Christian world issued a definition which has been the touchstone of belief about Christ's divinity for most of Christianity ever since. The Roman Catholic church and all the various branches of Eastern Orthodoxy have abided by that decision, and the major branches of the sixteenth-century Protestant Reformation also strictly reaffirmed Chalcedon in spite of their break with Rome on other issues.

The Definition of Chalcedon did not lay out "a" correct theological system, which answered all Christological issues in systematic detail. It simply gave a set of broad guidelines, within which Christians could think about the relationship of God and Christ in any way that they wished. Chalcedon declared only that in Jesus Christ one must speak of two "natures" (the divine and the human) united in one "hypostasis."

"Nature" in ancient Greek thought meant what made a thing what it was instead of something else, how it behaved or functioned, and what it would, could, and could not do. The nature of fish meant that they could not breathe air, and the nature of human beings meant that they could not fly like birds, to use two of the favorite ancient theological examples. God had to remain God by nature; Jesus had to remain a human being by nature. In the debates of succeeding centuries, it was made clear by theologians like Maximus the Confessor (c. 580–662) and conciliar decrees like that of the Third Council of Constantinople in 680 A.D., that one could not renege on Jesus' essential humanness in any way. He had a human body which required food, drink, and sleep. He wept. He was born as a tiny baby and had to increase in wisdom and stature like any human being. He had a finite human mind, which did not know everything. He had a human will of his own, separate from God's. The word "personality" in the modern sense was not used in the ancient world, but the emphasis

on a separate, finite human mind and a separate human *will* (Maximus's most important contribution) meant that the early Church clearly regarded Jesus as having a separate center of personal consciousness, distinct from God's mind and will.

The word "hypostasis" is much more difficult to interpret in modern terms. A common ancient example pointed out that, although Peter and Paul were both human beings, they were still distinct individuals. Their common humanity was their "essence"; their individuality arose because each had his own separate hypostasis. The term hypostasis therefore refers to what makes each human being the distinct person he or she is. To need food, drink, and sleep is part of our common, essential humanness. So is any other characteristic, whether mental, physical, or moral, which is true of all human beings everywhere. The word hypostasis refers to what is left over, which makes Peter a different person from Paul.

Any way of explaining what the term hypostasis means in modern terms involves a measure of interpretation. Since hypostasis refers, however, to the existence of the individual rather than to the universal essence of things, one very obvious place to look for tools for explaining this concept in the present century would be contemporary existentialist philosophy. It is the existentialists who have emphasized the priority of existence over essence, and have sought to place the irreducible individuality of each person at the base of their philosophical system. If one patiently immerses oneself totally into the overall metaphysical structure and philosophical psychology of ancient Christian theology, the use of existentialist language can be seen to be not at all as bizarre or arbitrary as might appear at first glance. If one remembers in particular the full meaning of the Logos concept in early Christianity, the philosophical interpretation of divine kingship which lay in the background, and especially Maximus the Confessor's detailed study of freedom and the human will, one can see that the proper use of existentialist terminology can in fact do a very adequate job of explaining with good technical precision what was philosophically implied by the doctrine of the hypostatic union.

In existentialist language one can say that each person defines himself or herself as a person in terms of a "project." This is the

ultimate specific goal or purpose around which all the person's other goals and purposes are organized. Since each person on this earth has a separate, different project, each lives in a separate "world" with its own separate moral rules. If a judge, for example, demands that a newspaper reporter reveal his confidential sources in court or go to jail for contempt, an existentialist would insist that there are no universal moral rules which are finally useful in resolving the reporter's dilemma. It has to be decided by that person individually, in terms of the way he has defined himself and his purposes and goals in life. Two different people, put on the stand in the same external circumstances, might make totally opposite decisions, and yet each could be authentically following his own inner code and his own inner goals.

Project and hypostasis mean close to the same thing. The atheistic existentialist Sartre said that every human being's project was to become God. A Christian existentialist could simply reverse this and say that every human being is in reality a separate project (in the etymological sense of pro-ject, a throwing forth) of God himself. It is God who provides the hypostasis in which each one of us can individuate himself as a distinct and separate person. God has a plan, in other words, for each of our lives, something special that he wants us to do: for one person, leading a revolution; for another, helping a special child; for another, being a missionary to a foreign country; for another, being a farmer and making the earth green with growing plants. Human beings can reject God's project by their own free will, and make the futile, ultimately self-destructive effort at an autonomous project of their own. This is the basic nature of sin, as Augustine emphasized so well. It is the attempt to build a City of Man instead of the City of God. It never succeeds, and carries within itself the seeds of its own failure. Only when a person recognizes himself as a pro-ject of God can he truly find the inner core of his own individuality.

The universal Logos or Word of God is in similar fashion, God's plan for all of human history. It is the hypostasis or central purposive axis running through all of God's mighty acts in history. Jesus took as his personal hypostasis that of God's universal Word. This was different from any other figure in the Bible. Moses was sent to carry out a very particular task, for example, that of

leading the people of Israel out of Egypt. The prophet Amos was sent to preach a particular message of doom to eighth-century northern Palestine, while Second Isaiah was assigned a particular message of forgiveness which was to be spoken to sixth-century Jews in resettlement camps in Babylonia. Ezra was set to the particular task of rebuilding the fallen walls of the city of Jerusalem. Jesus, on the contrary, was sent to declare, to all the world and every century, God's universal message of love, faith, and hope. Jesus showed us where the whole plan of God was going. He refused the lure of false autonomy. He did not try to center his life around some personal project defined by his own selfish desires. He took God's project as his own, and thereby turned into something more than human. Because the core of his own personal identity was simply the divine hypostasis itself, he was in fact simultaneously human and divine.

To put this in slightly different words, the teaching of the Council of Chalcedon was that Jesus was a man who had so totally devoted himself to God's will and purpose at the deepest level of his personal values, that he had become a perfect mirror of the divine will. When Jesus spoke, one could not say whether they were God's words or human words; they were both simultaneously. When Jesus acted, to forgive or comfort or heal, one could not say whether they were God's actions or human actions; they were both simultaneously. As the four Chalcedonian adverbs made clear, in every word and every deed of the incarnate Christ, the divine and the human were united, without dissolving one into the other *(asynchytôs)*; without changing either the divine or the human into anything different *(atreptôs)*; without splitting them into two, merely accidentally related beings *(adiairetôs)*; and without confining them to separate realms of activity *(achôristôs)*.

Since the individual hypostasis or project is the ontological basis of the individual's existence as a concrete individual, the hypostatic union is ontologically real, not simply a verbal convention. The fact that hypostasis can be viewed as a psychological concept does not mean that it is not an ontological concept as well, since the psyche is the base of both authentic being as a human and authentic human existence.

An existentialist interpretation is therefore one way that one

could go in giving a modern interpretation of the hypostatic union between God and man in Jesus Christ. It is certainly not the only one. Any modern theological or philosophical system which enables one to speak of human individuality and the perduring effect of personal self-identity at a sophisticated enough level, could be used just as well. The contemporary Christian ethicist, Stanley Hauerwas, has emphasized for example the role of what he calls moral "character" as the long-term continuity of the self through a series of specific ethical decisions. It is in reciting a "narrative"—the story of a person's life—that character is revealed. Hauerwas has criticized those ethicists who have concentrated too narrowly on the analysis of specific moral decisions, and have neglected the role that Christian teaching should have in forming the kind of basic moral character which would inform all particular ethical decisions. This would be a very workable direction to go: The word "character" as Hauerwas uses it is not a bad translation at all of hypostasis in the Christological sense. One should also remember that Hebrews 1:3 does speak of Christ as "the radiant splendor of God's glory, and the *charactêr* of his *hypostasis.*"

Process philosophy provides yet another possible interpretation. In Alfred North Whitehead's *Process and Reality,* the "subjective aim" is said to be directed not only towards the immediate present but also towards the "relevant future," which makes it the basis of "the greater part of morality" (1.2.3). But it is not all parts of the subjective aim with which the classical Christian understanding of hypostasis would be concerned, only the question of the self-preservation of the actual entity as an "enduring object," defined as a certain *persona* or "character" passed along serially through time by the continuous inheritance of certain "defining characteristics" in subsequent actual occasions (see 1.3.2). Hypostasis will necessarily be a dynamic concept in process philosophy. It will be the current vector of a creatively evolving trajectory of subjective aims, insofar as the subject must decide who he truly is, and how his *true* selfhood as an enduring object may be creatively expressed and positively assimilated in each novel situation.

In essence, therefore, any modern philosophical or theological

system can be used to interpret the Chalcedonian doctrine of the hypostatic union of humanity and divinity in Christ if it adequately balances off human free will against some real sense of the continuity of the self and its goals and values over extended periods of time. This, together with an adequate doctrine of revelation and the sovereignty of grace, keeps Christology from falling into a Nestorianism or Pelagianism where Jesus is made to decide—in some absurd concept of total freedom, each and every moment of his life, *de novo*, and without influence of personal awareness of God's presence or the constant, shaping prevenience of divine grace—whether he will be the Christ or not.

But to return to the patristic and medieval church: the basic link between Christ as divine and salvation as divinization dominated the thought of the first nine or ten centuries of the Christian era. In Anselm, however, in the eleventh century, a new perspective on both these issues was developed. In his *Cur Deus Homo?* ("Why the God-Man?") Anselm worked out his substitutionary doctrine of the atonement, where our salvation was understood principally in terms of Christ dying on the cross to render satisfaction to God the Father for our sins. It was not a forward-looking emphasis on our human potential for embodying God in our lives which now dominated, but a backward-looking emphasis on sins past that needed to be forgiven. (This is not intended to be a pejorative description of Anselm's ideas, since the necessity for forgiveness of sins is good New Testament doctrine.) Christ still needed to be divine, but now in this new Christology because only a God-man could render, by his death, the infinite satisfaction needed for the sins of the whole world. Christ also still needed to be human, since Christ had to be a member of that human race who had grieved God, so that he could then vicariously represent them on the cross. Since Anselm's Christ had to be both completely human and completely divine, the basic Chalcedonian formulation still stood as fundamental Catholic dogma for the remainder of the Middle Ages.

The sixteenth-century Protestant Reformers took Anselm's doctrine of the atonement as their basic starting point, and the Wesleys and other eighteenth-century theologians of the evangelical revival movement in England and America did likewise, so that

most contemporary Protestant denominations at least officially and formally hold to the doctrine of Jesus Christ as both human and divine.

At all periods of history, of course, there has been a temptation for Christians to fudge on one side or the other of the union of God and man in Christ. There is a constant temptation to ease the tension by making Jesus other than human or less than fully divine. The ancient world erred more commonly in the direction of trying to make him superhuman. He was portrayed at times as an omniscient being who ate and slept only so as not to alarm his disciples. Some gnostics even pictured him as a bodiless spirit who only appeared to have flesh and blood. The New Testament, of course, and Chalcedon, rejected any such denials of Jesus' full humanity.

The modern period (regardless of official doctrine) has been tempted to ease the apparent paradox by denying the other side of the theandric union. Jesus in contemporary theology is all too often simply a good man who taught about the Golden Rule, or about an authentic openness to the future, or about some other saving truth which could have been gotten in any number of other places just as well.

A Christian's understanding of the incarnation is inescapably tied up however with his evaluation of the human possibility itself. "He became like us that we might become like him." It is no accident that the temptation to deny or weaken Jesus' divinity has come to a peak in Christian teaching in the same century which has seen the most massive depersonalization and denigration of humanity in most of recorded history. The twentieth century is the era of the Nazi death camps, of Stalinist purges, and of massive nuclear confrontation where military strategists speak calmly of annihilating most of the human race. Behaviorist psychologists, sociologists, and a wide variety of modern philosophical systems attempt over and over to turn human beings into mechanisms—machines, able to be programmed and manipulated by positive and negative reinforcement, and societal pressures, into any form one pleases. The denial of Jesus' divinity in the present century seems to have gone hand in hand with the denial that human life itself is sacred.

What one construes as Jesus' divinity is automatically a statement about the true human potential. This is the problem which confronts the modern world. Can human beings live and die with inner dignity and nobility, as bearers of some divine spark, or are they no more than animals in the pejorative sense, breeding, feeding, and struggling for bare survival? Can human life embody God at all? The teaching of the incarnation, properly understood, is not a denial of this world and this life, but a demand upon the human race for a far higher understanding of the full human potential than it has normally dared to believe.

Chalcedon gave the basic guidelines for a modern understanding of Christ's divinity: two natures (divine and human) united in a single hypostasis. This means on the one hand that Jesus must be seen as a human being with the same natural limitations as any other human being. God on the other hand cannot be other than God. He cannot die, and in his essential nature he is invisible and ineffable. Yet in Jesus Christ there was an effective linkage—a hypostatic axis of action—which allowed God to live and act through a human life. Whatever understanding of Christ's person and work is preached in the modern world, based upon whatever philosophy or cosmology, it should do justice to all three parts: God, the human Jesus, and the common axis (however it is construed) which joined their activities into one.

The salvation offered in the New Testament is a salvation that is offered here and now, in this life and on this earth. This is because it is the daily toil of our bodily existence—sweating, bleeding, hurting, crying—which must be redeemed. In the early church, Irenaeus and Athanasius both saw the crucial issue. If true divinity cannot enter human life in its totality, then there is in fact no salvation in this life or on this earth. It is not just the presence for a few years of a good man here in this world which gives us the real courage to go on; it is the fact that his name was Immanuel, God-is-with-us. Or as Anselm would have put it, the Christian gospel is not that Jesus of Nazareth was a good man who spoke well and wisely about morality and love, or who challenged us to authentic openness; it is that in the cross of Christ, God himself came and gave us—himself. The divinity of Jesus Christ is not a doctrine that Christianity can give up lightly.

That is why the modern world must work out some way of saying clearly and unequivocally that in Jesus Christ we confront, not just a good man, but somehow, some way, God himself in his glory, his grandeur, and his life-affirming, unconditional love and compassion. Because it is only then that we fully see the other side as well: God suffering with our pain, weeping for our misery, and rejoicing with shouts of delight at our return to him, the beloved home from which we never should have strayed. The part of God revealed in Christ is the part which we must have in order to be saved.

❖

The Redeemed Humanity

I n trying to explain the nature of Christ's redeeming work down through the centuries, Christianity has always been driven beyond the issue of purely individual salvation to a larger human context. It is not just this one person's particular sins as an individual and that other person's particular sins as an individual which are at stake, but a kind of massive human solidarity in sinfulness. At all periods of history and in all the nations of the world, a pervasive general human immorality spreads its effects, producing selfishness, cruelty, greed, violence, irreligiousness, and every other form of godlessness and inhumanity to one's fellow human beings.

But on the other side, redemption in Christ is ultimately communal as well, not purely individual. At the simplest level, Christianity obviously teaches each individual's reponsibilities to the other people around him. But it goes beyond this to assert that the fullness of the New Life in Christ is only to be found through participation with one's fellow Christians in the Redeemed Community. When he saves us, Christ transfers us from one enormous group of human beings—those still locked in the pervasive general sinfulness of most human societies—to membership in another group whose members are bound together by living bonds of faith and love, the Redeemed Humanity with Christ as its head.

The New Testament stresses in many ways that salvation is

more than the redemption of an individual soul. A person can only achieve the fullness of salvation by inclusion in a group whose whole is greater than the sum of its parts, and whose ties are formed by bonds which are far more important than the life or death of any single individual.

Paul, for example, says that the church is the very body of Christ (1 Cor. 12:12–27, compare Eph. 1:23). In spite of "its many limbs and organs," it remains a single body in which each part is dependent on all the others. "The eye cannot say to the hand, 'I do not need you'; nor the head to the feet, 'I do not need you' " (1 Cor. 12:21 NEB). The author of the Gospel of John makes the same point in his image of Christ as the True Vine: "I am the vine," Jesus says in John 15:5, "and you the branches. He who dwells in me, as I dwell in him, bears much fruit; for apart from me you can do nothing" (NEB).

In the Old Testament, as well, it was the moral and spiritual character of the entire people of Israel that was basically at stake, not that of individuals seen as separate from the community. Salvation came from being included within the people of Israel. The *Heilsgeschichte*—the history of salvation—was the history of a nation, not a handful of isolated individuals. It is hence very important to note how quickly the Christian community began to see itself as the New Israel. The links continually established in the New Testament between the church and the historical people of Israel show how significant this issue was for early Christianity.

In Romans 4, for example, Paul is arguing that non-Jews who have a faith like Abraham's can also be heirs to the salvation which God promised originally to Abraham's biological descendants (the Jewish people) alone. In chapters 9–11 he develops the argument further. Salvation comes from membership in the people of Israel, which had commonly come to be construed in his time as all those people who were Jewish by race, that is, direct biological descendants of the patriarch Abraham. But, Paul says, not all those who were physically descended from Abraham were "true" children of his, mentioning Ishmael and Esau as examples. On the other hand, non-Jews can become "true children" to Abraham by having a faith like his. The important thing to note is that salvation still means, even for non-Jews, inclusion (by adoption at least) within the historical community of Israel.

At the end of that section Paul uses another biological meta-phor, based on the phenomenon of grafting. With many species of plants, including apple trees and grape vines in this country for example, a branch can be cut off one plant, and a lopped-off branch from a different plant of the same basic species can be fastened onto the stem of the first plant so that the two cut edges are held in firm contact. In a few weeks, the transplanted limb will be growing on the new stem. In this way, one can produce such curiosities as an apple tree which bears yellow apples on one branch and red apples on another. All the grape vines raised in Europe nowadays have branches from highly developed Europe-an wine grapes grafted onto hardy, disease-resistant, American Concord grape rootstocks.

Using this sort of metaphor, in Romans 11:16–24 Paul speaks of the historical people of Israel as an olive tree, and the non-Jews who have now received salvation as wild olive branches grafted onto that tree. What is important is to see how salvation for Paul here means being an organic part of a living group of people, extending all over the world, and back through history for thou-sands of years. Salvation is not a radically individualistic thing.

Ephesians 2:11–16 regards the inclusion of the Gentiles within the historical community of God's promise as the central work of Christ. Non-Jews were once "strangers to the community of Isra-el," and only Jews were heir to the promise of salvation. But now Jesus, "in his own body of flesh and blood," has acted "so as to create out of the two a single new humanity in himself" (NEB). It was not individual salvation per se, but the creation of a re-deemed humanity which was Christ's central purpose.

Baptism and communion have been the great sacramental sym-bols of this corporate salvation in the worship of the church down through the centuries. Christian baptism was simply brought over directly from the Jewish tradition, where it was part of the ritual in which a non-Jewish proselyte made his or her formal conver-sion to Judaism, and was received into membership in the histori-cal people of Israel. It retained the same basic meaning in Christianity as well. It was the initiation rite in which the Chris-tian church (as the New Israel) accepted newcomers into the com-munity of salvation.

Baptism in the catholic tradition is not a single individual standing up and proclaiming his or her individual faith. It is the community descended from Abraham, Moses, Jesus, Paul, Irenaeus, and Athanasius admitting that particular individual into membership with them in the people of the New Israel, which is the mediator of God's grace to the world. There is a confirmation service used at present by one of the churches of this country, which sums up in one passage the essence of this catholic understanding of baptism and corporate salvation better than any other description I have ever read:

> Dearly beloved, the Church is of God, and will be preserved to the end of time, for the conduct of worship and the due administration of his Word and Sacraments, the maintenance of Christian fellowship and discipline, the edification of believers, and the conversion of the world. All, of every age and station, stand in need of the means of grace which it alone supplies.

The Christian communion service likewise came directly from Jewish roots. It was derived partly from the blessing over the bread and wine at the Jewish Sabbath evening meal, a happy time of family fellowship; and partly from the Jewish Passover ritual, with its commemoration of God's mighty act in leading the whole people of Israel out of bondage in Egypt, so that the promise to Abraham and his descendants might ultimately be fulfilled. The Christian reinterpretation, with its heavy emphasis on eating the flesh and drinking the blood of Christ, simply stressed all the more the notion of salvation as a real, organic, physical incorporation in a redeemed community, which now shared a common flesh and blood and had Christ as its head.

It is necessary to understand this basic Christian presupposition of the communal nature of salvation in order to comprehend what was really being said in the proclamation of Christ as the Second Adam, and in Christian discussion of the image of God in man. It was the apostle Paul who first used this concept of Christ as the Second Adam (Romans 5:12–18):

Therefore sin came into the world through one human being, and through sin came death, so that death passed through all of humanity, because all sinned.... Death reigned as king from Adam to Moses, even over those who did not sin exactly as had Adam, who was the prefigurement *(typos)* of the one to come. But the gift of grace was not at all like the original falling away. For if many died through the fall of one man, it was exceeded by so much more, for so many people, by the grace of God and what he gave us in the grace of that one man Jesus Christ.... For if death reigned as king due to the fall of one human being, a single person, then by so much more will those reign in life who receive such an abundance of grace and the free gift of righteousness through the one man Jesus Christ. So then, just as by the one fall, condemnation came to all human beings; in the same way, by one righteous act, all human beings were brought into justification and life.

Paul's objective was to elevate both sin and salvation from the individual to the universal level. Christ's saving act was portrayed as an event that affected the sinful character of the whole human race as such. It had a significance which could only be understood against the whole history of the world.

The word Adam simply meant "man" of course in Hebrew, and in one way or another, he came to represent the totality of sinful humanity, in Christian theology of all centuries. In the early church, the followers of the third-century theologian Origen said that Adam was not a single historical individual at all, but an allegorical symbol for all human souls. Our human intellects had all existed, the Origenists believed, before this present material world was even created. Because we sinned in that previous existence, God caused us to be born in physical bodies here on earth (the "garments of skin" in Gen. 3:21) as punishment and discipline, until we should repent and return to heaven where we belonged.

Augustine in the early fifth century had a more literal view. Adam and Eve were for him real, flesh-and-blood human beings who lived at the beginning of the earth's history, and from whom all human beings who have ever lived were biologically descended. But Augustine devised a theory of "original sin" in which Adam and Eve's sinfulness was physically passed down to all their descendants in the act of sexual intercourse itself. Adam therefore again became the representative in fact of the entire human race.

Most western European theologians in the Middle Ages and Reformation period followed Augustine's doctrine of original sin, and regarded Adam and Eve as real historical figures. It was in this spirit that Archbishop Ussher in the seventeenth century claimed that the creation of the world (and of a literal Adam and Eve) could be dated precisely in 4004 B.C. His dating scheme is still frequently reproduced by publishers in the margins of King James translations of the Bible to this day, although most modern theologians would reject Ussher's dating scheme totally.

Ninety-five to ninety-eight percent of modern biblical scholars would in fact view Adam, not as a literal, historical individual, but as a purely symbolic figure, named "Man," who stands for the fundamental sinfulness which comes out so often in all human beings. This is partly because of modern knowledge of biology, geology, archeology, and ancient history; but partly also because of what has been learned by scholars of comparative religion about the true meaning and religious function of creation stories in the various religions of the world. When Adam is no longer regarded as a single historical individual, but as a symbol of human sinfulness in general, then of course it becomes automatically true that "in Adam's fall we sinned all," because, whenever we become trapped in our own sins, we *are* Adam. The modern emphasis, in other words, is not on providing an explanation for why human beings as a race are so incredibly and universally sinful, but simply on pointing to the observable fact that this is so. Human beings *are* sinful, and that is the problem Christ came to solve.

In the history of Christian thought there was another passage on Adam that was just as important as the one in Romans 5, and frequently connected with it in one way or another. This was the statement in Genesis 1:26 that God originally created man in his own "image" and after his own "likeness." The idea of the image of God became, in every century of Christian history, one of the most important ways of talking about what was good about human beings, which made them (at their best) so radically different from animals. The image of God was the spiritual gift which God gave to Adam at his creation, which, had he not sinned, would have enabled him to live and develop as God had originally intended him.

In early Christian theology the image of God in man was frequently equated with such things as reason, free will, freedom from the passions, the true knowledge of God or of the good, and immortality or incorruptibility. When Adam fell into sin, the image of God in all human beings was lost, obscured, or incapacitated. There have been many different ways of interpreting this through Christian history.

One tradition is represented by theologians from the eastern, Greek-speaking end of the Mediterranean world. One can see the basic outlines of this position as early as Irenaeus in the second century. These theologians were greatly affected by 2 Corinthians 4:4, which says that fallen human beings have had their "minds blinded" or their "understanding darkened," so that they can no longer see the image of God. Gregory of Nyssa in the fourth century said that fallen man still had the image of God within, but obscured like a painted portrait that had been so covered with layers of mud and filth that it was no longer recognizable.

The members of this eastern tradition always insisted however that human free will was not lost in the fall. The essence of human sinfulness was not seen in some defect of the will. No matter how sinful they had become, human beings always retained their freedom to decide and choose whatever they wished. Sin came instead from a darkening of the understanding. Sinful human beings wandered freely but blindly. They pursued illusions instead of reality. Gregory of Nyssa told the story here of the dog carrying a bone in its mouth who stopped to look over the edge of a small bridge. The bone being carried by the dog reflected in the water below seemed so much juicier that he opened his mouth to seize the illusory bone and thereby lost both it and the real one. Gregory points out that human beings are not much more intelligent in practice. The illusions which human beings pursue are many—the lure of endless wealth, absolute power, unlimited sexual pleasure, undying fame as an athlete or author—but all lead to sin and do enormous harm to both the sinner and those around him when they are pursued without bound. The fantasies of our daydreams can be dangerous if we begin to act without distinguishing illusion from reality. Adolf Hitler, one must remember, simply started out as a housepainter with a dream.

The Greek word for image was "icon," a word that Plato uses frequently, so in Eastern Orthodox thought through subsequent centuries, the idea of the image of God in man developed powerful Platonic overtones of mirrored intellectual images and symbols reflected back and forth between different ontological levels. In Platonic thought the icon or image participates in the form of which it is the shadow or reflection, which meant that if human beings renew the image of God in their souls with the help of Christ, they can thereby participate in the divinity of God himself. All the rich associations in Orthodox worship with the veneration of painted icons of Christ and the saints, also become involved in this eastern understanding of the image of God. When Christ renews the image of God in a human soul, it therefore becomes a partial "portrait" of God, or a "mirror" reflecting God's light into the world.

One part of this eastern Christian tradition, which seems most alien to modern westerners, is their so-called physical doctrine of the atonement and the associated idea of the solidarity of all humanity. It is called the "physical" theory of the atonement from the Greek word *physis,* meaning "nature." Human nature itself was corrupted by Adam's fall, when the divine image in us was obscured. Human beings are then saved in this interpretation, not by the sacrifice on the cross, but by the incarnation itself, which restored fallen human nature, renewed the image of God in man, returned us to the vision of God which is eternal life, deified us, and destroyed the power of death. Athanasius, the fourth-century defender of the Nicene faith, is an important representative of this tradition, as is Gregory of Nyssa later in the same century.

Christ in this system affects not just individuals, but human nature as a whole. This idea arises from the eastern Christian conception of the solidarity of humanity. The underlying belief comes out in startling fashion in Gregory's work *To Ablabius: On Why Not Three Gods.* He says there that speaking of three persons of the Trinity in no way implies three gods, in the same way that speaking of many people in the world (though a verbal convention) does not alter the fact that there is really only "man" in the singular. The idea that it is metaphysically false to speak of human

beings in the plural is so alien to modern western ways of thought, that this passage in Gregory's work has drawn repeated notice. Some modern commentators have tried to read Gregory here as an extreme Platonist, who believes that only the Platonic idea of man is "really" real, whereas individual human beings are only illusory "shadows" cast by that ideal, eternal form.

But in Gregory's *Catechetical Orations* (32) he expands on this idea of the solidarity of all humanity and explains more clearly what he means. "The whole of human nature," he says, "constitutes as it were a single living being." Gregory points to the way in which sense perception in any part of the human body is almost instantly transmitted in its effects over the whole body, and argues that the diverse people who make up the human race are similarly bound together into a marvelously articulated system of communication and response.

One is reminded here partly of Richard Dawkins, a modern philosopher, who coined the word "meme" to speak of ideas which spread from person to person and are passed down by the human race (via intellectual contact) in the same way that genes are passed along by sexual reproduction. Tunes, catch-phrases, the idea of the wheel or the bow and arrow or the arch, a particular moral concept—all these "memes" are continually transmitted from mind to mind, and have a life of their own which can extend through generations of their comparatively short-lived human hosts. Gregory of Nyssa, who was a metaphysical idealist, meant this, and more, and intended quite literally to say that the interconnections between human beings are so massive, and so constitutive of what it means to be human, that one must regard the whole human race over all its history as the "real" living organism. Separating out individual human beings would be as misleading, to use a modern analogy, as dividing out a human body into its separate constituent cells, and then trying to figure out why the separated cells suddenly died.

These fundamental ideas continued to play a role in Eastern Orthodoxy for centuries. One of the most important works of modern Orthodox spirituality, though it is not often recognized as such, is *The Brothers Karamazov,* by the nineteenth-century Russian novelist Dostoyevsky. The characters include Father

Zossima, the starets and existentialist saint, who teaches that paradise is life here on earth, lived in love and humility (vi. 1), and the skeptical brother Ivan, who worries for page after page (v. 4) about the Origenist conception of the ultimate salvation of all souls, even Satan himself, which he cannot accept. Through the whole book, in fact, the major characters ponder at enormous length over all the central motifs of the Byzantine religious tradition. Dmitri is the one who discovers the solidarity of all humanity. In his dream about "the babe" (ix. 8, see also xi. 1 and 4) he suddenly realizes that he is one with the poor people holding their cold, starving babies who huddle in the Russian snow in burned-out huts. He is part of them and they are part of him. In his dream he suddenly feels love for them. When he awakes, he is suddenly able to accept other people's love for him for the first time. He bursts into tears with gratitude for the simple, anonymous kindnesses of those around him. He has now accepted his place as part of the whole—ready to bear the guilt of others, ready to love and be loved, no longer afraid of humiliation (ix. 8–9, compare vi. 1a).

This is an exceptionally fine presentation of what Gregory of Nyssa, and the Orthodox tradition, had meant by the solidarity of humanity. The incarnation of Christ meant that God himself had now become part of this universal human network in which compassion, love, responsibility, and voluntarily taking on the guilt of others and bearing their punishment, were the threads which could make the totality of human nature itself both the context, and in fact the substance, of salvation.

The western tradition, starting with Augustine in the early fifth century, developed the idea of Adam's fall and man's loss of the image of God in a quite different direction. Augustine believed in a literal Adam and Eve, as has been noted, who lived at the beginning of the world. They were created by God *posse non peccare,* "able not to sin." That is, they had free will, and the ability to use that freedom to avoid sinning. But then when they disobeyed God's direct command, as part of the consequence they were left only *non posse non peccare,* "not able not to sin." That is, there was now a defect in their wills such that they could not in fact make themselves stop sinning. This defect in the will was passed down to all their biological descendants in the act of sexual

propagation itself, and is called "original sin." The power of original sin is so great that, after Adam's fall, all human beings in their natural state are affected by sin in all their actions.

Augustine's *Confessions* gives two memorable images of the nature of original sin. One is the baby, lying in his crib, who screams, rages, and shouts inarticulate demands at the top of his lungs when his slightest whim is denied. Augustine was trying to point out that there is some of this screaming baby down deep inside in every adult, only when it occurs in a grown man or woman, the tyrannical, selfish, egocentric nature of this infantile behavior is seen more clearly to be an essentially sinful attitude toward the world and other human beings. Adults hide it most of the time under a mask of proprieties and conventional behavior, but a shrewd observer of human beings, Augustine insists, can see that infantile egoism breaking out again and again in the everyday behavior of one's superiors, one's subordinates, friends, neighbors, and enemies alike. One sees pettiness, injured vanity, unreasonable demands, supersensitivity, whininess, and every other sort of childishness in even civilized adults; in a king, a dictator, or a crazed despot one can frequently see this infantile behavior turning truly demonic.

The other image Augustine gives of original sin is in the form of a story from his youth. He and a group of other boys vandalized a man's pear tree—not because they wanted to eat or sell the pears, not because they had a grudge against the man, but simply out of the desire to be destructive for its own sake. The very pettiness of this particular act of vandalism makes it all the more useful for Augustine's argument. It was thoughtless and pointless. But again, the enormous cruelties which adults wreak on other adults are so often marked by the same pointless destructiveness for the sheer pleasure of the destruction. From the boss who verbally tears down his employees' efforts on every possible occasion to the Nazi plan (aborted fortunately) to blow up all the irreplaceable monuments of Paris as they retreated from the city, there is a frightening capacity in the human race to hurt, maim, and destroy for no discernible rational reason.

Augustine differs strongly from the eastern Christian tradition in regarding this quality of original sin as a defect in the human

will rather than a darkening of the understanding. This is because of the influence of Paul on him at a decisive point in his development, as J. Patout Burns has pointed out in his book on *The Development of Augustine's Doctrine of Operative Grace.* In Romans 7, when the apostle discussed the mystery of human compulsive behavior, he saw a deeply paradoxical quality to it (vv. 19–24, NEB):

> The good which I want to do, I fail to do; but what I do is the wrong which is against my will. . . . In my inmost self I delight in the law of God, but I perceive that there is in my bodily members a different law, fighting against the law that my reason approves and making me a prisoner under the law that is in my members, the law of sin. Miserable creature that I am, who is there to rescue me out of this body doomed to death?

When the alcoholic struggles to avoid the bottle; when sexual desire drives people to do what they later realize were incredibly foolish things; when someone tells himself that he will hold his temper in his encounter with another person but finds himself inexorably swept into uncontrollable rage after five minutes, the power of original sin is at work. It is not that their understanding is darkened, Augustine says, because they know right from wrong. It is a defect in their wills which makes them incapable of doing even the good they know.

Overemphasis on Augustine's doctrine of the will and his mechanism for explaining the presence of original sin nevertheless should not hide the basically communal character of original sin in his thought. Here he is no different in his ultimate conclusions from the eastern Christian tradition, since there is a species-wide human solidarity in sin for him as much as for them. The figure of Adam is therefore a representative figure for him also, as much as for them, though in a different way.

This comes out clearly in Augustine's *City of God,* where all human beings who have ever lived are divided into one of two groups: the Earthly City, which is totally in the grasp of original sin; and the City of God, which is made up of those whom God and Christ have freed at least in part from the controlling power of sin. The "City of God" is Augustine's metaphor for those

people who make up the Redeemed Humanity. Like the eastern
Christian tradition, he does not ultimately believe in the possibili-
ty of isolated, individual salvation.

The members of the City of God (the redeemed humanity) are
partially freed from the power of original sin by divine grace. At
the very beginning of his *Confessions,* Augustine links grace to the
preaching of the gospel in a quotation from Romans 10:14: "How
can they hear without a preacher?" This was the direction which
the Protestant Reformation was to emphasize a thousand years
later. But elsewhere Augustine stresses the importance as well of
the catholic sacraments as sources of grace. In medieval catholi-
cism, the sacramental system became the key device for creating
the redeemed humanity. Baptism washed away the guilt of origi-
nal sin, penance provided a route back for those who had fallen
again into sin, and regular communion provided a continual
strengthening of the redeemed will.

Thomas Aquinas, for example, in the thirteenth century basi-
cally followed the Augustinian system, with a sacramental em-
phasis. The person who had fallen into mortal sin had to confess
his sins to a priest. In receiving the absolution of the priest, the
sinner received totally unmerited grace, which not only absolved
him of the punishment for his sin, but also gave him grace sufficient
to restore his free will so as to enable him not to fall into mortal
sin again.

The best way of understanding the Protestant Reformers who
came at the end of the Middle Ages is as highly trained Catholic
theologians who took the basic Augustinian position and pushed
it much more radically than the Catholic tradition had ever done
before. In his work entitled *The Bondage of the Will,* Luther said
that the fallen human soul had no effective trace of its free will left
at all. In Adam's fall, the image of God had been lost in everything
but name only. The human soul was therefore in the position of
a mute donkey with two riders—Christ and Satan—struggling to
get on its back. Whichever rider won would flick the reins, and
the donkey would go wherever it was guided. Luther also stressed
the point that no one, not even the greatest saint, was even then
totally freed of sin in this life. Christian perfection could only
come when we were as the angels in the life to come.

The idea that some traces of sin—spiritual pride, residual selfishness, or something of the sort—will still remain in this life in even the greatest saint is of the essence of Protestantism, and is one of the two or three single most important points which separates Protestantism from Roman Catholicism (and Eastern Orthodoxy as well). It should be said that the difference is partly verbal: A Protestant will typically regard as sinful (without a qualification) a variety of temptations and nondeliberate actions which a Roman Catholic would consider as only venial rather than mortal sins. But the Catholic definition of mortal sin as a conscious violation of a known law of God is too narrowly defined for most Protestants, who would regard the distinction between mortal and venial sin as one which is difficult or impossible to make in practice, and which tends to lead to a casuistry which minimizes the seriousness of sin. So the differences are not all verbal. There is in particular a sensitive "Protestant conscience" which sees sin with a more uneasy awareness of omnipresent human guilt than most Roman Catholic moral teaching would be comfortable with.

Luther saw the principal locus of the divine grace which attacks the power of original sin in the verbal proclamation of the gospel. We must be saved by faith alone, because original sin keeps us from ever perfectly fulfilling the moral law and "earning" salvation by our own works and merits. Hence he translated the Bible and the Mass out of Latin into the language of the people, and strongly emphasized the role of the sermon in Christian worship, so that people could actually hear the gospel preached. Nevertheless, both Luther and the Lutheran churches continued to take the sacraments of the church with total seriousness, as anyone can see who has ever attended a Lutheran service. Christ to Luther was truly present "in, with, and under" the bread and wine of the mass, even though he rejected the technical Aristotelian terminology of transubstantiation. Furthermore, Luther himself in his 1520 treatise *On Faith* saw the mystical solidarity of the believer with Christ in terms as concrete as the Eastern Orthodox doctrine of the mystical solidarity of the redeemed humanity. The corporate nature of the body of believers, bound to Christ by faith and to one another through the sacraments, was (and is) as real to Lutheranism as it was to any part of the preceding Catholic tradition.

In the next generation after Luther, the Protestant Reformer John Calvin set forth an even more tightly argued Augustinianism than his predecessor's. After Adam's fall, the image of God in man was not totally lost, but so corrupted that all human beings were in the grips of a "total depravity." By this Calvin meant not that human beings were totally evil, but that there was no aspect of their minds or lives which was not touched by sinfulness in some way or another. Saving grace was therefore a totally free and unmerited gift of God. There was no condition which human beings should or could fulfill in advance, and no genuinely autonomous reponse that could be required of them, because anything good at all was the work of God in them and not their own work. Hence Calvin followed Augustine in teaching that the decision as to which human beings were to be saved and which were to be damned was a matter of "predestination," that is, it was determined in advance by a totally arbitrary decision of God's.

From the time when the sixteenth-century Reformation began to establish itself in England, the Anglican church has normally been divided between one wing, which was rather Calvinist-leaning and, on the other side, a very catholic wing. One of the most interesting theologians from this tradition was John Wesley, who was both a fellow of Lincoln College at Oxford University and a priest of the Church of England. There in the middle of the eighteenth century, Wesley built on his Anglican background to attempt a Protestant-Catholic, eastern-western synthesis. From the western Christian tradition he took an Anselmic doctrine of the atonement and a specifically Protestant (Calvinist) doctrine of justification by faith alone. From the eastern Christian tradition (he was thoroughly read in the Greek fathers of the early church) he took his definition of original sin as a darkening of the understanding, his complete denial of predestination and defense of free will, and his belief that the goal of the Christian life was a kind of dynamic perfection in love in one's present life here on earth. He learned from the New England Calvinist Jonathan Edwards how to preach evangelical revivals in the coal mines and the industrial slums of Great Britain, but combined this with what would later be called a very "High Church" catholic emphasis on the sacraments of the church. Preachers trained in his doctrines

had extraordinary success, both in Great Britain and in the United States, where "circuit riders" on horseback rode into the wilderness and followed the growth of the American frontier westward, even though frequently at the cost of their lives.

Wesley's followers eventually broke with the Church of England and formed the various Methodist and holiness churches. He prefigured in many important ways, however, a movement in the next century which did establish itself securely within the Church of England. This was the nineteenth-century Oxford Movement. Its key leaders came from evangelical backgrounds, and all were associated with Oxford University. John Henry Newman later converted to Roman Catholicism, but Keble and Pusey and many others remained Anglicans.

The goal of the Oxford Movement was to reinstill in the Church of England a respect for Catholic tradition, a patristic theology based on the teachings of the fathers of the early church and, most importantly of all, a renewal of the sacramental sense of the Church as the Redeemed Humanity, united by the sacramental bonds of water, bread, and wine into the living community of faith. The use of medieval vestments and the other traditional Catholic practices emphasized by the Oxford Movement, were ways of emphasizing that salvation for the Christian meant inclusion in the historical community of faith that extended back in a continuous line of tradition to the first apostles.

In the present century the modern liturgical movement has modified both Anglican and Roman Catholic practice even more. The rediscovery, at the beginning of the century, of Hippolytus's *Apostolic Tradition* showed the structure of the mass as it was celebrated at Rome in the early third century, which, combined with second-century material like Justin Martyr's *First Apology,* enabled scholars to reconstruct for the first time the liturgy of the communion service in that period. The Second Vatican Council (1962–65) opened the door for Roman Catholic liturgical scholars to produce a sweeping revision of the medieval Catholic mass, to bring it more in line with the new knowledge of second- and third-century practice. The mass was also taken out of Latin and put in the ordinary vernacular language of the Roman Catholics in each country. This was not done so much for Luther's reason

(which had been to make the proclamation of the gospel intelligible to the common people), but out of the realization that the corporate, communal character of the church at worship could be better realized if every part of the sevice was done in the usual language of the congregation. The new Roman Catholic mass stressed active congregational participation in every possible way. The church as the Redeemed Humanity could only exist when all its members felt themselves to be an organic part of both its communal work and its communal worship.

The various Anglican churches began experimentation with the communion liturgy during this same period with the same basic goals and principles in mind. The central parts of the liturgy in the Book of Common Prayer were often rewritten to bring them more closely in line with Hippolytus's *Apostolic Tradition* and other early Christian liturgical practices. In the reinstitution of the congregational greeting (or "Kiss of Peace," to use the ancient term), in the moving of the altar away from the wall so that the officiating priest was able to face the congregation, and in other changes of this sort, the motive was to emphasize the active participation of the entire congregation in what could then become a truly corporate act of worship. The Anglican and Roman Catholic liturgical reforms began to influence many other Christians during this period as well. There has been a widespread trend as a result toward greater involvement of the congregation in most of the churches which had more priest or pastor-oriented services.

The doctrine of original sin had a quite different history during the last hundred years or so, with a quite different set of issues being raised. The more liberal Christians of the nineteenth and early twentieth centuries did not' like the doctrine at all. They preferred to think of human beings as naturally good, and argued that sin came from the already existing corruption of the societies into which we were born. A child brought up in a slum, or a laborer in a nineteenth-century mill or coal mine, could not be expected to have his native goodness still surviving unblighted after the horrendous social forces for selfishness, irresponsibility, and evil to which he had been subjected. The liberal goal was to produce the Kingdom of God—the perfect human society—here

on earth. In this perfected society, the natural goodness in every human being would be allowed to blossom and flourish without hindrance. The peculiar effect of liberal thought, as can be seen, was that it denied original sin (the traditional Christian image for dealing with one end of this issue) but only ended up affirming all the more the other end, that is, the corporate nature of salvation. The creation of the Redeemed Humanity here on earth *was* salvation itself to liberal Christianity with a this-worldly literalness never seen to that extent before in Christian teaching.

Among most Protestant theologians, the First World War was the death knell to this kind of liberal thought. Those who witnessed the suffering in the trenches found themselves never again able to believe in the natural goodness of man. Karl Barth, Paul Tillich, Rudolf Bultmann, Reinhold Niebuhr, and others of that period founded what was called "Neo-Orthodox" theology. By that they meant the orthodoxy of the sixteenth-century Protestant Reformers, with their emphasis upon original sin and fallen man's incapacity to do any more, even with divine grace, than struggle against his own sinfulness.

All these theologians accepted the findings of modern biblical criticism, and none of them believed in a literal Adam and Eve, but the pure symbolism of the biblical story of the loss of Eden and the corruption of humanity seemed to them the only language strong enough to speak about the actual state of the human race. Human beings were in fact evil, arrogant, selfish, grasping, self-deceiving sinners who killed one another with guns and bombs, and put one another into death camps, and delighted in beatings, lynchings, torture, and rape. The Neo-Orthodox movement simply pointed to the facts of human existence, and insisted that only a universal doctrine of original sin could take the massive solidarity of human sinfulness with the seriousness it demanded. It did not matter whether Adam was a literal, single human being or merely a symbol—the traditional Christian teaching of omnipresent, universal human sinfulness was obviously true to every observed fact.

Something from outside humanity had to break in to counteract the power of sin, the Neo-Orthodox theologians said, because sinful human beings could not and did not even want to save

themselves. This something was the grace of a real, external God who stood apart from this fallen world, and sent Jesus Christ to us as the messenger and mediator of his all-forgiving grace.

The saving work of Christ has therefore been seen at almost every period of history as the transference of human beings from one enormous group of people—those still trapped in the pervasive wickedness of human society in general—to another group of people, the community of the redeemed. The idea of the essential solidarity of humanity, whether in sin or salvation, has always been a part of this teaching.

It is fair to ask, therefore, whether this aspect of traditional Christian teaching really is defensible in terms of the modern world view. One part of the answer is of course clear immediately. If one were to put aside the question of whether Adam was a totally symbolic figure or a real flesh-and-blood human being, and simply asked instead whether most human beings were in fact sinful, the answer would obviously be yes. One need only pick up any history book or any daily newspaper to read about murder, theft, rape, greed, and violence without end. Eyewitness accounts of Nazi concentration camps, Stalinist work camps, slave ships traversing the Atlantic, the Irish potato famine, or a truly sadistic rapist or child abuser, are so sickening to read that the mind is left reeling with a kind of fundamental horror.

But there is a quieter, less obvious sinfulness that is even more widespread. Modern psychiatry, regardless of whether it is Freudian, Jungian, Gestalt-oriented, or what have you, comes up with the same findings over and over again. If a skilled therapist takes the nicest and most proper person one has ever met, and starts that person talking about his goals, his fantasies, his evaluations of his parents and his friends, his hopes and his apprehensions, what invariably emerges is a set of deep, unacknowledged feelings that run the whole gamut of sin in the traditional Christian sense: anger, hatred, jealousy, perverse sexual desires, fear, guilt, and resentment.

A Christian psychotherapist who approached his patients from an eastern Christian perspective would see their problems principally in terms of fantasies and illusions (about both the self and others), and would attempt to lead them toward a more realistic

assessment of themselves and the world. A more Augustinian psychotherapy would see the patients' problems in terms of spontaneous feelings which were attached to totally inappropriate objects and needed to be redirected, and in terms of guilt-based compulsive behavior patterns that could be overcome by resolving the guilt.

The idea of the fundamental solidarity of humanity is also not at all alien to modern thought. This is what makes modern sociology work as a science. Sociology studies the molding effect of the frequently unconscious presuppositions of a society upon its members. No human being is as much of a free individual as he consciously feels himself to be. His ideas, attitudes, and values are drawn from the society of which he is a part to such an extent that he can never be consciously aware of (and rebel against) more than a fraction of these internalized societal presuppositions. The phenomenon of "culture shock" shows in particular how illusory the feeling of our own individualism can be. A student or businessman who works for two or three years in a foreign country unconsciously internalizes the values of that alien culture to such an extent that he at first finds himself a stranger in his own land when he eventually returns home. It takes six months to a year of sometimes acute discomfort to readjust to his own society.

This is why membership in some Christian social unit (church, sect, cenobitic monastery, commune, congregation, study group, or other community) is necessary to the long-term maintenance of Christian values in the life of the individual. A person who is Christian and wishes to remain Christian must band together with other Christians in some kind of group, or eventually fall away. There is no other alternative given to us here.

Our salvation is *through* Jesus Christ, but *in* the community of faith which he formed. The true community is far larger than the individual Christian groups which make it up. It is actually the whole people of Israel, not only the Hebrew people of Old Testament times, but also the New Israel which is the church of Christ across the centuries. This is the Redeemed Humanity to which Christ calls us to join ourselves.

The enormous sweep of the redeemed community, across continents and centuries, is nowhere better made concrete than in the

Christian service of communion. Whenever we partake of the bread and wine, we celebrate our fellowship with all the Christians who have ever served the Lord: the Apostle Paul and all the members of his missionary churches, Justin Martyr, Irenaeus, Athanasius, Basil and Macrina, Columbanus and Boniface, Thomas Aquinas and Francis of Assisi, Gregory Palamas, Luther and Calvin, Teresa of Avila, John Wesley and E.B. Pusey, William Carey and Francis Xavier, Martin Luther King, Jr., John XXIII, and all the countless men and women whose names may have been neglected by the professional historians and writers of books, but whose lives of quiet piety and daily compassion made them indelible and necessary parts of God's own plan for human history. This is the Redeemed Humanity, and we can only pray to be included among their number, for they are the ones who will receive the crowns of glory at the final consummation of human history, when every knee shall bow at last to the Lord of all.

CHAPTER EIGHT

❖

The Easter Faith

Those who have experienced the end of someone very close know the awesomeness of death. All our words and theories ring hollow in the actual face of this event. We can repeat phrases and sentences, but only in a strangely detached manner that does not touch our hearts. It has all the character of a theophany, the manifestation of God himself. The magnitude of what we confront is simply too great to be touched by any human words. The mind recoils within itself in the face of the totally other, the incomprehensibility of the divine abyss which we glimpse through the clinical manifestations of death. For hours afterward, one moves through the dreadful emptiness of grief, moving like a sleepwalker. One moves one's arms and legs, one speaks words, but all with a sense of total detachment. Only the emptiness seems the true reality.

One recovers from grief with time. But the problem of death has confronted the human race since its beginning. The most ancient literary works in every culture struggle with this fact. The Epic of Gilgamesh in ancient Mesopotamia began with the hero watching his best friend die. The problem of death and human finitude was what Homer's *Iliad* was really about. The story of Buddha began when the sheltered prince saw a corpse for the first time. In the modern novel and short story, authors like Conrad and Hemingway struggle with the problem of courage and dying.

Even before written language, the burials of primitive cavemen
show the bones sprinkled with red ochre, the last offering of their
friends in some now-forgotten but clearly formal and solemn
funeral ritual.

Every pastor has discovered that even professed atheists want
Christian funerals for their loved ones. Perhaps our hearts can
know more than our heads. Perhaps our hearts at times of stress
sometimes know how to separate the real message from the verbal
formulation. At any rate, the problem of death raises questions
that every religion or true philosophy must deal with in one way
or another.

The answer given however need not necessarily be cast in terms
of a promise of personal survival after death. For most of the Old
Testament period there was no belief in a life after this one, or a
belief at most in a dark, shadowy underworld where the dead lay
silently in the dust until a sorcerer or medium called up their
ghosts. The Old Testament account of the witch of Endor bringing
up the ghost of the dead Samuel (1 Sam. 28:3–19) was no different
in principle from the story in the *Odyssey* of Odysseus pouring
blood on the ground and calling up the shades of the fallen Greek
warriors to speak to him for a moment. There was a Hebrew
word, *nephesh,* used frequently in the Old Testament and com-
monly translated into English as "soul," but this referred only to
an impersonal, unconscious life force. It could therefore not be
used to speak of any survival of personal consciousness after
death.

At the very close of the Old Testament period, however, a new
concept entered the Hebraic thought-world, that of the resurrec-
tion of the dead. It was one of the ideas associated with the
movement called apocalypticism. There was still no idea of any
sort of "soul" which could live and be conscious apart from the
body. But the apocalyptic teaching was that this present world
would be destroyed by God in the near future, and that all the
dead bodies in the graves would then be brought back to life.
There would be a judgment, and those who had been wicked
would be thrown into a lake of fire or otherwise punished, while
the righteous would be allowed to live at peace in a new earth
which God would then create. It would be like the Garden of Eden

once again. People would have flesh-and-blood bodies, eat, drink, and have children. The plants would yield food without human work or cultivation. This new idea was first taught clearly in the book of Daniel (12:2), written between 168 and 165 B.C. A passage in Ezekiel (37:1-14) may indicate that apocalyptic doctrines were known earlier, but they did not become a major force until there in the second century B.C. when Daniel was written.

The new apocalyptic teaching, with its idea of the resurrection of the dead, dominated the Jewish writings of the intertestamental period, including the famous Dead Sea Scrolls. In Palestine in the early first century A.D. the major Jewish group called the Pharisees also believed in the new teaching, although the more conservative Sadducees rejected it, and continued to hold to the earlier Old Testament belief that there was no life after this one.

The authors of the New Testament came out of this apocalyptic Jewish background, with its belief in a last judgment and the resurrection of the dead. It is continually taught or alluded to in the New Testament. But to complicate matters, Christianity was also influenced at a very early point by Greek philosophical ideas on this topic.

The idea of an immortal soul first appeared in the Greek world in the teachings of the mysterious Orphic movement, which emerged in the sixth or seventh century B.C. The soul—divine and eternal—was good, whereas the body *(sôma),* made of the ashes of the Titans, was an evil tomb *(sêma)* which imprisoned the true soul-self. Only with death would we be liberated into true consciousness. Pythagoras and Plato elaborated this into the classical Greek philosophical notion of an incorporeal, immortal soul which would be reincarnated again and again in a whole series of lives on this earth.

The normative Catholicism of the Middle Ages developed a synthesis of these two strands of thought, the Platonic doctrine of the natural immortality of the soul and the Jewish apocalyptic idea of the resurrection of the dead. Thomas Aquinas, for example, taught that the human soul was immortal, and that it separated from the body at death and continued to maintain an incorporeal but conscious existence until the Last Judgment. At this time its body would be resurrected from the grave and

rejoined to it, for either eternal bliss or eternal suffering in hell. Dante likewise maintained this basic, normative Catholic teaching, though mixed in his case of course with a very medieval view of the structure of the cosmos. In his *Divine Comedy* the souls of the saved rose up after death to the spheres of the seven planets which surrounded this earth. Each soul went to its appropriate sphere in heaven: the warriors of God went to the sphere of the planet Mars, for example, while the souls of the great contemplative mystics dwelt within the sphere of the planet Saturn. At the time of the last judgment, however, all these souls would be reclothed in perfect flesh, more radiant even than their present disembodied celestial form (*Paradiso* 14.43–66).

The problem for this medieval synthesis came in the seventeenth century, at the beginning of the modern era. The new physics of Sir Isaac Newton and the new philosophical psychology of John Locke (the real father of contemporary behaviorist psychology) seemed increasingly to many thinkers to leave no room for an immortal soul. With the rejection by the new science of Aristotelian notions of substance and the Platonic concept of eternal forms, there was no longer even a good vocabulary for talking about any kind of immortal soul.

By the beginning of our own century, the problem had become great indeed. The most common contemporary argument against personal immortality, for example, would run, in oversimplified form, as follows: The human brain is composed of neurons linked by synapses. What we call human thought is simply the flickering of minute electrical charges and changing chemical levels within these brain cells. If one took an electronic computer and destroyed the metal wiring and transistorized elements, the memory banks and programs of that computer would cease to exist. How then could the disintegration of human brain cells after death have any different effect?

There is no broad Christian consensus at present on how to handle the problem that modern science has raised on this point. Many Roman Catholic teachers continue to defend the Thomistic concept of an immortal soul by attacking the presuppositions of the more naively empiricist philosophers of science. A strong current of Protestant fundamentalism upholds the apocalypticism

of Daniel and Revelation, preaches the rapid coming of the end of the world, and attacks the findings of modern science across the board. One strand of Protestant liberalism denied personal immortality but encouraged people to seek a different kind of immortality by devoting their lives to the perfectibility of human life on this earth.

An important group of Christian existentialists taught that the awareness, at the real existential level, of the inescapability of death as the final, total end of each person's life, was the freeing insight that librated us to live authentically in the finite lifespans which we were in fact given. But another strand of Christian existentialism, beginning with Pascal, insisted that one must take the leap of faith and accept the risk of belief in God and immortality in spite of the ultimate lack of this-worldly guarantees. The process theologians, following Alfred North Whitehead and Charles Hartshorne, took a totally different approach: they argued, on the grounds of their process metaphysics, that each moment of our lives will necessarily be included eternally in the ongoing becoming of God; it is true that we are not given consciousness after death, but nothing of what we have been or done will ever be lost. To increase this rather incredible spread of ideas, I have found that a surprisingly large number of my own university students, Protestant and Catholic alike, believe strongly in the transmigration of souls.

It is this unbelievable diversity of modern beliefs about life after death, together with the major historical shifts within the Judeo-Christian tradition itself over the past three thousand years, that makes it difficult to speak about the resurrection of Christ today. It clearly fits most easily into the thought-world of first-century Jewish Palestine, where the apocalyptic doctrine of the end of the world and the general resurrection of the dead permitted one to speak of Christ's rising from the dead as merely the first-fruits of a physical return to life which was promised to all humanity at the end of time. Jewish apocalypticism also regularly associated the appearance of the Messiah with the period of the end of the world.

There were ideas current in the pagan world in the first century A.D. which also furnished some sort of background for the

Christian doctrine of Christ's resurrection. One of the standard mythological motifs of the pagan world was that of the dying and rising god. In Greek mythology Persephone went down to the underworld to be the wife of Pluto for six months out of every year. The vegetation on earth withered and died. Then she rose from the land of the dead to return to earth, and the plants and flowers bloomed again in their yearly cycle. In Phoenicia it was the god Adonis who died and rose again every year. In Egypt the myth of Isis and Osiris told of the return from the dead of Osiris in the form of his son Horus. In Babylonia it was the goddess Ishtar who went down to the land of the dead and then returned. The cycle of Heracles stories in Greek mythology had a number of other variants on this theme: stealing the three-headed dog which guarded the gates to the underworld, and obtaining the golden apples of the Hesperides, among others.

The pagan idea of the divine man, which was also part of the first-century background, has already been discussed in an earlier chapter. He was frequently said to have ascended to heaven at death, and stories of resurrection appearances were not uncommon: Romulus, Apollonius of Tyana, and even (though this was said in satire) in Lucian's *Life of Peregrinus.*

The ancient pagan world was therefore very familiar with the idea of a god or divine man who died and rose again, appeared to certain of his selected disciples after death, and ascended into heaven to reign as a god. This, coupled with the Jewish apocalyptic teaching that the Messiah would appear just before the end of the world to herald the general resurrection of the dead, furnished the basic background out of which the teaching of the New Testament appeared.

But God's act in Christ was too profound, too complex, too different from anything that had ever happened before, for it to be described so simply. The authors of the New Testament took these preexisting categories of thought and broke all their boundaries and presuppositions. What Christ was and did was too great to be explained literally in any normal human categories. Jesus was the Messiah, they said, but he did not lead an Israelite army in battle against the Romans. He was sacrificed for our sakes, they taught, but he was executed as a common criminal and was not

literally slain by a priest on a stone altar. He was the Word of God, but in total paradox he was a word made out of flesh instead of vibrations in the air. He triumphed over death, but unlike the dying and rising gods of most ancient mythologies, he did not do so to make the wheat sprout and the flowers bloom every spring. He "ascended to heaven," but not in the physical pagan sense, where it meant literally becoming a visible star or constellation, or at least part of the flowing Milky Way.

In the Myth of Er at the end of Plato's *Republic,* a Greek soldier came back to life after apparently being slain in battle, and gave a detailed account of all the workings of the life to come: the judgment, the punishments, the Three Fates, the selection of new lives by those who were to be reincarnated, the drink from the River of Forgetfulness just before being reborn. Jesus' resurrection appearances were totally different. The appearances recorded in the New Testament taught absolutely nothing about life after death, not even a hint of a detail. They served a totally different purpose and function, which broke through all the old categories of human thought even when they seemed most dependent upon them.

It was customary in an important strand of early Christian theology to insist that we had no truly literal knowledge of God. It was called the apophatic-cataphatic method, or in the west, the *via negativa.* It might be very useful to apply this same method to many of our statements about Christ, particularly when he is regarded as divine or the agent of God, because the same epistemological problems apply to speaking of God as savior which apply to speaking of God in any other function. In this method one must first show (in cataphatic fashion) what the symbols literally mean which are used to describe Christ's saving work, and what spheres of human life they come from. Then, in apophatic fashion, one negates them by showing how, qua symbols, they also in fact cannot be taken literally. Only by this combination of simultaneous affirmation and negation can one gain an intuition of that reality which the symbols point toward rather than literally describe.

One must read the New Testament accounts of Christ's resurrection in this way. These were people attempting to use human

language to describe a cataclysmic implosion of the power of God into this world. But one can never describe God literally—such a God would be an idol. One can only tell stories, use symbols, call up analogies, and try over and over to point people in the right direction, saying constantly, "Look, look, God is there, only you must see him yourself to know what he truly is."

If this is so, it helps to explain why the New Testament speaks in so many different ways about Jesus' resurrection. It might be useful to outline briefly at this point what some of those ways were.

The earliest written witness to the resurrection was the apostle Paul, since his letters were composed between 50 and 60 A.D. approximately, whereas the gospels were probably not written until somewhere between roughly 70 and 90 A.D. At one level Paul spoke in very physical terms, taken from the language of Jewish apocalypticism, with some admixture of the kind of contemporary late Stoic ideas seen in Seneca's *De consolatione ad Marciam.* The preexistent Messiah came down from heaven and took on human form in Jesus of Nazareth (Phil. 2:6–11). He was crucified, dead, and buried, but then rose from the dead and appeared to his disciples and to Paul (1 Cor. 15:3–8). At the end of the world the dead will come back to life, but in "spiritual bodies" *(sôma pneumatikon)* instead of the "physical bodies" or "ensouled bodies" *(sôma psychikon)* which they had here on this earth before death (1 Cor. 15:44). After their resurrection, the righteous dead, together with Christ's followers who are still alive at the end of the world, will be lifted up into the clouds to see the Messiah, coming back down from heaven to meet them in mid-air (1 Thess. 4:16–17). Even here, of course, Paul never mentions any story of an empty tomb after Jesus' resurrection, and given the fact that he regards the resurrection as spiritual, not physical, there would have been no reason why the purely physical body of Jesus could not have remained buried somewhere, as far as Paul's own understanding of the matter was concerned.

And Paul's thought also works at a very different level from this concrete apocalyptic schematization. It must be remembered that the account of Paul's conversion to Christianity given in Acts (9:3–19, 22:5–16, and 26:12–18) was written somewhere roughly

between 70 and 90 A.D., almost two generations after the event. The consensus of most modern scholarship is that the author of Acts, contrary to the tradition which first appears in the late second century, was not a companion of Paul and had no first-hand knowledge of the apostle's life or writings. When one then turns to Paul's own account of his experience of the resurrected spiritual Christ (Rom. 8:9 — *Pneuma Christou)* there is no mention of voices, visible light, blindness, or scales on his eyes. In 1 Corinthians 15:5–8, he simply uses the bare word *ôphthê,* "appeared," four times in a row, with no further explanation. In Galatians 1:12 and 16, he uses the the noun *apokalypsis* and the verb *apokalyptein,* which refer to a "revelation," or the uncovering of something already there but hidden in such a way that it could not be seen. In other words, based on the common experience of devout Christians in our own period, it seems very likely that Paul had what a modern revivalist would call a conversion experience, where he suddenly realized or "saw" in his heart, with an overpowering conviction, that Christ's death applied to him too.

The incredible power of Christ that Paul suddenly realized at the moment of his conversion is also available, he says, to anyone who is converted to Christianity. It is the power of Christ to bring any one of us from death to life, where "death" means the kind of life on this earth where we are sunken deep in our sins, ruled by our basest emotions, slaves of our bodies, at enmity with God, and trying to win our own salvation by simpleminded legalisms and meaningless, mechanical works of piety. "Life" in this sense means the opposite: living here on this earth filled with divine grace, the knowledge of forgiveness, and the spirit of God's love. When Paul speaks of Christ being resurrected from death to life, this is the second level of meaning on which those terms operate (Rom. 6:5–13 RSV, compare 4:24–25, 5:10–11, 5:17, 6:3–4, 7:4–6, and 8:9–10):

> For if we have been united with him in a death like his, we shall certainly be united with him in a resurrection like his. We know that our old self was crucified in him so that the sinful body might be destroyed, and we might no longer be enslaved to sin For we know that Christ being raised from the dead

> will never die again The death he died he died to sin, once
> for all, but the life he lives he lives to God. So you also must
> consider yourselves dead to sin and alive to God in Christ
> Jesus. Let not sin therefore reign in your mortal bodies, to
> make you obey their passions. Do not yield your members to
> sin as instruments of wickedness, but yield yourselves to God
> as [those] who have been brought from death to life.

Paul's second level of meaning, in other words, interpreted resurrection from death to life as a repentance and a conversion in the same sense in which the term was used in the parable of the prodigal son (Luke 15:24 RSV): "For this my son was dead, and is alive again; he was lost, and is found."

The Gospel of John read the resurrection in even more symbolic terms. A large part of the New Testament speaks normally in terms of a "future eschatology," that is, the literal Jewish apocalyptic notion of a judgment and a resurrection that will come for all the world simultaneously at some specific historical date in the future. But John in particular speaks instead in terms of a "realized eschatology," in which Judgment Day comes whenever an individual human being hears the message of Christ and rejects him, and the Day of Christ's Resurrection comes whenever an individual hears the message of Christ and accepts him as the light of God (John 3:18-19, 5:24, and 6:47, noting the tense of the verbs). For John, in other words, Easter, Judgment Day, and even Pentecost all come on the same day—the hour and day in which any human being is confronted by Christ and must decide for or against him.

For John, "eternal life" is a specific technical phrase. It means something the true Christian already has. It does not mean going to heaven after death. He defines it in 17:3 (NEB): "This is eternal life: to know thee who alone art truly God, and Jesus Christ whom thou hast sent." The key word is knowledge. That is, eternal life for John means living continuously in the immediate knowledge of God's presence. God has always been here; he has always been present with us. But Jesus came to open our eyes to this presence, and it is the Easter resurrection, the triumph of Christ, whenever a human being is brought to saving awareness of the eternal living presence of God's love through Jesus' words and deeds.

The celebration of Easter is simply a way of stating unequivocally that Jesus' death was not a defeat but a victory, not a tragedy but a triumph, for "I lay down my life of my own free will" (John 10:18). John has Jesus proclaim, "When you *hypsôsête* the Son of Man you will know that I am what I am" (John 8:28 NEB, compare 12:32). The Greek verb is a pun. It means to "lift up," that is, to crucify on the cross; but the same verb also means to "exalt," to raise to the heights of glory and victory. That is what the Easter faith means to John.

The Gospel of Matthew, in its final chapter, speaks in far more literal terms. Matthew 28:1–15 tells the story of the discovery of the empty tomb on Easter morning, and verses 16–20 recount a resurrection appearance of Jesus to the eleven disciples in Galilee. Twentieth-century form critics have argued that the resurrection appearance story has to be from the earliest Christian tradition, since it also is referred to in Paul's first Letter to the Corinthians (15:5), but that the account of the Empty Tomb was a later legendary accretion, appearing presumably after the almost total destruction of Jerusalem and the surrounding area by the Romans in the great Jewish War of 66–70 A.D. More conservative modern scholarship has taken the story of the empty tomb more seriously, of course, about which more will be said toward the end of this chapter.

Luke has the same combination, the account of the discovery of the empty tomb on Easter morning in 24:1–11, and then a resurrection appearance, but a different one, on the road to Emmaus. It is important to note the actual function of the resurrection stories in both Matthew and Luke. The resurrected Jesus does not give a detailed account of life after death, as the revived soldier did in Plato's Myth of Er. In Matthew the resurrection appearance gives the command to do missionary work in all the world, and promises that the personal power of Christ will always be with his disciples. In Luke the resurrection appearance gives the power to understand the true meaning of the Old Testament, and again, the continuing personal presence of Christ is promised, revealed to his disciples in the breaking of the bread, that is, in the sharing of bread and wine in the Christian eucharistic service.

Orthodox Christian theologians of the patristic and medieval

period usually assumed that the tomb was empty on Easter morning, and that the dead body of Jesus came back to life. But they also spoke regularly of the continued presence of the resurrected Christ, and the Christian hope of triumph over death, in ways that went beyond the purely physical language of Jewish apocalypticism.

In the fourth century, for example, the great church historian Eusebius of Caesarea became involved in an argument with a pagan named Hierocles, who insisted that Apollonius of Tyana, not Jesus, was the true divine man. It was claimed by pagans, one remembers, that Apollonius had also healed the sick, cast out demons, ascended into heaven at the end of his life, and came back in a resurrection appearance. Eusebius's central argument was that the followers of Christ, unlike the pagan followers of Apollonius, had spread over the entire known world in spite of persecution, a frequent lack of sophisticated philosophical education, governmental opposition, and every other possible hindrance. The incredible power of Christ continued after his death and appeared over and over again in the lives of his followers, even centuries later. There could be no greater proof, Eusebius stated, that Jesus was the true divine man. He was crucified, but he still lived.

Although Plato himself had been willing to speak in quite concrete terms about the nature of life after death, and the adventures of our souls through the thousands of years they spent there, he also stated explicitly that this was a "myth," a "likely story." In fact, on the grounds of Platonic metaphysics, talk of our souls having adventures and temporal experiences in the hereafter was totally impossible in any but completely symbolic fashion. Plato's fundamental assertion was that the soul at death went to the eternal realm, and eternity for Plato was the opposite of time. The soul could not have a sequence of adventures, where a series of different things happened, unless it was involved in time and temporality.

Many Christian Platonists in the patristic and medieval period understood this, and although they were willing, like Plato, to speak mythologically or symbolically when it was required, they knew that on Platonic grounds the soul at death was reabsorbed

into the eternal vision of God. Death was a journey back into the light of God's goodness, where neither time nor space existed any more, only the eternal awareness of a brightly shining love and infinite goodness. It was something like this which was being prayed for in the well-known lines sung repeatedly as a binding theme throughout the course of the Roman Catholic mass for the dead:

> *Requiem aeternam dona eis, Domine,*
> *et lux perpetua luceat eis.*

> Eternal rest grant to them, O Lord,
> and let perpetual light shine upon
> them.

And strictly speaking, in Platonic terms, since death is an event in time (the very hour and minute can be noted on an official death certificate), the eternal soul, qua eternal, could not experience death at all. It was at its roots very similar to the classical Buddhist concept of Nirvana, where one can ask neither where Nirvana is or how long it lasts, or which "way" (spatially) the self goes when it enters Nirvana.

The traditon of Greek patristic and Byzantine theology that spoke of salvation as re-creation in the eternal hypostasis of God the Word also provided a kind of immortality, though not thereby a consciousness after death. If I have totally bound my life and will into God's own plan for human history, then all my individual, personal contributions to God's work will form a necessary and intrinsic part of his plan. Nothing that I do will be lost or without eternal meaning, even if no other human being is consciously aware of my contributions. My immortality comes from participation in that which is truly immortal—God's project for his creation. As suggested before, modern process theology uses a different metaphysics to offer a closely analogous solution.

One strand of Protestant liberalism also moved in this basic direction. The person who devotes his life to working for God's kingdom here on this earth will find that his life was not in vain,

because at some point in the future that perfected human society will finally be brought to reality. The question of whether my own personal consciousness will continue after death in some life in another realm is not really the central psychological problem about dying—it is rather the question of whether something that I have done or accomplished will live on after me. That is why men and women write books, why fathers want their sons and daughters to continue the family business, why the wealthy want buildings and universities named after them, why the elderly treasure their grandchildren so much, why people buy life insurance, why in their wills they bequeath treasured personal mementos to friends, why it is so psychologically important to those who know that they are dying to "put their affairs in order."

But the truly crucial problem for the modern period has been what to do with the story of the Empty Tomb. If asked whether the body of Jesus still lies buried somewhere in Palestine, the vast majority of modern New Testament scholars would answer yes. There are still quite a substantial number of scholars who would answer no, however, as would undoubtedly a majority of ordinary Christian laypeople. Quite a few of those laypeople, though, who would say that they believed that Jesus' body came back to life, would have a surprising amount of inner doubt and uncertainty lying behind their affirmation. The official position of most Christian churches is clear—Roman Catholic, Anglican, Orthodox, Lutheran, Presbyterian, or what have you—the tomb was empty on Easter morning because the body was raised back to life by God. But official church dogmas do not ease the *de facto* tension and dichotomy articulated in most modern theological writings and felt more inarticulately by an enormous number of laypeople at the present time.

Some well-marshalled arguments have been advanced in this century by theologians who have insisted that the New Testament reports of the empty tomb have to be taken seriously. They are summed up very well by Van A. Harvey in *The Historian and the Believer* (together with a good account of the historical development of the debate over the past 150 years), even though that author ultimately argues against them, using modern Anglo-American linguistic philosophy.

This modern argument for the reality of Christ's physical resurrection begins with the observation that all historians have presuppositions which color their writings and their judgments. A Republican writing about the presidency of Franklin D. Roosevelt may have exactly the same data as a Democrat also writing on that same topic, but their conclusions will often be extremely different. An economic historian, who believes that broad social and economic forces totally determine the course of history, will give a completely different interpretation of the French Revolution and Napoleonic era from a historian who believes that individual human decisions (of some of the key leaders at least) also shape the course of events. There is no such thing as a neutral history; some kind of presuppositions are always involved.

Likewise, this argument runs, many modern secular historians begin their analysis of the historical data about Jesus' resurrection with the presupposition already established in their own minds that such a resurrection would be physically impossible. Their so-called historical proofs that such a resurrection did not occur are not proofs at all, and do not involve a true reading of the data, but are simply the reemergence of the presuppositions already built into their analysis at the beginning.

This sort of modern secular historiography, according to their argument, begins with a particular view of scientific methodology which inescapably commits them to discounting the possibility of a man rising again from the dead. The model of scientific procedure that they assume is one which makes sense for chemists, physicists, and psychologists who run rats through mazes. Scientific proof, in that model, is based upon reproducibility of results. If a chemist says that he mixed chemicals A and B in such and such an experimental setting, and obtained chemical C as a reaction product, then it is not regarded as proven until other chemists have tried the same experiment in their labs and gotten the same results. The problem with this understanding of scientific method, according to the argument, is that it automatically removes most of history from scientific analysis, because history is made up of unique events. The Bolshevik revolution in Russia in 1917 cannot truly be reproduced in a laboratory experiment, nor could one put Mark Antony and Cleopatra together again in a controlled

environment to see if they would automatically fall in love. The resurrection of a man who had been dead for three days is in particular a totally unique event, but if an event is regarded as unhistorical simply because, and only because, it never happened before or since, then practically nothing of history will be left.

The true problem in knowing how to deal "scientifically" and "objectively" with the resurrection may lie even deeper however. The Italian film director Pasolini, though not himself a believer, made a memorable movie version of the Gospel according to St. Matthew. Unlike most cinematic lives of Christ, he made no major insertions of detail to provide background or continuity. He simply presented the stark, disconnected scenes of the gospel narrative itself one after another, with often ghostly lack of context and with the gospel's own jarring, choppy transitions from one time and locale to another. The power of the movie is magnified by this technique, which simply lets the gospel speak for itself. When the empty tomb finally appears on the screen, the deep rumble of the African drums of the Missa Luba suddenly starts up on the soundtrack, and a deep chill runs down the viewer's spine. Pasolini was right. There is something primitive and frightening here. It is not comforting or reassuring; not the validation of the thin veneer of "civilized" beliefs. It is a warning. It is the ominous rustle of footsteps through the leaves in the darkness beyond the campfire, and the sudden roll of jungle drums in the night from the unknown forests ahead. It is primeval power, raw, age-old, primitive, and it does not necessarily follow our civilized rules of behavior.

If miracles do occur—if there are gaps appearing in the fabric of scientific knowledge from time to time that show the unknowable abyss yawning for an infinite depth below—then it is right to be frightened. Whether miracles occur or not, our scientific explanations are in fact a very thin layer over the top of reality, not supported on any end by anything that rational investigation can disclose. As Tillich pointed out, that was the real meaning of Thomas Aquinas's five proofs for the existence of God. They raise the question of being and of nonbeing; they do not answer it. We give our rational explanations of why things are, but when we look over the edge, we feel the vertigo of the primeval fear of falling, as we gaze down into the unfathomable depths below.

At the other end of the spectrum of modern Christian thought, one has the Christian existentialist Rudolf Bultmann and his program of "demythologizing" the New Testament. The word "myth" here is used in the sense in which it would be employed by modern scholars in comparative religion: Mircea Eliade, for example, and also people like Carl Jung and Paul Ricoeur. It does not mean a story which is not true, but to use Bultmann's language, an attempt to speak symbolically about "the other-worldly in terms of the this-worldly." Heaven is not literally above us spatially, nor hell a specific number of miles below the earth's surface. But how else can one speak about the otherness of God, and our human encounter with him, than by symbol, metaphor, and analogy? The only other route is through philosophy, and Bultmann believed that the existentialist philosopher Heidegger could give the same base to modern Christian thought that Plato had given to Augustine's theology in the fifth century, and Aristotle to Thomas Aquinas's in the thirteenth.

Bultmann said that New Testament language about a literal, physical coming back to life of Jesus' body, and a literal, historical end of this world in divine fire, was mythological. Modern human beings could not believe in these myths as literally true. But if one asked what the immediate existential crisis would be if someone did believe that the world was coming to an end at almost any moment, the answer is that one would have feelings of having all one's worldly security chopped out from under one, of having to confront the reality of one's own death, of having to bear the guilt of all that one had not done, of suddenly having to take serious responsibility for one's own actions, of being cut loose from all this-worldly standards of behavior and propriety and social rectitude, and of being open for the first time toward seeing other people as they really were. At the immediate existential level, the New Testament teaching of the imminent end of the world could be translated directly into the language of twentieth-century existentialism—Heidegger, Sartre, and Camus. What they gave was simply a modern version of dying with Christ and being freed from the law.

There are two extreme positions at either end of the spectrum of modern Christian belief therefore, one represented by those

who believe that Jesus' body came back to life on Easter morning as a guarantor of our own eventual resurrection, and the other represented by the Bultmannian position. But it must be asked what is truly at stake on both sides.

Salvation itself in the biblical understanding is not the going to heaven. This is a Victorian distortion. The fear of death is very closely tied to our salvation however, because it is one of the major roots of sin. When fear of death overwhelms us, we try to fight against it by attempting to build a this-worldly security based on power, money, and control. We refuse to take risks. We try to be "good" as the conventions of society define the rules, in the subconscious hope that if we are good, we will not be punished or abandoned. We torture other people and tyrannize over them to try to delude ourselves into believing that we are in total control of life and death. None of this really works, of course, but fallen humanity still continues to try to hide from its overwhelming fear of death by lying to itself and deceiving itself about the reality of death and finitude in this world. Hence all our other attitudes toward the world become sinfully distorted as they get bound up into the lies and self-deceptions.

Being willing to face the necessity of one's own death openly brings a marvelous freedom and honesty. By dying with Christ one is freed from the law. One is given the freedom to consort with tax collectors and sinners if necessary, without worrying about the hostility of the socially proper Pharisees. One is given the ability to die for another person. One is freed from overwhelming greed for wealth and power. One is freed to be open to other people without continually trying to defend oneself against them. Being able to confront one's own death honestly does not make a person a Christian per se, but it is a necessary precondition if one is going to be able to act like a Christian in this world.

The two poles of contemporary Christian belief simply approach this problem from opposite ends. Those who insist that our bodies will live again in another world know that the thought of the irrevocable death of our bodies paralyzes us with fear. By proclaiming the salvation of our bodies from ultimate destruction, we are also freed spiritually to live and act like Christians.

The existentialists start from the other end, with the necessity for a spiritual freedom, but they know that this is the crucial point because otherwise the thought of the irrevocable death of our bodies will paralyze us with fear and make us unable to live and act like Christians.

From whichever end one wishes to argue it, or at any point in between, the resurrection of Christ stands for the human possibility to triumph over the dreadful power of death. Death may make us feel fear—as even Jesus cried out in the Garden of Gethsemane—but it need not make us sinners and damn our entire existence to the writhing, tortured lies of hell. The characteristic Eastern Orthodox icon of the *Anastasis* (the resurrection of Christ) shows him with a flail in one hand, driving back a ravening pack of demons as he once drove the money-changers from the temple. With the other arm he shields us, the saved, behind him, as a mother would shield her children from danger with her own body. The demons symbolize the power of sin to make us writhe inside our minds with unbearable agony and despair. The power of the resurrection is the power to confront those demons, name them, and bring them once more into submission to God.

In the preceding chapters, we looked at all the things that Christ does for us. And as in the liturgical calendar of the church itself, Easter here brings us to the triumphant conclusion of the full cycle of the Christian message. Jesus voluntarily gave himself as a sacrifice on the cross, but Easter tells us that his self-sacrifice was not a defeat; it was the ultimate victory over sin. He was the Messiah, and although the Messiah had to suffer and die, Easter tells us that he was still the Christ, the true King of Israel. He was the Word of God, and at Easter we remember what Second Isaiah said (Isaiah 40:6 and 8, RSV):

> *All flesh is grass,*
> *and all its beauty is like the flower*
> *of the field.*

> *The grass withers, the flower fades;*
> *but the word of our God will*
> *stand for ever.*

He brought us the vision of God, and although a man died on the cross, at the Easter resurrection the vision of God burst forth again from his shrouded corpse. He was a human being, who ate and drank and walked on this earth, but he was also God, and God cannot die. He came to free the whole world from its sins, and incorporate all who follow him into the Redeemed Humanity, which Easter tells us is the *living* body of all who know the Lord, with Christ himself as its head.

In the gospel accounts the resurrected Christ speaks to us. He tells each of us, "Feed my sheep" (John 21:17). He shows us how to read God's plan for all of history (Luke 24:44–47). He commands us to preach the gospel of God's love to all the world (Matthew 28:19–20, Luke 24:47). He tells us he will still be present with us, every time, "in the breaking of the bread" (Luke 24:30–35, John 21:9–14). And he promises us, "Lo, I myself am with you always, even to the end of the world" (Matthew 28:20).

Or as the apostle Paul sums it all up in Romans 8:35–39 (NEB):

> Then what can separate us from the love of Christ? Can affliction or hardship? Can persecution, hunger, nakedness, peril, or the sword? . . . in spite of all, overwhelming victory is ours through him who loved us. For I am convinced that there is nothing in death or life, in the realm of spirits or superhuman powers, in the world as it is or the world as it shall be, in the forces of the universe, in heights or depths—nothing in all creation that can separate us from the love of God in Christ Jesus our Lord.

This is the Easter faith, this is the gospel itself: God loves us, and his love can reach to any corner of the universe, to any realm or time that ever existed or will ever come to be. All who call upon this love will be saved by it. "Go in peace," as the traditional benediction says, "love and serve the Lord."

Suggestions for Further Reading

GENERAL REFERENCE

The Interpreter's Dictionary of the Bible, 5 vols. incl. updated supplement issued in 1976 (Nashville: Abingdon, 1962 and 1976). Good, readable summaries of the best modern scholarship (with references to other books for further reading). Articles on individual books of the Bible, people, events, and important concepts such as faith, the divine man, and eschatology.

Oxford Dictionary of the Christian Church, 2nd ed. (London: Oxford University Press, 1974). The most-used book on my own reference shelf.

Johannes Quasten, *Patrology,* 3 vols. (Utrecht: Spectrum, 1950-60). All major Christian authors from the late first century to the fifth, with biography, summary of theological position, detailed comments on each major work, lists of critical texts and all available modern translations, and bibliography of key secondary sources.

Berthold Altaner, *Patrology,* one vol., trans. H. C. Graef (New York: Herder and Herder, 1960). Similar to Quasten, covers down to eighth century.

J. N. D. Kelly, *Early Christian Doctrines,* 3rd ed. (London: Adam & Charles Black, 1965). The best and most dependable general history (for reference use) on Christian doctrine from the close of the New Testament period (c. 95 A.D.) to the Council of Chalcedon (451 A.D.).

Chapter One • THE SACRIFICE ON THE CROSS

NOTE ON ABELARD'S DOCTRINE OF THE ATONEMENT: It should be noted that many theologians regard the doctrine of the atonement presented in Peter Abelard (or Abailard) in the twelfth century as yet a fourth major type of atonement theory, to be placed alongside the "ransom to the devil," substitution-

ary, and physical doctrines. Abelard taught that Christ, by revealing God's love both in his life and in his death on the cross, enabled human beings to trust God and to love God in return. Only an atoning act which is seen primarily as the revelation of love can cause love to appear in return.

A. Victor Murray, *Abelard and St. Bernard: A Study in Twelfth Century 'Modernism'* (New York: Barnes & Noble, 1967). In pp. 117-39 Murray gives a detailed analysis and defense of Abelard's understanding of Christ's atoning work.

Roland de Vaux, *Studies in Old Testament Sacrifice* (Cardiff: University of Wales Press, 1964). Passover, holocaust, communion and expiatory sacrifice; also human sacrifice.

Jacob Milgrom, *Cult and Conscience: The* Asham *and the Priestly Doctrine of Repentance* (Leiden: E. J. Brill, 1976). He argues that the *asham* sacrifice in the Old Testament has to do with the sacred and the profane, while the *hattat* sacrifice deals with the sacred and the impure; that is, the first deals with desecration, the second with contamination.

Sam K. Williams, *Jesus' Death As Saving Event: The Background and Origin of a Concept,* Harvard Dissertations in Religion 2 (Missoula, Montana: Scholars Press, 1975). Williams argues that it was the Jewish concept of martyrdom and the death of the righteous ones which supplied the context for early Christian belief about Christ.

Johannes Lindblom, *The Servant Songs in Deutero-Isaiah* (Lund: C. W. K. Gleerup, 1951). A critique of Christopher North's messianic interpretation of the Suffering Servant; the Servant Songs are metaphorical, symbolic, and allegorical pictures of Israel in exile in Babylon, not eschatological in form.

H. H. Rowley, *The Servant of the Lord and Other Essays on the Old Testament* (London: Lutterworth, 1952). Argues that the Suffering Servant in the *fourth* song (but that one only) does refer to an individual who will come in the future. The concepts of the Suffering Servant and the Davidic Messiah were never brought together however until they were applied simultaneously to Jesus in the Christian era.

Gustav Aulén, *Christus Victor: An Historical Study of the Three Main Types of the Idea of Atonement,* trans. A. G. Hebert (New York: Macmillan, 1951). An excellent and readable introduction for the beginner.

Gregory of Nyssa, *Great Catechetical Oration* ("An Address on Religious Instruction") in Edward Rochie Hardy (ed.), *Christology of the Later Fathers* (Philadelphia: Westminster, 1954), pp. 268-325. Gregory's short, beautifully done summary of the basics of Christian belief. Sections 22-24 discuss his ransom to the devil theory.

Anselm of Canterbury, *Basic Writings,* trans. S. W. Deane, 2nd ed. (LaSalle, Illinois: Open Court, 1962). Contains the *Cur Deus Homo (Why the God-Man)* where Anselm lays out his substitutionary doctrine of the atonement, and other writings.

Rudolf Otto, *The Idea of the Holy,* trans. J. W. Harvey (London: Oxford University Press, 1923). A foundational work for understanding the concept of the "holy" or "sacred" in the history of religions school.

Mircea Eliade, *The Sacred and the Profane: The Nature of Religion,* trans. W. R. Trask (New York: Harcourt Brace Jovanovich, 1959). A good introduction to the history of religions approach to the concept of the "sacred" or the "holy," by one of the formative thinkers of that school.

Chapter Two • THE MESSIAH

J. H. Eaton, *Kingship and the Psalms* (Naperville, Illinois: Allenson, c. 1976). A study of the "Royal Psalms," that is, those psalms in the Old Testament which relate to the role and function of the king; one of our most valuable sources for understanding Israelite kingship.

Aage Bentzen, *King and Messiah,* 2nd ed. rev. by G. W. Anderson (Oxford: Basil Blackwell, 1970). Sacral kingship in the Old Testament and the Ancient Near East is linked here to Near Eastern myths of the Primordial Man, who stood at the beginning of the world, or who exists as an archetypal being in sacred time.

Sigmund Mowinckel, *He That Cometh* (Nashville: Abingdon, 1954). The idea of the Messiah in the Old Testament and later Jewish thought.

Geza Vermes, *The Dead Sea Scrolls in English,* 2nd ed. (Baltimore: Penguin, 1975). An excellent and dependable translation of the actual documents, with a careful explanation of the Qumran community's beliefs.

Abba Hillel Silver, *A History of Messianic Speculation in Israel: From the First through the Seventeenth Centuries* (Boston: Beacon Press, 1959). A famous Jewish scholar looks at the history of Jewish belief in the Messiah.

Gershom Scholem, *The Messianic Idea in Judaism and Other Essays on Jewish Spirituality* (New York: Schocken Books, 1971). A well-known Jewish scholar in the area of gnosticism and mysticism explores the traditional Jewish understanding of the Messiah.

Werner Kramer, *Christ, Lord, Son of God* (Naperville, Illinois: Allenson, 1966). An analysis of the application to Jesus of the three titles "Christ," "Lord," and "Son of God" in the pre-Pauline and Pauline material in the New Testament.

Chapter Three • THE WORD OF GOD

C. H. Dodd, *The Interpretation of the Fourth Gospel* (Cambridge: Cambridge University Press, 1953). Part II, chapter 12 deals with the Johannine concept of the Logos in great detail.

R. D. Hicks, *Stoic and Epicurean* (New York: Charles Scribner's Sons, 1910). An excellent introduction to Stoic philosophy: the universal Logos is God himself in the Stoic's rather pantheistic theological system.

Seneca, *On Providence,* in the collection of his *Moral Essays,* Vol. 1, trans. J. W. Basore, Loeb Classical Library (Cambridge, Massachusetts: Harvard University Press, 1928), pp. 2-47. A famous statement of the Stoic belief that the Logos shapes the providential course of human life.

Epictetus, *Discourses and Manual,* 2 vols., trans. W. A. Oldfather, Loeb Classical Library (Cambridge, Massachusetts: Harvard University Press, 1959-61). The greatest Stoic philosopher of the Late Stoic period; strong emphasis on living one's

life forcefully, positively, and assertively within the ongoing providence of the divine Logos.

John M. Dillon, *The Middle Platonists, 80 B.C. to A.D. 220* (Ithaca, New York: Cornell University Press, 1977). The Stoic concept of the Logos was mediated to early Christianity largely through what is called Middle Platonism—a basically Platonic view of the world expressed partly in borrowed Stoic concepts.

Erwin R. Goodenough, *An Introduction to Philo Judaeus,* 2nd ed. (New York: Barnes & Noble, 1962). Philo, the great first-century Jewish philosopher, interpreted the Old Testament in Middle Platonic terms by speaking of the Logos or "Word" of God as the first stage in the downward flow of God's divinity toward the material world.

G. L. Prestige, *God in Patristic Thought,* 2nd ed. (London: S.P.C.K., 1952). The Christian doctrine of the Logos as member of the Trinity, from the second century to the eighth century A.D.

Origen, *On First Principles,* trans. G. W. Butterworth (New York: Harper & Row, 1936). Origen's Christology, and his understanding of the fall and redemption of humanity.

Robert C. Gregg and Dennis E. Groh, *Early Arianism—A View of Salvation* (Philadelphia: Fortress, 1981). The Arians presented an alternate view of the Logos, as a self-equipped divine mediator who possessed a free will of his own.

Philip S. Watson, *Let God Be God! An Interpretation of the Theology of Martin Luther* (Philadelphia: Fortress, 1947). Still one of the clearest introductions to Luther's theology; see Chapter V on the Word of God.

Karl Barth, *Church Dogmatics,* Vol. 1: *The Doctrine of the Word of God,* Part 1 trans. G. T. Thomson (Edinburgh: T. & T. Clark, 1936); Part 2 trans. G. T. Thomson and H. Knight (same publisher, 1956). In Part 1 he discusses the Word of God as preached, written, and revealed; in Part 2 he discusses the incarnation of the Word in Jesus Christ.

Herbert Butterfield, *Writings on Christianity and History,* ed. with introd. by C. T. McIntire (New York: Oxford University Press, 1979). Butterfield, an influential Cambridge historian, comes up with one of the best solutions to the problem of divine providence anywhere in print. "Providence" in the correct sense always means asking what the moral consequences of past events are in terms of present moral responsibility.

Chapter Four • THE VISION OF GOD

F. C. Happold, *Mysticism: A Study and An Anthology,* rev. ed. (Baltimore, Maryland: Penguin Books, 1970). A hundred pages of simple but very complete introduction, followed by well-chosen selections from thirty important mystics and mystical texts, both Christian and non-Christian.

William Ralph Inge, *Christian Mysticism* (New York: Meridian, 1899; reprinted 1956). A classical study, especially good on the interaction between Christian theology and Platonic philosophy.

W. T. Stace, *Mysticism and Philosophy* (Philadelphia and New York: J. B. Lippincott, 1960). A defense of mysticism, and a sensitive and insightful analysis

of a number of its historical philosophical formulations, by a scholar who uses the techniques of modern linguistic philosophy to clarify the basic issues.

Vladimir Lossky, *The Vision of God,* trans. A. Moorhouse (London: Faith Press, 1963). A beautiful and superbly written introduction to the patristic and later Eastern Orthodox understanding of the vision of God, from Irenaeus in the second century to Gregory Palamas in the fourteenth.

Gregory of Nyssa, *From Glory to Glory: Texts from Gregory of Nyssa's Mystical Writings,* ed. Herbert Musurillo (New York: Scribner, 1961). The introduction, by Jean Daniélou, is an excellent analysis of the major themes in Gregory's understanding of the mystical vision.

Hoxie Neale Fairchild, *Religious Trends in English Poetry,* Vol. III: *1780-1830, Romantic Faith* (New York: Columbia University Press, 1949). A thorough study of the religious ideas of the poets of the English Romantic period.

Friedrich Schleiermacher, *On Religion: Speeches to Its Cultured Despisers,* trans. J. Oman (New York: Harper & Brothers, 1958). The original German edit. appeared in 1799. Religion was based on intuition and feeling, not dogma. It was an attack by the Romantic era on Protestant orthodoxy and eighteenth-century rationalism.

William P. Alston, "Religious Experience and Religious Belief," *Nous* 16 (1982) 3-12. An epistemological defense of the immediate personal religious experience of God by an extremely competent philosopher: norms, reliability, justification, and comparison with the epistemological limitations of sense experience.

John Calvin, *Institutes of the Christian Religion,* 2 vols., ed. John T. McNeill, trans. Ford Lewis Battles (Philadelphia: Westminster, 1960). The foundational work in Calvinist theology. See Calvin on the nature of saving faith, especially Book III, chapt. 2, sects. 14 and 19-20.

Perry Miller, *Jonathan Edwards* (Cleveland, Ohio: World Publishing Co., 1949). A superb intellectual biography of a man who was perhaps the greatest philosophical theologian whom North America has ever produced. Edwards adapted the classical Protestant understanding of justification by faith alone to what would become frontier revivalism.

Jonathan Edwards, *Basic Writings,* ed. Ola Elizabeth Winslow (New York: New American Library, 1966). See espec. *A Divine and Supernatural Light* (pp. 123-134) where he shows that salvation arises from an intuition (an immediate moral/ aesthetic awareness or "sense" rather than a rational demonstration) of the divine "excellency" (what an ancient Platonist would have called the transcendental intuition of God as the Good and the Beautiful).

John Wesley, "An Earnest Appeal to Men of Reason and Religion," in Albert C. Outler (ed.), *John Wesley* (New York: Oxford University Press, 1964), pp. 384-424. Wesley's own stated definition of faith, based on Hebrews 11:1 and repeated over and over in his writings, is that faith is an intuitive awareness, partly analogous to but different from sense perception, of God himself in his light, glory, grace, forgiveness, and love.

Karl Barth, *The Epistle to the Romans,* trans. E. C. Hoskyns (London: Oxford University Press, 1933). The intersection between the two planes, of God's world and our human world, can be proclaimed as a real event, but never "explained"

in terms of our human world. In fact, it is the denial of all our human pretensions of knowledge and control.

Paul Tillich, *The Courage to Be* (New Haven: Yale University Press, 1952). One of the three greatest theologians of the twentieth century describes that absolute faith which can look openly into the abyss of nonbeing and still courageously affirm the power of being.

Martin Buber, *I and Thou,* trans. Walter Kaufmann (New York: Charles Scribner's Sons, 1970). Buber has been widely read by college students for his warm and loving description of God as an intensely personal presence in the universe, and for his insistence that every human being as well must be treated as a Thou, not an It.

Chapter Five • THE HUMANITY OF CHRIST

Hans Jonas, *The Gnostic Religion,* 2nd ed. (Boston: Beacon Press, 1963). An excellent introduction to gnosticism. Strongly existentialist in interpretation; the beginning student should skip the first three chapters.

David R. Cartlidge and David L. Dungan, *Documents for the Study of the Gospels* (Philadelphia: Fortress, 1980). Within this collection is a good selection of actual gnostic texts for the beginning student to read, including the Gospel of Thomas, the Acts of Thomas (and the Hymn of the Pearl), and the Gospel of Philip.

Irenaeus, *Against Heresies,* trans. A. Roberts and W. H. Rambaut in Vols. 5 and 9 of the Ante-Nicene Christian Library (Edinburgh: T. & T. Clark, 1869-71). His major work against gnosticism. There is a good set of excerpts from this rather long work in pp. 358-397 of Cyril C. Richardson (ed.), *Early Christian Fathers,* Library of Christian Classics 1, (New York: Macmillan, 1953).

Lars Thunberg, *Microcosm and Mediator: The Theological Anthropology of Maximus the Confessor,* English revised by A. M. Allchin (Lund: C. W. K. Gleerup, 1965). The most complete work in English on Maximus.

Vladimir Lossky, *Orthodox Theology: An Introduction,* trans. I. and I. Kesarcodi-Watson (Crestwood, New York: St. Vladimir's Seminary Press, 1978). Good on the Christology of the patristic and later Eastern Orthodox periods, especially p. 106 on the vital distinction between the natural will and the gnomic will in the Christology of Maximus the Confessor.

John Baillie, *The Idea of Revelation in Recent Thought* (New York: Columbia University Press, 1956). A small classic, written by a Scots theologian. An excellent and sensitive overview, for either the rank beginner or the advanced, of how the understanding of the Bible as God's revelation has moved from older theories of verbal inerrancy to the modern theological idea of revelation as God's disclosure of *himself* to us.

Albert Schweitzer, *The Quest of the Historical Jesus: A Critical Study of Its Progress from Reimarus to Wrede,* trans. W. Montgomery (New York: Macmillan, 1910). The book that convinced the bulk of New Testament scholars that the old, nineteenth-century quest was impossible because of what it sought and how it hoped to find it.

James M. Robinson, *A New Quest of the Historical Jesus* (London: SCM Press, 1959). Following the lead of Ernst Käsemann's critique of Bultmann, Robinson argued that a new quest was possible, which avoided the insurmountable problems of the old quest described by Albert Schweitzer.

Van A. Harvey and Schubert M. Ogden, "How New Is the 'New Quest of the Historical Jesus'?" in Carl E. Braaten and Roy A. Harrisville, *The Historical Jesus and the Kerygmatic Christ* (Nashville: Abingdon, 1964), pp. 197-242. Attacks Robinson's claim that the new quest is fundamentally different from the old, and overcomes its insoluble problems.

Rudolf Bultmann, *Jesus and the Word,* trans. L. P. Smith and E. H. Lantero (New York: Scribner, 1958). Bultmann uses form criticism, of which he was a major developer, to recover what he believes was the original witness to the words of Jesus. This book served as the jumping-off point for a good deal of the subsequent theological discussion of the historical Jesus.

Joachim Jeremias, *Rediscovering the Parables* (New York: Charles Scribner's Sons, 1966). A classic of form criticism; should be read by any student who regards the methodology as irredeemably negative in its implications.

Leander E. Keck, *A Future for the Historical Jesus* (Nashville: Abingdon, 1971). An excellent analysis of the issues surrounding the historical Jesus in modern theology; his illuminating summaries of the positions held by other contemporary theologians are done with great knowledge, fairness, and skill.

Leonardo Boff, *Jesus Christ Liberator: A Critical Christology for Our Time,* trans. P. Hughes (Maryknoll, New York: Orbis Books, 1978). Latin American liberation theology. Not too difficult for a beginner, but his skillful interpretation of the historical Jesus merits reading by any theologian working on this problem.

Chapter Six • THE DIVINE MAN

NOTE ON HYPOSTASIS: There were two classical definitions of hypostasis in medieval scholastic theology. (The Latin word *persona* could translate either of the two very different Greek words, *prosôpon* or *hypostasis,* but here the latter was meant.) Boethius (c. 480-c. 524) in his *Opuscula sacra,* tract. 5, *Opusculum contra Eutychen et Nestorium* 2 (PL 64.1343) gave the *definitio: "persona est naturae rationalis individua substantia."* "Hypostasis is the individual substance of a rational nature," that is, hypostasis means the individualized *subject* (perduring through time and change) when one is dealing with the sort of being who makes free, rational decisions. Richard of St.-Victor (d. 1173), a Scotsman who was prior of the abbey of St.-Victor in Paris, defined hypostasis in *De trinitate* 4 (PL 196.944-5) as *"intellectualis naturae incommunicabilis existentia,"* "the incommunicable existence of an intellectual nature," where "incommunicable" meant that which could not be held in "common" with others. That is, hypostasis is the unique, purely individual, unshared *existence* itself of a being who thinks and understands.

David R. Cartlidge and David L. Dungan, *Documents for the Study of the Gospels* (Philadelphia: Fortress, 1980). A very good collection of "divine man" material from the ancient world for the beginning student (including an abridged version of Philostratus, *The Life of Apollonius of Tyana,* containing all the important parts).

Moses Hadas and Morton Smith, *Heroes and Gods: Spiritual Biographies in Antiquity* (New York: Harper & Row, 1965). The divine man biography in the ancient Greco-Roman world.

Hans Dieter Betz, "Jesus as Divine Man," in F. Thomas Trotter (ed.), *Jesus and the Historian* (Philadelphia: Westminster, 1968), pp. 114-133. Argues for a Hellenistic "Divine Man" (*theios anēr*) Christology as one separable strand of New Testament thought, alongside a Son of Man Christology, a Preexistent Redeemer Christology, and a Logos Christology.

Glenn F. Chesnut, "The Ruler and the Logos in Neopythagorean, Middle Platonic, and Late Stoic Political Philosophy," in *Aufstieg und Niedergang der Ro chen Welt*, ed. Hildegard Temporini and Wolfgang Haase, Band II 16.2 (Berlin: Walter DeGruyter, 1978), pp. 1310-1332. Briefer version in Glenn F. Chesnut, *The First Christian Histories* (Paris: Beauchesne, 1977), pp. 133-156. The king or emperor as embodiment of the divine Logos in the Hellenistic theory of divine monarchy; important as a model for later Christian doctrines about the divinity of Christ.

Vladimir Lossky, *In the Image and Likeness of God,* ed. J. H. Erickson and T. E. Bird (Crestwood, New York: St. Vladimir's Seminary Press, 1974). The fifth essay, "Redemption and Deification," defends the patristic idea of salvation as deification, and attacks the Western Anselmic doctrine of the atonement as a reductionistic, merely juridical concept of redemption.

R. V. Sellers, *Two Ancient Christologies* (London: S.P.C.K., 1940). One of the best introductions to the two Christological systems—the Alexandrine school and the Antiochene school—which came into conflict at the Councils of Ephesus and Chalcedon in the fifth century.

Richard A. Norris, Jr. (ed.), *The Christological Controversy* (Philadelphia: Fortress, 1980). Contains an English translation of Apollinaris, *On the Union in Christ of the Body with the Godhead* (the earliest one-nature, Alexandrian-type Christology) and Theodore of Mopsuestia, *On the Incarnation* (the greatest Antiochene two-nature theologian in the period before Nestorius and Chalcedon.)

Richard A. Norris, Jr., *Manhood and Christ: A Study in the Christology of Theodore of Mopsuestia* (Oxford: Clarendon, 1963). Explores the roots of the classical Antiochene Christology (with its strong emphasis upon the humanity of Christ) by looking at their understanding of the human soul, its freedom, and its union with the body.

Roberta C. Chesnut, "The Two Prosopa in Nestorius' *Bazaar of Heracleides,*" *Journal of Theological Studies* (Oxford) N.S. 29 (1978) 392-409. Excellent analysis, should be read before turning to any other work on Nestorius and the *Bazaar*—it makes real sense out of both the document and the Christology.

R. V. Sellers, *The Council of Chalcedon* (London: S.P.C.K., 1953). A thorough study of the Council of Chalcedon (451 A.D.), its background and aftermath; its clarity also makes it a good introduction for the beginner.

Roberta C. Chesnut, *Three Monophysite Christologies: Severus of Antioch, Philoxenus of Mabbug, and Jacob of Sarug* (Oxford: Oxford University Press, 1976). The essential theological concerns of the Alexandrian school, with its one-nature Christology, can actually be seen far more clearly in the monophysitism of the period immediately after Chalcedon.

Stanley Hauerwas, *Vision and Virtue: Essays in Christian Ethical Reflection* (Notre Dame, Indiana: University of Notre Dame Press, 1974). An ethics of virtue and character, and the self as story or narrative; many implications for the role of the story of the historical Jesus of Nazareth in the development of the Christian life.

W. Norman Pittenger, *The Word Incarnate: A Study of the Doctrine of the Person of Christ* (New York: Harper and Brothers, 1959). An important and widely published Anglican theologian, strongly influenced by process philosophy, who upholds the classical Antiochene Christology.

John C. Cobb, Jr., *Christ in a Pluralistic Age* (Philadelphia: Westminster, 1975). One of the most important early leaders in process theology. The "Logos" (identified with what Whitehead called the Primordial Nature of God) is the transcendent, omnipresent power of creative transformation and novelty in the universe; "Christ" means the immanence or incarnation of that transcendent power in the world of temporal process in each and every particular instance in which creative transformation and true novelty occurs.

Schubert M. Ogden, *The Point of Christology* (San Francisco: Harper & Row, 1982). A recent book, by one of the most notable early leaders in process theology; very important because he argues convincingly that a Christology must be supported by a metaphysics or it will form a merely mythological assertion which must then be demythologized.

Chapter Seven • THE REDEEMED HUMANITY

Robin Scroggs, *The Last Adam: A Study in Pauline Anthropology* (Philadelphia: Fortress, 1966). The Jewish interpretation of the significance of Adam, and the apostle Paul's adaptation of this to speak of Christ as the new Adam.

David Cairns, *The Image of God in Man* (New York: Philosophical Library, 1953). An excellent historical study, from the Old Testament and pagan Greek background, through such figures as Irenaeus, Athanasius, Aquinas, Luther, Calvin, and Karl Barth.

Glenn F. Chesnut, "The Pattern of the Past: Augustine's Debate with Eusebius and Sallust," in John Deschner, Leroy T. Howe, and Klaus Penzel (eds.), *Our Common History as Christians: Essays in Honor of Albert C. Outler* (New York: Oxford University Press, 1975), pp. 69-95. The City of God and the Earthly City, original sin, and providence in Augustine's theology of history.

Augustine, *The City of God,* trans. M. Dods (New York: Random House, 1950). See espec. Books 12-14 on Adam and original sin, and Books 15-18 on the City of God vs. the Earthly City.

Gustaf Wingren, *Man and the Incarnation: A Study in the Biblical Theology of Irenaeus,* trans. R. Mackenzie (Philadelphia: Muhlenberg, 1959). The image and likeness of God, Christ, recapitulation, and victory over Satan in Irenaeus' theology.

Glenn F. Chesnut, *The First Christian Histories* (Paris: Beauchesne, 1977). Chapters 4-6 discuss Eusebius of Caesarea (early fourth century) and his very Origenistic understanding of the fall of Adam, the redemption of humanity, and

the formation of a Christian society; a typical and influential example of eastern, Greek Christian attitudes towards free will, sin, and salvation.

Werner Jaeger, *Two Rediscovered Works of Ancient Christian Literature: Gregory of Nyssa and Macarius* (Leiden: E. J. Brill, 1954). Part One, Chapter 5 (pp. 70-114) has an excellent discussion of Gregory of Nyssa's theology, particularly his use of a synergistic doctrine of free will instead of a doctrine of predestination.

John Meyendorff, *Byzantine Theology* (New York: Fordham University Press, 1974). The role of icons (religious images) in Eastern Orthodox churches; the image of God in man in Eastern Orthodox theology.

Thomas Aquinas, *Nature and Grace: Selections from the Summa Theologica,* trans. A. M. Fairweather (Philadelphia: Westminster, 1954). Original sin, predestination, grace, merit, faith, hope, and love in the great thirteenth century Catholic theologian.

Martin Luther, *On the Bondage of the Will,* trans. Philip S. Watson in *Luther and Erasmus: Free Will and Salvation,* ed. E. Gordon Rupp *et al.* (Philadelphia: Westminster, 1969), pp. 101-334. Although the Lutheran tradition has usually refused to use the actual word predestination, Luther's view of the powerlessness of fallen man to save himself is as emphatic as Calvin's.

John Calvin, *Institutes of the Christian Religion,* 2 vols., ed. John T. McNeill, trans. Ford Lewis Battles (Philadelphia: Westminster, 1960). The foundational work in Calvinist theology: God, scripture, the Fall, Christ, Law, gospel, grace, faith, predestination, the Church.

Albert C. Outler (ed.), *John Wesley* (New York: Oxford University Press, 1964). Thanks to Outler's pathfinding work, Wesley is coming increasingly to be appreciated as a very complex, but systematic and utterly logical theologian. He translated the patristic Logos theology into English by reading Logos as "Law" (Newtonian physics and natural moral law) and *theôsis* (divinization) as "Christian perfection."

Owen Chadwick (ed.), *The Mind of the Oxford Movement* (Stanford, California: Stanford University Press, 1960). Well-chosen selections from Keble, Newman, and Pusey—the leaders of the nineteenth-century Oxford movement in the Church of England—arranged according to theological topics.

William R. Hutchison, *The Modernist Impulse in American Protestantism* (Oxford: Oxford University Press, 1976). A history of Protestant liberalism in the United States, the "Social Gospel," and both the fundamentalist and the Neo-Orthodox reactions.

Reinhold Niebuhr, *The Nature and Destiny of Man,* 2 vols. in one (New York: Charles Scribner's Sons, 1941). A leader in the United States in the Neo-Orthodox attack on Protestant liberalism; applied the doctrine of original sin to produce an activist Christian political and social ethic.

Chapter Eight • THE EASTER FAITH

Erwin Rohde, *Psyche: The Cult of Souls and Belief in Immortality among the Greeks* (New York: Harcourt, Brace & Co., 1925). The historical development of ideas about the dead and life after death in ancient Greek literature and philosophy.

Plato, *The Republic,* trans. D. Lee, 2nd ed. (Baltimore, Maryland: Penguin Books, 1974). The conclusion (613e-621d, in this trans. pp. 447-455) tells the Myth of Er, where a dead soldier comes back to life and tells about the land of the dead. See also Plato's *Phaedrus,* and his *Phaedo,* on what happens to the soul after death.

Stanley Brice Frost, *Old Testament Apocalyptic: Its Origins and Growth* (London: Epworth, 1952). The influence of general Ancient Near Eastern myth on Old Testament ideas; apocalyptic as the mythologizing of eschatology.

Christopher Rowland, *The Open Heaven: A Study of Apocalyptic in Judaism and Early Christianity* (New York: Crossroad, 1982). An important book: he deemphasizes the eschatological aspect and concentrates on apocalypticism as an attempt at direct apprehension of the divine world, which led ultimately (in ancient Jewish thought) to rabbinic *merkabah*-mysticism.

C. F. Evans, *Resurrection and the New Testament* (Naperville, Illinois: Allenson, 1970). Looks at 1 Corinthians; then at the four gospels as separate theological expressions of the Easter faith, which cannot be harmonized logically, but which are nevertheless real.

Rudolf Bultmann *et al., Kerygma and Myth: A Theological Debate,* ed. Hans Werner Bartsch, trans. R.H. Fuller, rev. ed. (New York: Harper & Row, 1961). The initial statement (pp. 1-44) by Bultmann, who was one of the three most important theologians of the first part of the twentieth century, is a very clear statement of his program of "demythologizing" the New Testament.

Richard R. Niebuhr, *Resurrection and Historical Reason* (New York: Charles Scribner's Sons, 1957). Laws of nature are highly abstract, dealing with certain very generalized aspects of reality; they cannot totally account for the arbitrariness, uniqueness, specificity, and independence of the resurrection of Jesus or, in truth, of any other particular historical event.

Van A. Harvey, *The Historian and the Believer* (New York: Macmillan, 1966). Harvey describes the historical relativism of the defenders of the empty tomb quite fairly, then argues that their position obscures the distinction between fact and interpretation, and also leaves them with no method of deciding between different interpretations of Jesus' life, even among believers.

Wolfhart Pannenberg, *Jesus—God and Man,* trans. L. L. Wilkins and D. A. Priebe (Philadelphia: Westminster, 1968). He has been the leader of an important, basically anti-Bultmannian movement, in part of German theology. The appearances of the resurrected Jesus were real historical occurrences, not subjective visions, but such as to be describable only in the language of the apocalyptic eschatological expectation of the great resurrection. It is "because the end of the world is already present in Jesus' resurrection" that God himself is "revealed in him."

OTHER MODERN WORKS ON CHRISTOLOGY

Thomas J. J. Altizer, *The Gospel of Christian Atheism* (Philadelphia: Westminster, 1966). A "death of God" theologian who constructs his Christology here on the principle that God actually died in Christ in a cosmic event, that God cannot be brought back to life, and that this provides the opportunity for a liberated humanity in a world without God.

John Hick (ed.), *The Myth of God Incarnate* (Philadelphia: Westminster, 1977). A group of English scholars attacks the notion that traditional language of "incarnation" is an adequate way to speak of Jesus' role in Christianity. Maurice Wiles' essay, "Myth in Theology," is a very fine historical and critical discussion of the concept of myth in the English-speaking world.

Jürgen Moltmann, *The Crucified God,* trans. R. A. Wilson and J. Bowden (New York: Harper & Row, 1974). The resurrection of Jesus was a "promise event," proclaiming the future victory of the righteousness of God in a way which cannot be demonstrated to this world except through a faith which runs contrary to this world. See also his earlier book, *Theology of Hope.*

Karl Rahner, *A Rahner Reader,* ed. Gerald A. McCool (New York: Crossroad, 1975). A good introduction to the Transcendental Thomism of one of the best contemporary Roman Catholic theologians; chapter eight deals with Rahner's Christology. The Word of God could become man in Jesus Christ because man, as the self-utterance of the mystery of God, is himself mystery in the truest sense.

Edward Schillebeeckx, *Jesus: An Experiment in Christology,* trans. H. Hoskins (New York: Seabury, 1979). A truly excellent book by one of the most famous contemporary Roman Catholic theologians. He gives a provocative interpretation of the hypostatic union by denying that the human person (whose being as a creature is totally derived from God) can ever ultimately be contrasted with God: "being-as-man" is simply a way (distinguished by its finitude) of "being of God" (p. 629). See also his earlier book, *Christ, the Sacrament of the Encounter with God.*

Jon Sobrino, *Christology at the Crossroads,* trans. J. Drury (Maryknoll, New York: Orbis Books, 1978). Latin American liberation theology. Note how a deep concern for the historical Jesus goes hand in hand with social activism and the call to practical action in behalf of one's fellow human beings who are in pain and physical suffering.

Paul Tillich, *Systematic Theology,* repr. 1967 as three vols. in one (Chicago: University of Chicago Press, 1951-63). Along with Barth and Bultmann, one of the three great theologians of the first part of the twentieth century. Vol. 2, on Christology, presents Tillich's central idea of the New Being in Jesus as the Christ.

Index

A

Abelard, Peter 147-148
Abraham 31, 46, 85, 107, 109
Acts of the Apostles 134-135
Adam and Eve 17, 69, 110-113, 115, 116, 120, 123, 124, 155
Adam, Second 75, 109-110, 155
Aeons 72-73
Akiba, Rabbi 25
Alexander the Great 89, 91
Alexandrian school (one nature, monophysite) 77, 94-95, 154. *See also* Antiochene school; Monophysitism
Allegory—*see* Images
Alroy, David 25
Alston, William P. 61, 151
Altizer, Thomas J. J. 157
Anglicanism 30, 79, 120-122, 140

Anointing with oil, anointed one 20-21, 23. *See also* Messiah; Christ as title
Anselm x, 78, 102, 104, 120, 148. *See also* Atonement
Antiochene school (two natures) 77, 94-97, 154. *See also* Alexandrian school
Antiochus, King 91, 93
Antoninus Pius and Faustina 91
Apocalypticism 23-24, 82, 83, 126, 128-131, 134, 136, 138, 143, 157. *See also* Judgment, Last; Demythologization; Eschatology
Apollinaris (also spelled Apollinarius) 76, 94-95, 154
Apollonius of Tyana 90, 132, 138
Apophatic 133

159